PAINTING IN ISLAM

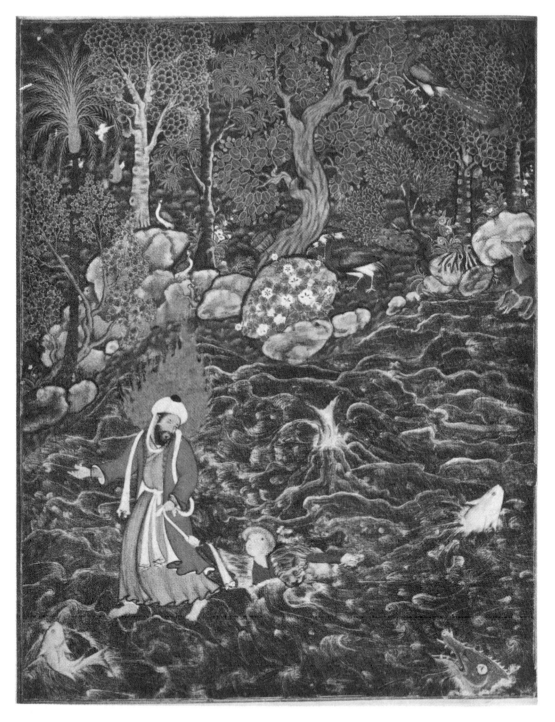

The Prophet Elias rescuing Prince Nūr ad-Dahr,
who had been thrown into the sea by a demon

PAINTING IN ISLAM
A STUDY OF THE PLACE OF PICTORIAL ART
IN MUSLIM CULTURE

By SIR THOMAS W. ARNOLD, C.I.E., F.B.A., LITT.D.

With a New Introduction by B. W. ROBINSON, M.A., B.Litt.
Deputy Keeper, Victoria and Albert Museum

DOVER PUBLICATIONS, INC.
NEW YORK

Published in Canada by General Publishing Company, Ltd., 30 Lesmill Road, Don Mills, Toronto, Ontario.
Published in the United Kingdom by Constable and Company Limited, 10 Orange Street, London W. C. 2.

This Dover edition, first published in 1965, is an unabridged republication of the work first published by the Oxford University Press in 1928, to which has been added a new Introduction by B. W. Robinson. Eight of the plates were reproduced in color in the original edition, but these are printed in black and white in this Dover edition.

This book is published by special arrangement with the Oxford University Press.

International Standard Book Number: 0-486-21310-2
Library of Congress Catalog Card Number: 65-12451

Manufactured in the United States of America

Dover Publications, Inc.
180 Varick Street
New York, N. Y. 10014

INTRODUCTION TO THE DOVER EDITION

THE study of Islamic painting is hardly older than this century. In 1928, when Sir Thomas Arnold's *Painting in Islam* was first published by the Oxford University Press, the literature on the subject was virtually confined to the sumptuous pioneer folios of Martin (1912), Marteau-Vever (1913), and Schulz (1914), and the later and more modest volume of Kühnel (1922). In all these works the illustrations far outweigh the texts in which, indeed, the authors were feeling their way like explorers in unmapped territory. A number of articles and monographs on Islamic painting had also come from the pen of M. Blochet of the Bibliothèque Nationale, but his views, always individual and often paradoxical, became quite irresponsible as time went on.

The present republication of such a classic in this field as *Painting in Islam*, in recognition of the centenary of the author's birth, should be widely acclaimed; it makes generally available once again a major work of scholarship, and is also an act of what the Romans called *pietas*—honour to the illustrious dead. We pay Arnold this honour not only for the high place he holds in the distinguished ranks of British orientalists by virtue of his wide learning, his exacting standards of scholarship, and his originality of research, but equally in recognition of his great gift of teaching and his outstanding qualities of enthusiasm, modesty, and humanity.

Thomas Walker Arnold was born on April 19, 1864, the third son of a Devonport businessman. He gained a scholarship to Magdalene College, Cambridge, where he read Classics, but was soon drawn towards oriental studies. At the age of twenty-four he was appointed teacher of philosophy at the Mohammedan Anglo-Oriental College, Aligarh (some sixty miles southeast of Delhi), a post which he held with conspicuous success for ten years, forming a very strong bond with Indian Muslims and working devotedly in the cause of reform in Islam. In 1898 he was made Professor of Philosophy at Government College, Lahore, returning to England in 1904, where he became Educational Adviser for Indian students. From 1921 until his death on June 9, 1930, he was Professor of Arabic and Islamic Studies at London University. He was knighted in 1921.

Thus by 1928 Sir Thomas Arnold could look back on more than forty years' scholarship in Arabic and Persian and a long and honourable career of university teaching at Aligarh, Lahore, and London, in the course of which

he had steeped himself in every aspect of Islamic culture. It was not until 1921, when he collaborated with Laurence Binyon on *The Court Painters of the Great Mughals*, and contributed a valuable article on the *Khusraw u Shirin* manuscript with miniatures by Riza-i 'Abbasi (Victoria and Albert Museum, 364–1885) to the *Burlington Magazine* that his flair for Islamic painting began to show itself. In 1924 his first individual publication on the subject appeared: a modest but highly original and suggestive paper, *Survivals of Sasanian and Manichaean Art in Persian Painting*, which he had delivered as the fourth Charlton Lecture at Armstrong College, Durham University, two years previously. In 1926 he collaborated with F. R. Martin in the publication of three outstanding Persian manuscripts in limited editions with plates by Max Jaffé of Vienna: the *Diwan* of Sultan Ahmad Jalair, now in the Freer Gallery, Washington; the British Museum Nizami of 1494 (Or. 6810); and the *Shah u Gada* of Hilali which had passed from Martin's own collection to the Nationalmuseum, Stockholm. *Painting in Islam* was followed in 1929 by *The Islamic Book*, a comprehensive work of profound scholarship written in collaboration with the distinguished Austrian Arabist, Dr. Adolf Grohmann. *Bihzad and his Paintings in the Zafar Nama MS* (the celebrated manuscript dated 1467, formerly in the collection of Schulz) appeared in the year of Arnold's death, and *The Old and New Testaments in Muslim Religious Art*, the Schweich Lecture he delivered before the British Academy in 1928, two years after his election as a Fellow, was published posthumously in 1932. His great catalogue of the Mughal miniatures in the Chester Beatty Library was not published until 1936.

But of all Arnold's works *Painting in Islam* is of the greatest value to the student of Muslim, and particularly Persian, painting. It set a new standard of scholarship in the subject, for Arnold's long apprenticeship in Arabic and Persian gave him free access to original sources; his deep interest in the religion and culture of Islam enabled him to see Islamic painting in its proper setting and proportion; and at the same time his humanity makes the book an eminently readable account of a somewhat abstruse subject. He went to previously untapped sources for many of his illustrations and examples—the Bodleian Library, the Royal Asiatic Society, and the India Office Library (where he had been Assistant Librarian from 1904 to 1909)—and thus widened the field of research for his successors. In his Preface he emphasizes that he has not attempted to write a general history of Islamic painting; the "purpose of the book is rather to indicate the place of painting in the culture of the Islamic world, both in relation to those theological circles which condemned the practice of it, and to those persons who, disregarding the prohibitions of religion, consulted their own tastes in encouraging it." Thus *Painting in Islam*

has been in no way superseded by later works such as Binyon, Wilkinson, and Gray's monumental *Persian Miniature Painting* (1933), or Stchoukine's admirable treatments of Persian painting under the Abbasids and Mongols (1936), the Timurids (1954), and the Safavids (1959 and 1964), but is complementary to them. Arnold was first and foremost a Persian and Arabic scholar; other writers on Persian painting have usually been art historians whose knowledge of the background of Islamic literature, tradition, and thought may be comparatively superficial, and whose acquaintance with the languages and script seldom stretches beyond the more or less laborious reading of a colophon or chapter-heading in a manuscript.

I hope I may be permitted to close on a personal note. I developed a love of Persian painting at a very early age; *Painting in Islam* appeared when I was halfway through my public school, but my parents, perhaps wisely, felt that four guineas—a very considerable sum in those days—was too much to lay out on such a book for a boy of sixteen. However, during my last year at school I managed to win a prize for a paper on Greek sculpture, the prize being £5 worth of books at the school bookshop. Thus, in 1931, I acquired my copy of *Painting in Islam*, and when I went on to Oxford it was Arnold's reproductions and descriptions of Persian miniatures in the Bodleian Library that gave me the idea of presenting a thesis on the Bodleian collection for the degree of B.Litt. This I did in 1936, and twenty-two years later this thesis was published, after much rewriting and expansion, as *A Descriptive Catalogue of the Persian Paintings in the Bodleian Library*. Thus, though I was never privileged to meet Sir Thomas Arnold, I can truthfully claim him as my preceptor, and his book as the progenitor of my own. It has, in fact, been a great honour and satisfaction to write the introduction to this most admirable book, which has been my companion and guide for over thirty years. I am quite sure that in its new form it will prove equally valuable to younger amateurs and students in the same field for many years to come.

B. W. ROBINSON

PREFACE

THE present work makes no claim to be a history of Muslim painters, either of Persia or of any other country, though a chapter has been added, giving from hitherto untranslated historical sources the scanty materials available for the biographies of the most famous Persian painters. The purpose of the book is rather to indicate the place of painting in the culture of the Islamic world, both in relation to those theological circles which condemned the practice of it, and to those persons who, disregarding the prohibitions of religion, consulted their own tastes in encouraging it. A chapter on landscape has purposely been omitted, since it was recognized that an adequate account of this aspect of the subject would require a separate treatise.

The author desires to express his grateful thanks to the following institutions for the use of photographs from their respective collections: the Museum of Fine Arts, Boston; the University Library, Edinburgh; the British Museum and the India Office Library, London; the Staatsbibliothek, Munich; the Ashmolean Museum and the Bodleian Library, Oxford; the Accademia dei Lincei and the Biblioteca Casanatense, Rome; the National-bibliothek, Vienna. To Mr. A. Chester Beatty he is indebted not only for Plate XXV but also for the number of prints required for the present edition, and for Plate XXXVII a; to Miss Jessie Beck for Plate XLVII; to Mr. Bernard Berenson for Plate XL; and to Professor Dr. Friedrich Sarre for Plate XVI. More examples would have been added from the collection in the Bibliothèque Nationale, had not the condition been imposed that two copies of the published work should be presented in exchange; it has been thought proper to resist the imposition of such a fine upon scientific work, and accordingly use has been made of pictures already published, for Plates VIII, XXXIV (the block of which was kindly lent by M. Paul Geuthner), and XXXV b.

CONTENTS

LIST OF ILLUSTRATIONS

NOTES ON THE ILLUSTRATIONS

Frontispiece. (British Museum, Department of Prints and Drawings 13270-1.) This is a page out of the enormous MS. of the *Dāstān-i-Amīr-Hamzah*, begun for the Mughal emperor Humāyūn and completed in the reign of his son, Akbar. It bears on the back, in the lower part of the text, the number 86 in red letters. The young prince, Nūr ad-Dahr, was the grandson of the eponymous hero of the romance, Hamzah. (See *Die indischen Miniaturen des Hæmzæ-Romanes im Österr. Museum für Kunst und Industrie in Wien und in anderen Sammlungen*, von H. Glück, 1925.)

I. (Bodleian Library, Douce 348 (Ethé 596), fol. 99 b. The *Haft Paykar* by Nizāmī, copied at Samarqand in A. H. 980 (A. D. 1572-3). This picture illustrates the story told to King Bahrām Gūr by the princess in the green pavilion.

II. (British Museum, Add. 16561, fol. 60.) This MS. contains a collection of Ghazals from the Divans of twelve Persian poets of the 8th and 9th centuries of the Hijrah. The inundation of the city of Baghdad, depicted in this picture, occurred during the reign of Shaykh Uways (1356–74), the son and successor of the founder of the Jalā'ir dynasty, and was referred to in a poem by Nāṣir, a dervish from Bukhārā, who at the time was on a visit to a famous poet, Salmān of Sāwa, the court-poet and panegyrist of the Sultan. As the date of the MS. is 1468—a whole century later than the disaster represented in the picture, and after the destruction caused by Tīmūr when he sacked Baghdad in 1401 and destroyed many of its public buildings—the picture is of no historic value, and merely represents what the painter thought the great capital of Islam ought to have looked like. The MS. is of interest, as having been produced in Shirvān, in one of the most northerly of the provinces of Persia, on the west coast of the Caspian Sea.

III. (British Museum, Or. 7693, fol. 255 b.) From a MS. of the *Mathnawī* of Jalāl ad-Dīn Rūmī, dated A. H. 695 (A. D. 1295–6).

IV. (British Museum, Or. 1373, fol. 16.) This picture, taken from an Album of pictures and specimens of calligraphy, bears no signature; the painter probably belonged to the school of Riżā 'Abbāsī.

V. (British Museum, Or. 2265, fol. 203 b.) This picture is one of those referred to on p. 149, as having been painted by Muḥammad Zamān, in the MS. of the *Khamsah* of Nizāmī, belonging originally to Shāh Ṭahmāsp.

VI. (Bodleian Library, Elliot 325 (Ethé 493), *Shāh Nāmah*, dated A. H. 899 (A. D. 1494), fol. 7.) Prince Baysunqur, a grandson of Tīmūr, is credited with having prepared a recension of the *Shāh Nāmah*, to which he prefixed a preface, giving an account of the historical sources of the epic, &c. In this picture the prince is represented as having a copy of the completed volume brought to him.

VII. (India Office Library, Persian MSS. No. 1129 (Ethé 982), fol. 29.) This MS. of extracts from the *Khamsah* of Nizāmī is dated A. H. 982 (A. D. 1574–5); no evidence is available as to the date of the mutilation of the picture. See pp. 46–7.

VIII. Examples of similar types in Christian and Muslim MSS.: a. (from the Schefer MS. of Ḥarīrī (reproduced here from P. A. Van der Lith's edition of *'Ajā'ib al-Hind*)) and b. (from an Arabic Gospel in the British Museum, Add. 11856, fol. 95 b.) illustrate the convention of indicating the outline of the nose by a line of white paint; c. is from a MS. of Ḥarīrī in the British Museum, Or. 1200, fol. 172; d. is from a Lectionary of the Jacobite Church (British Museum, Add. 7170, fol. 145); and e. is from the same MS. (fol. 108 b) as c.

IX. Examples of similar types in Christian and Muslim MSS.: a. is from the same MS. (fol. 100 b) as VIII c; b. is from the same MS. (fol. 7) as VIII d; c. is from the same MS. as VIII a; and d. is from the same MS. (fol. 145) as VIII d. (See pp. 58–9)

X. (British Museum, Add. 7293, fol. 285 b.) This illustration—a drawing in red ink—is taken from a MS. of the *Maqāmāt* of Ḥarīrī, copied in A.H. 723 (A.D. 1323). The composition of the picture appears to have been suggested by some Christian representation of Christ discoursing with the doctors, though the original passage which it illustrates describes how a rascally boy takes advantage of the effect produced by the exhortations of a preacher, who had urged his hearers to atone for their past transgressions by acts of piety and charity to the poor, and entreats them to make him the object of their benevolence, and so goes off with his bibulous father to spend the plunder in a wine-shop.

XI. a. Mechanical clock, from *Kitāb fī ma'rifat al-ḥiyal al-handasiyya* by Ismā'īl ibn ar-Razzāz al-Jazarī (Bodleian Library, MS. Graves 28, fol. 4).

b. Mechanical boat, with musicians and a drinking party (id. id., fol. 61 b). See E. Wiedemann und F. Hauser, *Über Trinkgefässe und Tafelaufsätze nach al-Ğazari und den Benû Mûsà* (*Der Islam*, viii. 73). (See p. 80.)

XII. (Bodleian Library, Marsh 458, *Maqāmāt* of Ḥarīrī, dated A.H. 738 (A.D. 1337).)

a. (fol. 36.) A drinking party (*Maqāmah* xxiv).

b. (fol. 92.) Abū Zayd, after receiving from his host a camel as a reward for his clever sayings, goes off when the rest of the guests fall asleep, without having explained to them the ambiguities in his various sentences (*Maqāmah* xliv).

c. Abū Zayd listening to the poetical exercises set by a teacher in Emessa to his pupils (*Maqāmah* xlvi).

XIII. From a MS. of the Khamsah of Jamālī, copied in Baghdad in A.H. 870 (A.D. 1465), in the India Office Library (No. 138 (Ethé 1284), fol. 101 b).

XIV. (British Museum, Or. 2834, fol. 79 b.) From a MS. of the Khamsah of Nizāmī, dated A.H. 895 (A.D. 1490).

XV. (Bodleian Library, Or. 133, fol. 43.) This picture of Sindbad and the old man of the sea occurs in a MS. of Abū Ma'shar's Treatise on the influence of the planets.

XVI. The symbols of the four Evangelists, from a MS. of Qazwīnī's *'Ajā'ib al-Makhlūqāt*, copied about A.D. 1400, belonging to Professor Friedrich Sarre of Berlin. (See p. 84.)

XVII. These fragments of frescoes from Sāmarrā are from the collection in the British Museum; a. and b. show portions of female heads, and c. illustrates the method of superimposing one layer of plaster over another. (See pp. 85–6.)

XVIII. (Edinburgh University Library, Arabic No. 161, *al-Athār al-Bāqiyah* by al-Berūnī.) (A.H. 707 (=A.D. 1307-8).)

a. fol. 122 b. Adam and Eve are said to have mourned so disconsolately after the death of Abel, that God took pity upon them and allowed their son to return to earth and remain with them for the space of twenty-four hours; he is here represented as sitting with his parents, who have prepared for him a generous feast.

b. fol. 7 b. Muḥammad preaching his farewell sermon on the occasion of his last visit to Mecca.

XIX. (Edinburgh University Library, Arabic No. 20, *Jāmiʿ at-Tawārīkh* by Rashīd ad-Dīn, dated A.D. 710 (A.D. 1310-11).)

a. fol. 45 b. When Muḥammad was a boy, he accompanied his uncle on a trading journey into Syria, and there a Christian monk, named Baḥīrā, is said to have recognized him to be a prophet. See p. 94.

b. fol. 47. When Muḥammad was about thirty-five years of age, the building of the Kaʿbah was so seriously damaged by a flood of rain, that it had to be rebuilt. A dispute arose as to who should have the honour of putting the Black Stone back in its old place. Upon Muḥammad's appearance on the scene, he was selected for the purpose. See p. 94.

XX. (id. fol. 47 b.) a. The angel Gabriel is represented as delivering to Muḥammad the divine message. See p. 94.

(id. fol. 65.) b. Muḥammad and Abū Bakr. See p. 94.

XXI. (*Rawḍat aṣ-Ṣafà*, by Mirkhwānd, belonging to Messrs. Luzac & Co.)

a. (fol. 85 b.) One of the first acts of Muḥammad on the occasion of his triumphant entry into Mecca (A.H. 8, A.D. 630) was to visit the Kaʿbah and destroy the idols there. Here he is represented as lifting up ʿAlī on his shoulders, so that he may throw them down to the ground.

b. (fol. 97 b.) This incident is said by the Shiahs to have occurred at Ghadīr al-Khumm, when the Prophet was on his return from his farewell pilgrimage to Mecca. The fact that ʿAlī is depicted with a flame halo of exactly the same type as that of the Prophet would seem to indicate that the painter was a Shiah, and desired thus to glorify the especial object of Shiah veneration. See p. 96.

XXII. (Bodleian Library, Elliot 287 (Ethé 2116), fol. 7.) See p. 97.

XXIII. (Edinburgh University Library, *Jāmiʿ at-Tawārīkh*, fol. 44.) See p. 99.

XXIV. (id. fol. 24.) See pp. 99-100.

XXV. (*Qiṣaṣ al-Anbiyā*, fol. 225, belonging to Mr. A. Chester Beatty.) See p. 100.

XXVI. (*Būstān* of Saʿdī, belonging to Mr. Gazdar, Bombay.) Jesus and the Pharisee. See p. 101.

XXVII. a. (Bibliothèque Nationale, Supplément persan 1111, fol. 102.) See p. 102.

b. (British Museum, Add. 6613, *Khamsah* of Niẓāmī, fol. 19 b.) See p. 102.

XXVIII. (Bodleian Library, Elliot 192 (Ethé 587), fol. 22 b, *Khamsah* of Niẓāmī, dated A.H. 906 (A.D. 1500), fol. 22 b.) See p. 102.

XXIX. (Vienna, Nationalbibliothek, A. F. 50 (143), fol. 8.) The upper figures represent Alexander the Great (on the left) and Zacharias (on the right); the lower figures, Jesus (on the left), and St. John the Baptist (on the right). See p. 103.

XXX. (*Būstān* of Sa'dī, belonging to Mr. Gazdar, Bombay.) See p. 105.

XXXI. (India Office Library, No. 737 (Ethé 1342), Jāmī's *Yūsuf u Zulaykhā*, fol. 9 b.) Dated A.H. 1007 (A.D. 1599). Abraham about to sacrifice his son. (See p. 105.)

XXXII. (Bodleian Library, Elliot 149 (Ethé 898), Jāmī's *Yūsuf u Zulaykhā* copied about the middle of the 16th century.

a. fol. 199 b. See p. 107.

b. fol. 190. See p. 108.

XXXIII. (Bodleian Library, Ouseley Add. 24 (Ethé 1271), fol. 127 b.) See p. 108.

XXXIV. (Bibliothèque Nationale, Supplément persan 1559, fol. 10 b.) From a 17th-century MS. of *Majālis al-'Ushshāq* by Sultan Ḥusayn Mīrzā. The painter of this picture probably sympathized with the defence put forward by some Muslim mystics for Satan's refusal to bow down before Adam, in that, by maintaining that worship was due to God alone, he had upheld the Unity of God, and they concluded that he would thereby be justified on the Day of Judgement, in spite of his disobedience to the divine command. (*La Passion d'al-Hallaj, martyr mystique de l'Islam*, par Louis Massignon, p. 864 sqq.) See p. 109.

XXXV. a. See p. 110.

b. See p. 109. (Reproduced here from *Mirādj-nāmeh*, publié par A. Pavet de Courteille. Paris, 1882.)

XXXVI. (Edinburgh University Library, *Jāmi' at-Tawārīkh*, fol. 25 b.) See p. 110.

XXXVII. a. (From MS. of Qazwīnī's *'Ajā'ib al-Makhlūqāt*, in the collection of Mr. A. Chester Beatty.) Mūsà ibn al-Mubārak visiting the queen of the island of Wāqwāq.

b. (Bodleian Library, Elliot 192 (Ethé 587), Nizāmī's *Iskandarnāmah*, fol. 333.) Dated A.H. 907 (A.D. 1501).

XXXVIII. (Bodleian Library, Ouseley Add. 176 (Ethé 501), fol. 311 b.) A late 15th-century MS. of the *Shāh Nāmah*. In the course of his wanderings, Alexander comes to a talking tree, which rebukes him for his lust of conquest and prophesies his death in a country far from his native land.

XXXIX. (Museum of Fine Arts, Boston.) A mystic meditating in a garden.

XL. (Collection of Mr. Bernard Berenson.) The mystical poet Jāmī and his friends, attributed to Bihzād.

XLI. (Bodleian Library, Douce Collection.) A group of Indian saints.

XLII. (Formerly in the possession of Mr. E. N. Adler.) A Turkish representation of the religious dance of the Mevlevis in Constantinople. (See p. 113.)

XLIII. (Bodleian Library, Elliot 339 (Ethé 2120), fol. 95 b.) Copied for Badi' az-Zamān, son of Sultan Ḥusayn Mīrzā, in A.H. 890 (A.D. 1485). Mystics discoursing in a garden.

XLIV. (British Museum, Stowe 16, fol. 36.) A group of Indian ascetics. This picture is interesting as indicating the friendly relations that sometimes existed between Hindu and Muhammadan mystics, for this group is made up of examples of either class.

XLV. (Bodleian Library, Ouseley Add. 24 (Ethé 1271).) From a MS. of *Majālis al-ʿUshshāq* by Sultan Ḥusayn Mīrzā, copied A.H. 959 (A.D. 1552).

 a. See p. 112. The incident in the life of Jalāl ad-Dīn here represented is that one day the saint, passing by some gold-beaters, fell into an ecstasy at the sound of the striking of the hammers and began to dance. Another mystic, Salāḥ ad-Dīn, who had formerly been his fellow pupil and had been compelled by poverty to take to the trade of a gold-beater, perceiving the saint rushed out of the shop and embraced his feet; and afterwards became his disciple.

 b. See p. 113.

XLVI. (id.) See p. 112.

XLVII. (From the collection of Miss Jessie Beck.) Dervishes dancing, by Muḥammadī. (See p. 113.)

XLVIII. a. (Bodleian Library, Ouseley Add. 24 (Ethé 1271), fol. 119.) See p. 114.

 b. (Bodleian Library, Douce Or. b. 2, fol. 47.)

XLIX. (Bodleian Library, MS. Pers. B. 1, fol. 33.) Ibrāhīm ibn Adham. See p. 112.

L. a. (Musée du Louvre.) A saint crossing a river on his prayer-mat.

 b. (India Office Library, No. 1779 (Ethé 1142), fol. 27 b.) The same subject from a MS. of the *Būstān* of Saʿdī, dated A.H. 1171 (A.D. 1757). See p. 115.

LI. (Bodleian Library, MS. Or. 133, fol. 42.) The rival saints. See p. 115.

LII. (India Office Library, No. 1097 (Ethé 2197), foll. 3 b, 6.) From a MS. of the *Akhlāq-i-Muḥsinī*, copied about A.D. 1600.

LIII. (Edinburgh University Library, *Jāmiʿ at-Tawārīkh*, fol. 72 a). See p. 119.

LIV. Prototypes of Burāq: a. Ivory carving from Nimrud (British Museum, No. 118863); b. Bronze bowl from Nimrud (id., No. 115504); c. Winged cow with female head, forming base of a column (id. No. 90954); d. Clay plaque from Eastern Crete (Ashmolean Museum, Oxford, No. G. 488). (See p. 119.)

LV. Prototypes of Burāq: a. Painted bowl from Rayy (British Museum, Ceramic Department 13270-3 ; b. Drinking vessel from Rayy (Musée du Louvre); c. Metal plate, made (about A.D. 1250) for the Atābeg Badr ad-Dīn Luʾluʾ of Mosul (Museum für Völkerkunde, Munich) (see p. 120); d. Late representation of Burāq, from MS. of *Būstān* of Saʿdī, dated A.H. 1171 (A.D. 1757), (India Office Library, No. 1779 (Ethé 1142)). (See p. 99.)

LVI. a. Muḥammad on Burāq passing through the heavenly spheres, with the earth in the centre (British Museum, Add. 6613, fol. 3 b).

 b. 18th-century representation of Burāq, with a Persian crown on her head and a peacock's tail (from a MS. of *Laylā wa Majnūn* by Niẓāmī in the Accademia dei Lincei, Rome, Collezione di Don Leone Caetani. A. b. 12, fol. 4). (See pp. 121-2.)

LVII. (Kusejr ʿAmra, von Alois Mosil. Vienna, 1907.)

 a. (Tafel xxvi.) See p. 124.

 b. (Tafel xv.) See p. 125.

LVIII. (British Museum, Or. 2265, fol. 195.) See p. 121.

LIX. Coins with effigies: a. The Caliph al-Muṭī (946–74) (see p. 126); b. The Caliph al-Muqtadir (908–32) (see pp. 125–6); c. The Emperor Akbar (1556–1605), on right, and the Emperor Jahāngīr (1605–28), on left (see p. 131); d. The Caliph al-Mutawakkil (847–61) (see p. 125).

LX. Representations of the planets: a. The sun on a coin of Masʿūd I, Atābeg of Mosul A.H. 585) (see p. 126); b. The sun (from MS. of Qazwīnī's *ʿAjāʿib al-Makhlūqāt*, Staatsbibliothek, Munich, Arab. 464, fol. 14 b.) (see p. 126); c. The planet Venus (id., fol. 14) (see p. 126).

LXI. (British Museum, Or. 2265, fol. 26 b.) See pp. 135–6.

LXII. (India Office Library, Johnson Collection, xxviii, foll. 14, 15.) Drawings by Muḥammadī.

LXIII. a. (Bodleian Library, Pococke 4000, fol. 97 b.) From a MS. of *Kalīlah wa Dimnah*, dated A.H. 755 (A.D. 1354).

 b. (British Museum, Add. 18579, *Anwār-i-Suhaylī*, dated A.H. 1019 (A.D. 1610), fol. 146. The animals in council. (See p. 81.)

LXIV. a. (India Office Library, Johnson Collection, xxii, p. 8.) A dervish, by Riżā ʿAbbāsī. (See p. 145.)

 b. (British Museum, Department of Prints and Drawings, 1920–9–17–0275.) A picnic party, by Riżā ʿAbbāsī.

I

THE ATTITUDE OF THE THEOLOGIANS OF ISLAM TOWARDS PAINTING

MUHAMMADAN art[1] may well claim a place among the greatest achievements of man's artistic activity. Its supreme expression is in architecture, in which the followers of Islam or the architects they employed worked out a scheme of building construction and of decoration in harmony with the austerity and dignity of their faith and adapted to its ritual and forms of worship. The great courtyard of the mosque of Ibn Ṭūlūn in Cairo, or of Akbar's mosque at Fathpūr-Sīkrī; the massive structures of the mosque of Ḥasan in Cairo, the great mosque of Qayrawān, the mosque of the Imām Riẓā in Mashhad, are among the noblest houses of worship in the world; and the mosque of Cordova, the Sulaymaniyyah mosque in Constantinople, the Dome of the Rock in Jerusalem, are unsurpassed for richness of colour decoration. The monumental tombs of monarchs and saints are also among the great achievements of Muhammadan architecture. In many other artistic expressions of civilized life, the achievements of the art of the Muhammadans are of the highest order; their carpets are among the finest in the world, and their silks in the Middle Ages were so highly prized in Europe that they were chosen above all others as wrappings for the relics of the saints; their metalwork and pottery have been distinctive and second to none; the very word 'arabesque', which has passed into most of the languages of Europe, bears testimony to the characteristic nobility of Muslim ornament.

But the art most highly valued by the Muhammadans themselves was that of calligraphy. This they were proud of cultivating themselves, and they did not call in the aid of foreign artists, as they were so frequently in the habit of doing in the case of other arts. Even kings did not think it beneath their dignity to compete in this art with professional calligraphists, and sought to win religious merit by writing out copies of the Qur'ān.[2] The following

[1] By this term is meant those works of art which were produced under Muhammadan patronage and in Muhammadan countries; the artists themselves were of diverse nationalities and were not always adherents of the faith of Islam. Mr. M. S. Briggs has put in a plea for the word Saracenic (*Muhammadan Architecture in Egypt and Palestine*, p. 3), but this is open to the objection that it is not distinctive of the Muhammadan period, since the word Saracenic had had a long history before the rise of Islam. Still more objectionable is the term Arabic art, as the Arabs themselves contributed to the sum total less than any other Muslim people; equally misleading, because of its restricted reference, is the Persian word 'Musulman' so commonly used by French writers, since it is unknown in Arabic-speaking countries.

[2] The Ghaznavid Sultan Ibrāhīm ibn Mas'ūd (*ob.* 1099) used to send a Qur'ān copied out with his own hand every year to Mecca (v. Appendix A).

passage from an encyclopaedic work entitled *Nafā'is al-funūn*, on the arts and sciences of the Muhammadan world in the fourteenth century, sets forth the reasons for the exalted place assigned to calligraphy in Muslim culture. The author, Muḥammad ibn Maḥmūd al-Āmulī, who wrote in Persian, divides his voluminous work into two main groups—first, the modern or Islamic sciences, comprising the literary, legal, mystic, and conversational sciences; and second, the ancient sciences, viz. practical and speculative philosophy, mathematics, physics, &c.—but it is noteworthy that even in so extensive a survey he can find no place for a mention of painting. His section on calligraphy, which is the first of the literary sciences, begins as follows:

'The art of writing is an honourable one and a soul-nourishing accomplishment; as a manual attainment it is always elegant, and enjoys general approval; it is respected in every land; it rises to eminence and wins the confidence of every class; being always held to be of high rank and dignity, oppression cannot touch it, and it is held in remembrance in every country, and every wall is adorned by its hand. Honour enough for it in this connexion is it that the Lord of Lords, whose names are hallowed in His incontrovertible Revelation, swore—"By the pen and what they write" (Qur. lxviii. 1), and He spake these words: "Recite! thy Lord is the most generous, Who hath taught by means of the pen, Hath taught man what he knew not" (Qur. xcvi. 3–5).

It is honour and exaltation enough for the writing pen
For ever, that it was by the pen that God swore.

The Prophet (peace be upon him!) said: "Beauty of handwriting is incumbent upon you, for it is one of the keys of man's daily bread." A wise man has said: "Writing is a spiritual geometry, wrought by a material instrument." And another has said: "Writing is the offspring of thought, the lamp of remembrance, the tongue of him that is far off, and the life of him whose age has been blotted out." Jāḥiẓ[1] says: "Writing is a tongue to which the heart runs and is the depository of secrets, the investigator of news, and the preserver of historical memorials." Another has said: "Writing is antimony to the sight and illumination to man's insight." Another has said: "Fine utterances (set out) in elegant handwriting are a pleasure to the eye, and a joy to the heart, and fragrance to the soul." Others have written: "Writing excelleth speech, in that writing is of profit both to him that is near and to him that is far off; but this is not the case with speech." With regard to the inventor of writing, the learned differ; some have said: Since God Almighty, in accordance with (the verse) "And He taught Adam all names" (Qur. ii. 29), taught Adam (on our Prophet and on him be peace!) the name and the utilities of everything, the utilities of the pen must also have been included in that total, and Adam communicated this knowledge to Seth, so that he is the originator of writing.'[2]

It is thus clear that the reason for the exalted position given to calligraphy in the Muslim world was its connexion with the Word of God and with the

[1] A well-known man of letters of the ninth century.
[2] fol. 6 (I.O. Library, Ethé 2221).

first of God's Prophets, Adam. The profession of the calligrapher was one of honour and dignity because he was engaged in copying the Qur'ān, and his labours thereby received a religious sanction. The importance of this connexion becomes obvious when it is remembered that the Muhammadan state was by theory a religious society, that the only citizenship it knew was acceptance of a particular creed and observance of the ordinances it prescribed. The supreme function of the ruler was the defence of the faith, and the national army was the body of true believers. The members of non-Muslim religions were indeed tolerated, but by theory they could not take part in Jihād, the holy war for the defence of Islam and the extension of its dominion, nor was their evidence accepted in the Muslim courts of law.

These considerations make clear the basis for the difference of status assigned to the calligraphist and to the painter in Muslim society, for the art of the latter was condemned by religious authority while that of the former was exercised in the service of religion. Accordingly we find that most extravagant sums were sometimes paid for the handiwork of the expert calligrapher,[1] and no expense was spared in the preparation of MSS., especially those of the Qur'ān; it is probable too that the arts of colour decoration and of gold illumination, as well as the whole craft of bookbinding in the Muhammadan world, derived their origin and attained their rich development from the fact that they were first employed in the perpetuation of the Word of God. Calligraphy even influenced the work of the painter, and his draughtsmanship has sometimes been described as a 'calligraphic art', because it suggests the flowing, rhythmic lines of the beautiful Arabic characters.[2] The art of the gilder likewise attained dignity as being exercised upon MSS. of the Qur'ān, and was quite distinct, as in the Middle Ages in Europe,[3] from that of the painter, though there were times when they might both be practised by the same artist, and many of the painters who append their signatures to their paintings describe themselves as 'Mudhahhib', 'gilder', obviously with the desire of claiming for themselves respectability.

[1] One calligrapher is said to have received 10,000 pieces of gold for 1,000 verses (A. Sprenger, *Catalogue of the Libraries of the King of Oude*, Vol. I, p. 23, Calcutta, 1854). A single line in the handwriting of Mīr 'Imād (*ob.* 1615) was sold for a gold piece, even in his lifetime (Ghulām Muḥammad Dihlawī, *Tadhkira-i-khushnavīsān*, p. 92, Calcutta, 1910). An Indian calligrapher, Mīr Muḥammad Ṣāliḥ (*ob.* 1651), once presented Shāh Shujā', the second son of the Emperor Shāhjahān, with some verses he had written himself, but made out that they were in the handwriting of Mīr 'Alī Mashhadī; the reward he received was 2,000 rupees, and the prince increased this sum when he learned that they were in Ṣāliḥ's own handwriting (Muḥammad Baqā, *Mirāt-i-Jahānnumā*, fol. 399, I.O., no. 1497).

[2] Herein is found the explanation of one of many foolish blunders of Karabacek, when he attempted to find a Persian inscription in the loose ends of a turban-cloth (J. von Karabacek, *Zur orientalischen Altertumskunde*, III, p. 21, Wien, 1911).

[3] J. P. Richter, *Lectures on the National Gallery*, pp. 28–9 (London, 1898).

On the other hand, it was the very lack of this religious sanction which lowered the status of the painter in Muhammadan society. For of the three great missionary religions of the world—Buddhism, Christianity, and Islam— each striving for the mastery of the world and endeavouring to win the allegiance of all men by various devices of propaganda, Islam alone has refused to call in the aid of pictorial art as a handmaid to religion. Any observer who has lingered in one of the great monuments of Christian architecture—some gorgeously decorated cathedral belonging to the Ortho- dox Eastern Church or to the Roman Catholic Church—and has thence passed into a Muhammadan mosque, must at once be struck with this fundamental difference of attitude in Islam as contrasted with the rival faith. The first may be filled with brilliant paintings and frescoes representing scenes of sacred history or individual saints, or even some pictorial adumbration of the Deity, in which the highest attainments of artistic skill have been placed at the service of religion and have obviously been inspired by devout feeling, and may even have been superintended in the course of their execution by ecclesiastical guidance; while the mosque is characterized by austere simplicity and by the absence of any kind of pictorial presentation of religious doctrine or history. Colour in marble or in paint, decorative design of a geometric or a floral character, may indeed be present in abundance, but what immediately strikes the Christian visitor is the absence of any imagery of 'Martyr or King or sacred Eremite' or any pictorial symbol of divine truth. This hostile attitude on the part of Islam to pictorial art has given to the whole history of its propaganda, and to the organization of its devout life, a complexion fundamentally diverse from that of either Buddhism or Christianity, both of which have made use of paintings in order to attract fresh converts or to instruct and edify the faithful.

This theological objection to pictorial art has been operative from an early period in the history of Islam, and has effectively prevented the admittance of painting into any part of the religious life of the Muslim world. In no mosque nor in any other religious building are there to be found either statues or pictures,[1] and orthodox religious sentiment has always been active in the destruction of pictorial representations of human beings wherever such destruction has been possible.

It is proposed now to consider this Muslim attitude of mind in some detail. It has sometimes been stated that the painting of pictures is forbidden in the

[1] That in the great mosque of Cordova there should have been pictures of the staff of Moses, of the seven sleepers of Ephesus, and of the raven of Noah, is a circumstance unique in the religious life of Islam (Makkarī, *Nafḥ aṭ-Ṭīb*, Vol. I, p. 367).

Qur'ān; but there is no specific mention of pictures in the Word of God, and the only verse (Qur. v. 92)—'O believers, wine and games of chance and statues and (divining) arrows are an abomination of Satan's handiwork; then avoid it!'—which theologians of a later generation could quote in support of their condemnation of this art makes it clear that the real object of the prohibition was the avoidance of idolatry. The theological basis of the condemnation of pictorial art must therefore be sought for elsewhere.

A more distinct utterance upon this subject is found in the Traditions of the Prophet, and it is from this theological source that the hostile attitude prevailing throughout the Muhammadan world derives its sanction. In the formation of Muslim dogma the Traditions of the Prophet have not been of less importance than the Qur'ān itself; they are held by Muslim theologians to proceed from divine inspiration, though unlike the Qur'ān, which is the eternal, uncreated Word of God, they are held to be inspired only as to content and meaning, but not in respect of actual verbal expression. Accordingly the Traditions enjoy an authority commensurate with that of the precepts of the Qur'ān itself and are equally binding on the consciences of the faithful. On the subject of painting the Traditions are uncompromising in their condemnation and speak with no uncertain voice, e. g. the Prophet is reported to have said that those who will be most severely punished by God on the Day of Judgement will be the painters.[1] On the Day of Judgement the punishment of hell will be meted out to the painter, and he will be called upon to breathe life into the forms that he has fashioned; but he cannot breathe life into anything.[2] The reason for his damnation is this: in fashioning the form of a being that has life, the painter is usurping the creative function of the Creator and thus is attempting to assimilate himself to God; and the futility of the painter's claim will be brought home to him, when he will be made to recognize the ineffectual character of his creative activity, through his inability to complete the work of creation by breathing into the objects of his art, which look so much like living beings, the breath of life. The blasphemous character of his attempt is further emphasized by the use in this Tradition of the actual words of the Qur'ān (v. 110) in which God describes the miraculous activity of Jesus—'Thou didst fashion of clay as it were the figure of a bird, by My permission, and didst breathe into it, and by My permission it became a bird.' The making of forms by the painter could only be justified if he possessed such miraculous power as was given by God to His divinely inspired Prophet, Jesus, the Word of God.[3]

[1] Bukhārī (ed. Juynboll), Vol. IV, p. 104 (no. 89). [2] Id., p. 106 (no. 97).
[3] I. Goldziher, *Zum islamischen Bilderverbot* (ZDMG, Bd. 74, 1920, p. 288).

The Arabic word for 'painter', which has passed from Arabic into Persian, Turkish, and Urdu in the same sense, is 'muṣawwir', which literally means 'forming, fashioning, giving form', and so can equally apply to the sculptor. The blasphemy in the appellation is the more apparent to the Muslim mind, in that this word is applied to God Himself in the Qur'ān (lix. 24): 'He is God, the Creator, the Maker, the Fashioner' (muṣawwir). Thus the highest term of praise which in the Christian world can be bestowed upon the artist, in calling him a creator, in the Muslim world serves to emphasize the most damning evidence of his guilt.

It is of interest to note what other sinners are condemned in company with the painter. A certain 'Awn b. Abī Juḥayfah relates:

'I saw my father buy a slave who was a cupper (i.e. a phlebotomist), and he ordered his cupping instruments to be brought and broken to pieces. When I asked him the reason for this, he said: "The Prophet forbade men to take the price of blood, or the price of a dog, or the earnings of a maidservant, and he cursed the tattooing woman and the woman who has herself tattooed, and the usurer and the man who lets usury be taken from him, and he cursed the painter." '[1]

The same contemptuous association of the painter with other abominations is expressed in the Traditions:

'The angels will not enter a house in which there is a picture or a dog.'[2] 'Those who will be most severely punished on the Day of Judgement are the murderer of a Prophet, one who has been put to death by a Prophet, one who leads men astray without knowledge, and a maker of images or pictures.' 'A head will thrust itself out of the fire and will ask, Where are those who invented lies against God, or have been the enemies of God, or have made light of God? Then men will ask, Who are these three classes of persons? It will answer, The sorcerer is he who has invented lies against God; the maker of images or pictures is the enemy of God; and he who acts in order to be seen of men, is he that has made light of God.'[3]

There is little doubt that these utterances, placed in the mouth of the Prophet by later writers, give expression to an intolerant attitude towards figured art which Muḥammad himself did not feel. Had he been so severe in his judgement of such objects as his followers in succeeding generations undoubtedly became, it could not possibly have happened that during his last illness his wives, sitting round his bed, should have discussed the pictures they had seen in a church in Abyssinia; two of them, Umm Salmah and Umm Ḥabībah, had been to that country and had been struck with the beauty of its ecclesiastical art. Muḥammad joins in the conversation and explains that it is the custom of the Abyssinians, when a holy man dies, to

[1] Bukhārī (ed. Krehl), Vol. II, p. 43 fin. [2] Id., Vol. II, p. 311 (ad fin.) et saepe.
[3] 'Alī al-Muttaqī, Kanz al-'Ummāl, Vol. II, p. 200.

build a house of prayer over his tomb, and paint such pictures in it; and though he is careful to add (or the traditionist puts the remark into his mouth) that such people are most wicked in the sight of God, still such a conversation is inconceivable by the death-bed of a Muslim saint of a later generation.[1]

Strangest of all, in view of the condemnation of such paintings by succeeding generations of Muslims, is the story that when, after his triumphal entry into Mecca, Muḥammad went inside the Ka'bah, he ordered the pictures in it to be obliterated, but put his hand over a picture of Mary, with Jesus seated on her lap, that was painted on a pillar, and said, 'Rub out all the pictures except these under my hands'. The same narrator adds that it was not until years later, in 683, when the anti-Caliph 'Abd Allāh ibn Zubayr was being besieged in the Holy City by the Umayyad troops, that these pictures perished in the fire which destroyed the Ka'bah.[2]

Further, the Prophet does not appear to have objected to the figures of men or animals on the woven stuffs with which his house in Medina was decorated, so long as they did not distract his attention while engaged in prayer, and so long as they were in their proper place, being either sat upon in cushions or trampled underfoot in carpets. When he found that 'Ā'ishah had hung up a curtain with figures on it at the door of her room, he exclaimed that those who thus imitated the creative activity of God would be most severely punished on the Day of Judgement; but he was quite satisfied when his wife cut up the offending fabric and made cushion covers out of it.[3] The great danger to be avoided was idolatry, any deviation from the absolute loyalty due to the One and Only God. Similarly, the Prophet does not appear to have taken exception to the dolls which 'Ā'ishah, who is said to have become his wife at the tender age of nine,[4] brought into the house; on one occasion he asked her what she was playing with, and she replied, 'The horses (or, the horsemen[5]) of Solomon'.[6] Similar laxity is recorded of the Companions of Muḥammad, for when, after the death of the Prophet, the loot of half the civilized world poured into Medina, they apparently felt no hesitation in retaining in their possession vessels of precious metals, adorned with figures, such as the workmen of Arabia were incapable of fabricating. Even the rigid Caliph 'Umar used a censer, with figures on it, which he had brought from Syria, in order to perfume the mosque at Medina.[7] In the

[1] Ibn Sa'd, *Biographien*, Vol. II, p. 34 (ll. 17–21) (Leiden, 1909).
[2] The authority for this story is Azraqī (*ob.* A.D. 858), who wrote the earliest extant history of Mecca (*Die Chroniken der Stadt Mekka*, Vol. I, pp. 111–12).
[3] Bukhārī, Vol. IV, pp. 76–7 (no. 91). [4] Ibn Sa'd, *Biographien*, Vol. VIII, p. 40 (l. 1.).
[5] The word خيل may have either meaning. [6] Id., Vol. VIII, p. 42 (l. 17).
[7] Ibn Rustah, *Bibl. Geogr. Arab.*, Vol. VII, p. 66 (ll. 15–19).

tendentious Traditions, which generally only refer to such matters in order to draw a moral, the Companions are described as mutually upbraiding one another for keeping such illicit objects in their possession. A certain Miswar ibn Makhramah was paying a visit to Ibn 'Abbās (one of the authorities most frequently cited in support of the authenticity of the Traditions of the Prophet) and was reproached by his host for wearing a robe of silk brocade with figures on it. Miswar made the lame excuse that the Prophet's prohibition was only intended to serve the purpose of keeping pride and vanity in check, vices of which he himself was innocent, and then he retorted on his host by drawing attention to some figures decorating a chafing-dish that he had in his room. Ibn 'Abbās was so taken aback, that the only excuse he could make was to ask: 'Don't you see that I have burnt them in the fire?' The story has an edifying sequel in that Miswar determines to sell his robe, after cutting off the heads of the figures embroidered on it, despite the protests of his friends, who warn him that in such a damaged condition it would fetch less money.[1] Figures were also to be seen in the house of Marwān ibn al-Ḥakam, at one time governor of Medina.[2]

Another tradition describes the horror of Abū Hurayrah on seeing an artist at work, painting pictures in the upper story of a house in Medina; he tells his companion that he had heard the Prophet say: Who is more wicked than a man who sets to work to imitate the creative activity of God? Let them try to create a grain of wheat, or create an ant![3] Another Companion of the Prophet, one of the earliest converts, Sa'd ibn Abī Waqqāṣ, appears to have been untroubled by any such scruples, for when after the capture of Ctesiphon in 637 he held a solemn prayer of thanksgiving in the great palace of the Sasanian kings, it is expressly stated by the historian that he paid no heed to the figures of men and horses on the walls, but left them undisturbed.[4] Indeed, these decorations appear to have survived the iconoclastic zeal of the Muslims for more than two centuries, judging from the description that Buḥturī (*ob.* 897) gives of the pictures in the ruined palace.[5]

Primitive Muslim society, therefore, does not appear to have been so iconoclastic as later generations became, when the condemnation of pictorial and plastic art based on the Traditions ascribed to the Prophet had won general approval in Muslim society. The genesis of these Traditions is obscure, but by the second century of the Muhammadan era compilations of them were being made, and they were certainly by that time beginning

[1] Ibn Ḥanbal, *Musnad*, Vol. I, p. 320 (Cairo, A.H. 1313). [2] Id., Vol. II, p. 232 (l. 5).
[3] Bukhārī, Vol. IV, p. 104 (no. 90). [4] Ṭabarī, Vol. I, p. 2443 (ll. 16–17). [5] See p. 63.

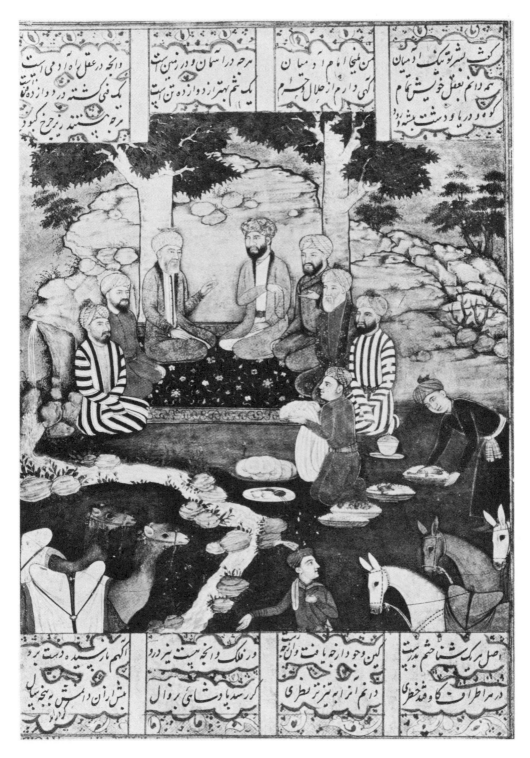

I. A rest by the wayside

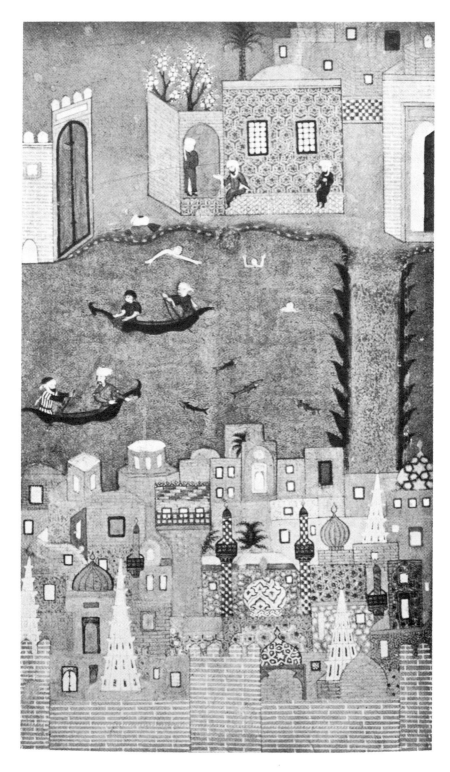

II. The city of Baghdad in flood

to mould orthodox opinion, and in regard to plastic art in particular the laxity of the first generation of the faithful was giving way, except in the atmosphere of a pleasure-loving court, before the severer attitude that had found expression in the Traditions quoted above. It is significant of this hardening of opinion that a governor of Medina in A.D. 783 had the figures of the censer which 'Umar had presented to the mosque of that city erased;[1] he apparently could not tolerate what the most devoted Companion of the Prophet, the revered model for later generations, had regarded with indifference. When in the third century the Traditions took permanent and authoritative form in the great canonical collections connected with the names of Bukhārī, Muslim, and others, no further doubt was possible for the faithful as to the illegality of painting and sculpture, and the same condemnation was embodied in the accepted text-books of Muslim law and was thus enforced by the highest legal opinion. A great legist of the thirteenth century, Nawawī, summed up the accepted doctrine of his own time in the following passage, and it may be taken as representing the orthodox view of succeeding generations also:

'The learned authorities of our school[2] and others hold that the painting of a picture of any living thing is strictly forbidden and is one of the great sins, because it is threatened with the above grievous punishment as mentioned in the Traditions, whether it is intended for common domestic use or not. So the making of it is forbidden under every circumstance, because it implies a likeness to the creative activity of God, whether it is on a robe, or a carpet or a coin, gold, silver or copper, or a vessel or on a wall, &c. On the other hand, the painting of a tree or of camel saddles and other things that have no life is not forbidden. Such is the decision as to the actual making of a picture. Similarly, it is forbidden to make use of any object on which a living thing is pictured, whether it be hung on a wall or worn as a dress or a turban or is on any other object of common domestic use. But if it is on a carpet trampled underfoot, or on a pillow or cushion, or any similar object for common domestic use, then it is not forbidden. Whether such an object will prevent the angels of God from entering the house in which it is found is quite another matter. In all this there is no difference between what casts a shadow and what does not cast a shadow. This is the decision of our school on the question, and the majority of the Companions of the Prophet and their immediate followers and the learned of succeeding generations accepted it; it is also the view of Thawrī, Mālik, Abū Ḥanīfah, &c. Some later authorities make the prohibition refer only to objects that cast a shadow, and see no harm in objects that have no shadow. But this view is quite wrong, for the curtain to which the Prophet objected was certainly condemned, as everybody admits, yet the picture on it cast no shadow; and the other Traditions make no difference between one picture and another. Az-Zuhrī holds that the prohibition refers to pictures in general, and similarly to the use of them and to entrance into a house in which they are found, whether it is a case of a design on

[1] Ibn Rustah, *loc. cit.* [2] i.e. the Shāfi'ī school.

a dress or any other design, whether the picture hangs on a wall or is on a robe or a carpet, whether in common domestic use or not, as is the clear meaning of the Traditions.'[1]

The historian is therefore faced with the problem of attempting to determine whence this fanatical attitude towards plastic and pictorial art derived its origin. Some have looked for it in a reaction against the naturalism and verisimilitude of Hellenic art, which had been manifesting itself in the Nearer East for some time before the rise of Islam. A more plausible solution[2] seeks in the influence of the Jewish converts to Islam the explanation of this violent antipathy towards pictorial representations of the forms of living beings. The city of Medina contained a large Jewish population at the time of the Hijrah of the Prophet, and a number of Jews were among his early converts. The influence of the Jewish converts on the development of thought and ritual in the early generations of Islam has recently been made the subject of more than one profound study.[3] Professor Mittwoch[4] has suggested that the obscure origins of the *Ṣalāt*, the liturgy of Muslim public worship, with its ordered arrangement of prayer, responses, and ritual movements, can be traced to the synagogue. In regard to Jewish influence upon many of the *Ḥadīth*, the Traditions of the Prophet, there can be no doubt whatsoever. A large number of these Traditions reproduce almost verbally the precepts enunciated in the Talmud,[5] and it seems more than probable that the Jewish converts to Islam carried over into their new faith the hostility to plastic and pictorial art which had been impressed upon them from childhood. The Jewish origin of the unkindly judgement of the painter seems distinctly to be indicated by his being associated with the pig and the Christian bell (or clapper, which the oriental Christians used for the purpose of calling the faithful to prayer) in several of the Traditions.

The hatred of idolatry, common to Islam and Judaism, caused a statue or a picture to be regarded with suspicion, through apprehension of the possible influence it might exercise on the faithful by leading them astray into the heresy most abhorred by Muslim theologians, *shirk*, or the giving a partner to God. Legend declared that a disciple of Idrīs (whom the commentators generally identified with Enoch) unwittingly introduced idolatry into the

[1] Yaḥyā b. Sharaf al-Nawawī, *Al Minhāj fī sharḥ Muslim b. al-Ḥajjāj* (Bulāq, 1304–6), Vol. VIII, p. 398.

[2] H. Lammens, *L'attitude de l'Islam primitif en face des arts figurés*, pp. 274–9; A. J. Wensinck, *The Second Commandment* (Mededeelingen der Koninklijke Akademie van Wetenschappen, Afd. Letterkunde, Deel 59, Serie A, no. 6, Amsterdam, 1925).

[3] See especially Professor A. Guillaume, *The Influence of Judaism on Islam* (The Legacy of Israel, pp. 129 sqq., Oxford, 1927).

[4] *Zur Entstehungsgeschichte des islamischen Gebets und Kultus* (Berlin, 1913).

[5] A. Guillaume, *op. cit.*, pp. 153 sqq.; A. J. Wensinck, *op. cit.*, p. 162.

world by making copies of the portrait of his dead teacher, in order to perpetuate his memory; some of these survived the Flood and became objects of idolatrous worship.[1]

Having once been promulgated, this theological prohibition found a ready acceptance in minds obsessed by the superstition common in the East, that an image is not something apart from the person represented, but is a kind of *double*, injury to which will imply corresponding suffering to the living person. This fear of thus placing themselves in the power of malevolent enemies made such people refuse to have their portrait taken—or in more modern times, to be photographed—because such a process was regarded as the taking away of a part of their own person.[2]

Another question in regard to the condemnation of the painter demands consideration here. It has frequently been asserted, in explanation of the abundance of the contribution made by the Persians to the history of painting, that the Shiahs, because they did not accept the Traditions set forth above by Sunni theologians, were unhampered by any such ecclesiastical condemnation, and could therefore practise the art of painting undeterred by the fear of hell. Thus, one of the ablest living authorities on Muslim art writes in reference to the Traditions quoted above:[3]

'Damit wäre nun freilich in unzweideutiger Weise der Entwicklung in der Richtung des Figürlichen ein Riegel vorgeschoben, wenn nicht von einem grossen Teil der Mohammedaner die orthodoxe Tradition (Sunna) abgelehnt und dem Koran andere Überlieferungen zur Seite gestellt würden. Zu den Anhängern dieses sogenannten schiitischen Bekenntnisses gehören vor allem die Perser.'[4]

A typical example[5] of this widespread misconception is found in the following extract from the *Bulletin of the Metropolitan Museum of Art*, New York (ix, p. 159), in which the writer, speaking of representations of animate art in Muhammadan painting, says:

'Such an art became possible only with the rise to power of the Shiites, the more liberal of the two great sects into which Moslemism was divided, and the downfall of the opposing and orthodox Sunnites. The latter sect had long ruled the Nearer East

[1] O. von Schlechta-Wssehrd, *Bericht über die in Konstantinopel erschienenen orientalischen Werke* (Kaiserliche Akademie der Wissenschaften. Phil.-historische Classe. Sitzungsberichte, Vol. XVII, p. 173, Wien, 1855).

[2] A. J. Wensinck, *op. cit.*, pp. 4–5. [3] Cf. above, pp. 5–6.

[4] Ernst Kühnel, *Miniaturmalerei im islamischen Orient*, p. 1 (Berlin, 1922). See also Georg Lehnert, *Illustrierte Geschichte des Kunstgewerbes*, ii, pp. 629–30 (Berlin, 1907–9); H. R. D'Allemagne, *Du Khorassan au pays des Backhtiaris* (Vol. II, p. 164, Paris, 1911) (La religion des Persans et des Mongols, qui sont des dissidents, permettait la représentation de la figure humaine, et leurs artistes en ont usé en toute liberté).

[5] Cf. also G. Griffin Lewis, *The Mystery of the Oriental Rug*, p. 20 (Philadelphia, 1914).

through the Fatimid Sultans in Egypt and the glittering Caliphs of the Abbasid line at Baghdad: but when these two great dynasties entered on their period of final decay about the end of the twelfth century, and the rise of new and less orthodox monarchies became inevitable, the artists and artisans of those regions began to disregard the ancient prohibitions, and to make their first essays in the pictorial art which they were later to bring to such perfection.'

A rectification of all the errors in this passage would require a separate treatise, but as emanating from the treasure-house into which have passed some of the finest examples of Persian painting that have survived to the present day, it is noteworthy as embodying the common error of the freedom of the Shiahs from the ordinary Muhammadan dislike of figured art.

The fact is that the Shiah theologians condemned the representation of living objects just as severely as ever their Sunni co-religionists did. The Shiahs possess collections of the Traditions of the Prophet of their own, and in these the art of the painter is unhesitatingly and uncompromisingly condemned. They warn him, as in the Sunni traditions quoted above, of the manner in which he will be convicted of the enormity of his offence by being bidden on the Day of Judgement to breathe life into the objects of his creation: 'but he will not be able to breathe life into them.' [1]

One of the most eminent of Shiah legists, al-Ḥillī, who died about 1275 and was the author of a standard work on Shiah law, included pictures among the articles which could not be bought or sold, because the making of them was an act intrinsically unlawful.[2]

Those modern writers who have ignored this stern judgement of the Shiah theologians upon the painter have also failed to notice that a Shiah government was not necessarily more favourable to the growth of a school of painting than was a Sunni one. The Umayyad prince who had his bath-house in Quṣayr 'Amra painted for his delight, and the Abbasid Caliph who had the walls of his palace in Sāmarrā similarly adorned,[3] were both Sunnis. The Saljuqs of Asia Minor and the Ortuqids and Zangids of Mesopotamia and Northern Syria, who were all Sunnis, showed their disregard for the theological prohibition by stamping on their coins heads which they borrowed from antique and Byzantine coins, or astrological emblems, such as centaurs, and beasts. The Timurid princes who did so much for the encouragement of Muhammadan art, under whose patronage Bihzād created the finest school of painting that Persia has ever known, were all Sunnis, as were also the Mughal emperors in India and the Ottoman Sultans in Turkey. That the

[1] Muḥammad Ḥasan an-Najafī, *Jawāhir al-Kalām* (Teheran, A.H. 1272), Vol. II, p. 8.
[2] Ja'far b. Sa'īd al-Ḥillī, *Sharā'i' al-Islām*, p. 151 *fin.* (Calcutta, 1839). [3] Sce pp. 29 31.

Fatimids in Egypt (969–1171) encouraged painters, as well as other artists, is no more due to the Shiah doctrines they promulgated than is the Abbasid or Timurid patronage of art the result of their Sunni form of belief. There have been several Shiah kingdoms that have been in no way distinguished for encouragement of the arts; for no particular school of painting is connected with the ascendancy of the Buwayhids, who during the second half of the tenth century kept the Abbasid Caliphs in subjection and divided Persia and 'Irāq between them, nor of the less powerful Shiah dynasties that had risen to power in Northern Persia before them; least of all the Zaydī Imāms of the Yaman, whose dynasty has had a longer life than that of any other in the history of Islam.

The common misconception in this matter is no doubt largely due to the fact that modern Persia is known to be a Shiah kingdom, but it is forgotten that Shiism did not become the state religion of Persia until 1502, with the establishment of the Safavid dynasty; moreover, only a few of the Safavid Shahs appear to have been distinguished as patrons of art, and the decline of Persian painting set in when Shāh 'Abbās (1587–1629) withdrew his patronage from the court painters. What painting was left in Persia by the eighteenth century was as actively practised under the Sunni rule of Nādir Shāh (1736–1747) and the rest of the Afshārids up to the end of that century, as had been the case under their Shiah predecessors.

The explanation of these facts is that the condemnation of the painting of living figures was a theological opinion common to the whole Muslim world, and the practical acceptance of it largely depended on the influence of the theologians upon the habits and tastes of society at any one particular time. Stern and uncompromising as this opinion generally showed itself to be, even it could on occasion relax some of its severity. It was probably respectful remembrance of 'Ā'ishah, as one of the Mothers of the Faithful and therefore a model to her sex, that caused even the theologians to allow little girls to keep their dolls, though it was one of the miscellaneous duties of the Muḥtasib[1] to add to his weightier obligations the task of seeing that the dolls of little girls were of such form and design as suitably to serve the purpose of encouraging the maternal instinct, but not of such a verisimilitude as to serve as temptations to idolatry.

Another concession was made to popular usage by the theologians in

[1] He was a kind of police officer and censor of morals, whose function it was to deal summarily with cases of crime for which the ordinary processes of the law-courts might prove too dilatory (e.g. he had to see that the city walls were kept in proper repair, to prevent encroachment on the public highway by traders who thrust their shops out into the street, to arrange suitable marriages for widows, &c.).

respect of the shadow plays which have for several centuries been connected in Turkey with the name of Karagös, and are popular in Egypt and Tunisia also. The puppets of this shadow play are quite frankly imitations of human figures, made of strips of camel skin scraped so thin as to be transparent, and variously coloured. The theologians gravely discussed the legitimacy of such puppets, and came to the conclusion that since a hole had to be made in each figure in order that it might be suspended from a string, and since the hole went right through it in a manner that would have been quite impossible in the case of a living human being, there was therefore clearly no irreverent or presumptuous attempt made here to rival the creative activity of God.[1] Some theologians, such as Ibn al-ʿArabī, the great Spanish thinker of the thirteenth century, even succeeded in finding material for edification in these shadow plays (which have commonly attracted the attention of occidental observers on account of their obscenity[2]) in the fact that the puppets being seen through the screen only in their shadowy semblance and not in their actual form might serve to turn the mind of the spectator to the contemplation of the divine reality that lies behind the shadowy, unreal appearances of this mundane existence, and that he might at the same time come to realize that God directs the affairs of men, just as the showman regulates all the movements of his puppets.[3]

A contemporary mystic, Ibn al-Fāriḍ, draws a similar lesson from the puppet-show, and compares the soul of man to the showman who throws his puppets—the phenomena of sensation—on to the screen, which typifies the body; when the screen is removed, he alone is seen to be the real actor; so the soul realizes that it is one with God.

> Regard now what is this that lingers not
> Before thine eye and in a moment fades.
> All thou beholdest is the act of one
> In solitude, but closely veiled is he.
> Let him but lift the screen, no doubt remains:
> The forms are vanished, he alone is all:
> And thou, illumined, knowest that by his light
> Thou find'st his actions in the senses' night.[4]

As illustrating the same spirit of interpretation, there is a story told of Saladin having rebuked his famous minister, al-Qāḍī al-Fāḍil, who had got up to leave the room when a showman was sent for to amuse the Sultan with

[1] H. Ritter, *Karagös, Türkische Schattenspiele*, p. 6 (Hannover, 1924).
[2] M. d'Ohsson, *Tableau général de l'empire othoman*, Vol. IV, p. 440 (Paris, 1791).
[3] G. Jacob, *Geschichte des Schattenspiels*, p. 49 (Hannover, 1925).
[4] R. A. Nicholson, *Studies in Islamic Mysticism*, pp. 191, 260 (Cambridge, 1921).

his puppets. After Saladin had made the scrupulous theologian stay to the end of the performance, he asked him what he thought of it; al-Qāḍī al-Fāḍil answered, 'What I have seen carries with it a weighty lesson; I have seen kingdoms come and go, and when the curtain was rolled up, lo! the mover of all was only One'.[1]

The shadow play has succeeded in retaining its popularity in a still more remarkable manner in another part of the Muhammadan world, namely Java; in this case it is national sentiment that has kept alive this remarkable survival from the heathen period of Javanese civilization, for the *wayang* (as the shadow play is here styled) has never been islamized, and still continues to put before admiring audiences the adventures of the heroes of the *Mahābhārata*. The explanation of this remarkable phenomenon is to be found in the gradual character of the conversion of the Javanese to Islam, for the new faith was not violently forced upon them, and their adoption of it was not (as happened in so many other parts of the world) accompanied by a violent breach with their ancient civilization. So the shadow play in Java continues to be cultivated as a part of the national life, and orthodox opinion appears to require no apology for it.[2]

But these exceptions are trivial in comparison with the prevailing hostile opinion which has succeeded in keeping out pictures entirely from the public religious life of Islam and from the greater part of Muslim society; and in view of the distinct prohibition of pictures by the accepted exponents of the faith of Islam, many writers have expressed surprise at finding any pictures at all in Muhammadan countries, or have considered the phenomenon to call for some extraordinary explanation. Such surprise is somewhat naïve on the part of European authors, as though they expected the daily practice of the members of a religious community other than their own to invariably conform to the prescriptions of the authoritative exponents of their creed. Such divergency between creed and practice has been common enough in Christian countries, and it would be strange indeed if Islam, which possesses no priesthood or any organization for enforcing uniformity in belief,[3] should have succeeded where Christianity, with its powerful hierarchy and its more efficient systematization of the religious life, has so often failed.

[1] G. Jacob, *op. cit.*, p. 53.

[2] N. J. Krom, *L'art javanais dans les Musées de Hollande et de Java* (*Ars Asiatica*, VIII), pp. 22–3 (Bruxelles, 1926).

[3] Though the persecution of heretics and the establishment of such an inquisition as that which supported Muʻtazilah teachings in the reigns of Ma'mūn (813–833) and the two Caliphs who succeeded him, and that which suppressed Manichaeism about the same period, have from time to time had the support of the state, the very absence of a hierarchy in Islam has made such efforts sporadic only, and it has never possessed a body with such a continuous life as that of the Inquisition.

The ecclesiastical annals of Christendom present such conspicuous examples of the disregard of the Christian virtues in the exalted persons of Pope John XII and Pope Alexander VI. When Pope John XXIII was arraigned by the Council of Constance, 'the most scandalous charges were suppressed; the vicar of Christ was only accused of piracy, murder, rape, sodomy, and incest'.[1] Neither Louis XIV of France, nor Charles II of England, nor Philip II of Spain can be considered patterns of Christian chastity, but they were scrupulous in the observance of their religious duties, and their orthodoxy was unimpugned.

Similarly in the Muslim world, there have been plenty of kings and nobles who, in spite of their general fidelity to the dogmas of their faith, have unhesitatingly disregarded the protests of their theologians whenever inclination pointed the way. The drinking of wine was even more distinctly prohibited in the Qur'ān[2] than the painting of pictures, and was enforced by the authority of the Traditions of the Prophet, but the Muslim monarchs who have abstained from wine have attracted attention rather by their singularity, and throughout the whole of Muhammadan history and literature the drinking of wine has been a common practice and a subject of laudation, at least by the poets. Even such a staunch upholder of the faith as Hārūn ar-Rashīd (786–809) drank habitually, though for decorum's sake he indulged in this vice in private or in the company of only a few chosen friends. Music was as sternly condemned by the theologians, but Arabic literature is full of stories of musicians and singers, and of the liberal patronage which was bestowed upon them by Muslim princes. In many other respects the practice of royal persons was in contradiction to the precepts set forth in the Traditions. In almost every Muhammadan country Sultans have sought to leave to posterity some memorial of themselves by the erection of a stately tomb; yet this practice is condemned along with painting in one and the same prohibition in a Tradition traced up to the son-in-law of the Prophet, as follows: ' 'Alī said, Shall I not give you the orders which the Prophet gave me, namely, to destroy all pictures and images, and not to leave a single lofty tomb without lowering it within a span from the ground?'[3] Similarly, the Traditions condemn the prevailing practice of making eunuchs, and exclude any one guilty of this practice from the community of the faithful, thus: 'Muhammad said, He is not of my people who makes another a eunuch or becomes one himself.'[4] The very existence of a Muhammadan court in most periods of the history of Islam is unthinkable without the

[1] Gibbon, *Holy Roman Empire*, chap. lxx (ed. Bury, 1914, Vol. VII, p. 300). [2] ii. 216; v. 92.
[3] *Mishkāt al-Maṣābīḥ*, p. 140 (ll. 8–9) (Bombay, A.H. 1295). [4] Id., p. 61 (l. 3 a. f.).

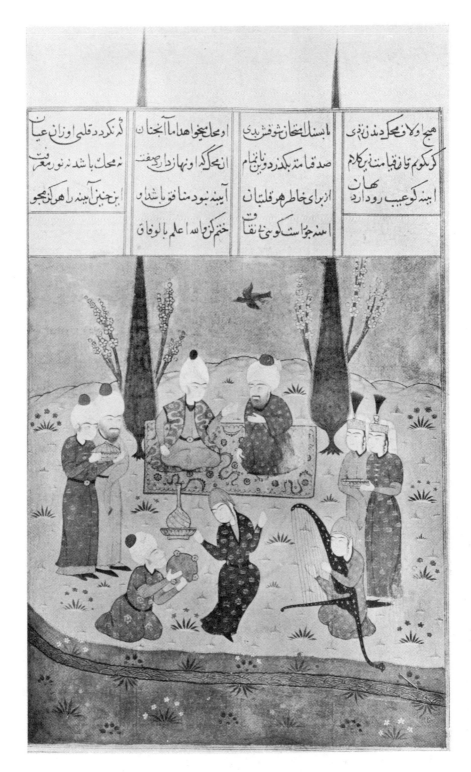

III. A festive party

IV. A religious teacher discoursing with his friends

eunuch, and among this class have been found statesmen and generals and benefactors of learned men and founders of pious endowments, together with at least one reigning monarch, Āghā Muḥammad Khān of Persia (1779–1797).

An interesting parallel could be instituted between Christendom and the Islamic world in respect of the failure of both of them to break free from the past and establish a culture that should have been wholly penetrated with the spirit of their particular religion; for just as the culture of the Christian world was mainly derived from the heathen literature of pre-Christian Greece and Rome, so in the Muhammadan world it was the heathen pre-Islamic poetry that was held up to admiration as being the supreme expression of literary excellence, and has consequently been continuously studied by the learned throughout the thirteen centuries of the Muhammadan era, though in sentiments and ideals it is the very antithesis of the teaching of the founder of Islam. The young Muslim student is set to read the great pre-Islamic poems full of the spirit of self-glorification, of licence in love and wine, and other forms of self-indulgence condemned by the theological literature that he has to study at the same time.[1] For this and for other reasons there has been continuously from the outset of the Muslim era an internal conflict between the Islamic ideals of asceticism, humility, self-depreciation, and piety, on the one hand, and those of pride, lust, and the joy of life, on the other—each set forth in a literature simultaneously held up to admiration. The 'ulamā—the learned—the guardians and exponents of the dogmatic teaching of Islam and of the rules of the devout life, the only equivalent of a priesthood that Islam has ever had, have been largely themselves to blame for the results of their encouragement of the study of a literature so alien in spirit to the ideals of their own faith.

Added to this has been the common self-assertiveness of the possessor of power and wealth, who rides rough-shod over the dogmatist and the moralist. The theologians have no more succeeded in imposing their point of view upon the men of the world in Islam than in Christendom, and Muhammadan history is full of examples of the authority of the learned being flouted by the rulers of the state. Two examples may be given in illustration: Qirwash ibn al-Muqallad, belonging to the 'Uqaylids, one of the oldest tribes of Arabia, who was Prince of Mosul from 1000 to 1050, being reproached for having taken to wife two sisters at the same time—a practice expressly forbidden by the Qur'ān (chap. iv, v. 21)—made the following reply: 'Tell me what thing we ever did that was permitted by law?' He added, 'I have nothing on my

[1] Goldziher, *Muhammedanische Studien*, Vol. I, pp. 9–39.

conscience except the death of five or six inhabitants of the desert whom I slew; as for the townsfolk, God takes no account of them'[1]—another flagrant disregard of clear Qur'ānic teaching (chap. iv, vv. 94-5).

The other example is taken from the history of one of the most energetic of the Sultans of the Khaljī dynasty in Dihlī, 'Alā ad-Dīn (1295-1315), who was notorious for his disregard of the injunctions of the Sacred Law of Islam, for, having made up his mind that the Sharī'ah had no concern with practical administration or policy, he was not in the habit of consulting the 'ulamā. But he once told one of the Qāḍīs of Dihlī, Qāḍī Mughīth ad-Dīn, that he had some questions to put to him. The unfortunate Qāḍī replied: 'My appointed time has come, since Your Majesty wishes to consult me on matters of religion; if I speak the truth, you will be angry with me and put me to death.' The Sultan reassured him and replied that all he wanted of him was true and correct answers to his questions. But as the conversation went on, the Qāḍī became more and more alarmed, and when the Sultan inquired what rights he and his children had upon the public treasury, the Qāḍī exclaimed: 'The hour of my death is at hand,' and when the Sultan asked him what he meant, said: 'If I answer your question in accordance with the truth, you will be angry and will put me to death, and if I give you an untrue answer, I shall hereafter go down into hell.' The Sultan tried to encourage him, saying, 'Tell me what is the ordinance of the Sacred Law, and I will not kill you'. But when the theologian would not budge an inch from his uncompromising attitude and denounced the illegality of every administrative measure in regard to which the Sultan consulted him, the monarch lost patience and exclaimed: 'Do you mean to declare that the whole of this is contrary to the Law and finds no place in the Traditions of the Prophet or the expositions of the 'ulamā?' The Qāḍī then rose and going to the end of the room placed his forehead on the ground, and cried out in a loud voice: 'O king, whether you send me, poor wretch, to prison or whether you order me to be cut in two, all this is unlawful and finds no place in the Traditions of the Prophet or in the expositions of the learned.' The Sultan restrained his anger at this outburst and went away into his palace, while the unfortunate Qāḍī made his way home, bade farewell to his family, and performed his ablutions in preparation for death; but the next day the Sultan was generous enough to give him credit for his courage and bestowed upon him a liberal reward, saying: 'Though I am not a man of learning or erudition, still I am a Muslim by birth and come of Muslim stock. To prevent rebellion, in which thousands might perish, I issue such orders for each

[1] Ibn Khallikān, *Biographical Dictionary*, trans. De Slane, Vol. III, p. 421.

occasion that arises as are for the good of the state and for the good of the
people. If men are troublesome and remiss and disobey my orders, I set
matters right and make it clear to them that they must obey. I know not
whether this is in accordance with the Sacred Law or not, but whatever I
consider to be for the good of the state or to be suitable for the occasion, I
give orders accordingly.'[1]

If, therefore, the prince, confident in the security of his position and power,
cared to show his contempt for the prohibitions of religion, he might make
light of the frowns of the theologians and even of the displeasure of the
general mass of his subjects; but, with few exceptions, such disregard of the
Sacred Law found expression rather in the interior of the palace than under
the public eye, and the instances given below of kings and nobles having
cultivated a taste for the plastic and pictorial arts have reference to their
private rather than to their public life. The Muslim state being founded on
a religious basis and held together largely through the acceptance of a
common faith, the feeling of Muslim loyalty tended to link together obedience
to God and obedience to the sovereign, and legal theory at least released
the subject from his oath of fealty to a ruler who had apostatized or proved
faithless to religion. The Muslim monarch, therefore, generally kept his
indulgence in forbidden tastes concealed from all except his intimates.

In the Umayyad period, if the historians may be believed, the majority
of the Caliphs and the members of their court were notorious for their
neglect of the prohibitions of religion, and the frescoes of Quṣayr 'Amra
may be taken as typical of the lengths to which they would go in their
encouragement of pictorial art. From what we know of the Umayyad
Caliph Yazīd (680–683), it is not surprising to find in the palace of the man
whom he appointed viceroy of Kūfah, 'Ubayd Allāh ibn Ziyād, figures of
fierce lions, barking dogs, and butting rams—to the great scandal of the faith-
ful.[2] Whether these objects were plastic or pictorial is not clear, but such
representations were probably more common than the paucity of record of
them would at first suggest. There was so much in the social life of the
Umayyad period which was contrary to the ideals and clear precepts of
Islam, that little hesitation would be likely to be felt in contravening also its
laws regarding art. Even during the pilgrimage to the Holy House in Mecca,
the Umayyad poet, 'Umar ibn Abī Rabī'ah (ob. 719), could find in the tent
of a princess of the royal house a curtain of red brocade, embroidered with
figures of gold.[3] Whether these figures were of men or of animals, the poet

[1] Ẓiyā ad-Dīn Baranī, Ta'rīkh-i-Fīrūz Shāhī, pp. 289–96 (Calcutta, 1860–2).
[2] Yāqūt, Mu'jam al-buldān, Vol. I, pp. 792–3. [3] Jāḥiẓ, Kitāb al-maḥāsin, Vol. I, p. 342 (l. 15).

does not say; but in either case such a piece of decoration was a profanity in so holy a place.

But even in the Abbasid period, when most of the Caliphs deliberately fostered a reputation for piety, there is evidence enough that the prohibition of figures was disregarded, at least by the great. Manṣūr (754–775), the founder of Baghdad, set up on the top of a dome in his palace the figure of a knight on horseback; it appears to have served as a kind of weather-vane, though popular superstition declared that it pointed its lance in the direction from which a rebel army might be expected to come; it was destroyed in a great storm in the year A.D. 941.[1] The Caliph Amīn (809–813) had great boats made in the shape of various animals, such as a lion, an eagle, and a dolphin, for his pleasure parties on the Tigris.[2] But, as explained above, the Abbasid Caliphs as a rule appear to have been careful to avoid shocking the feelings of the orthodox inhabitants of their capital in such a flagrant manner, though they probably frequently employed figures for the internal decoration of their palaces, as is revealed by the frescoes at Sāmarrā,[3] and at a later date the Caliph Muqtadir (908–932) had a tree made of gold and silver in the middle of a large tank in his palace in Baghdad; the tree had eighteen branches, studded with precious stones to represent fruits, and on each branch were gold and silver birds, that twittered when moved by the wind. At opposite ends of the tank stood fifteen horsemen, armed with swords and lances, and clad in costly silks; these also were movable and looked as though they were going to charge into one another.[4]

References to pictures of any kind in this early period are so rare that the following description of the figured decoration of a tent is of special interest. It occurs in a panegyric which the famous poet, Mutanabbī, wrote in 947 to celebrate the victorious return of his patron, the Hamdānid prince of Aleppo, Sayf ad-Dawlah, to Antioch, after a successful raid into Byzantine territory, during which he had captured the fortress of Barzuyah, which had hitherto been regarded as impregnable. By a wild flight of imagination the Byzantine Emperor was represented as standing, a prisoner, before Sayf ad-Dawlah, together with other conquered chieftains. This scene was probably the central point of interest, while the purely decorative panels were filled with garden scenes and conflicts of animals, e.g. lions breaking the necks of deer, an early *motif* in the art of Western Asia, which occurs in later centuries on the margins of hundreds of Persian MSS. The description of the internal

[1] Qazwīnī, *Kosmographie*, ed. Wüstenfeld, Vol. II, pp. 209–10 (Göttingen, 1848).
[2] Ibn Manẓūr al-Miṣrī, *Akhbār Abī Nuwās*, Vol. I, pp. 117–18 (Cairo, 1923).
[3] See p. 31. [4] Qazwīnī, *op. cit.*, pp. 210–11.

decoration of the tent, erected for the reception of the victorious prince, is as follows:

> Here are gardens that no rains have vext,
> And great tree branches where no doves have sung;
> A string of pearls that none with thread have pierced
> Runs round the border of the double ply;
> The forest beasts you here together find;
> Though foe fights foe, they yet in peace do dwell;
> Whene'er the tent-side billows with the wind,
> The horses ramp and lions outwit their prey.
> Here the crowned Roman crushed, dejected, stands
> Before his haughty, turbaned conqueror,
> Whose carpet lips of humbled monarchs kiss
> But dare not touch his fingers or his sleeve.
> His branding heals the fever of their pride,
> Between their ears each chieftain bears his mark.
> In awe they hold their pommels 'neath their arms;
> *His* purpose wins its way, though still unsheathed.[1]

From this description it is not clear whether the picture was painted on the canvas of the tent, or whether it had been woven into a curtain or worked in some form of embroidery. Whether such elaborate pictorial decoration was typical of tents intended for occasions of state, it is not now possible to say, but enormous sums of money were undoubtedly at times expended on their construction and figures were certainly sometimes employed in the decoration of them; such a sumptuous work of art was the tent made for Yāzūrī, the minister of the Fatimid Caliph Mustanṣir (1035–1094); it took one hundred and fifty workmen nine years to make it, and it cost Yāzūrī 30,000 pieces of gold; all the various animals of the world were included in the scheme of decoration, together with a number of other designs.[2]

It is in connexion with this art-loving Wazīr, who held office from 1050 to 1058, that the well-known story is told of the contest between the two rival painters. Attention was first drawn to this isolated incident in the annals of Muslim painting by H. Lavoix in 1875,[3] but as he somewhat embellished the simple narrative of Maqrīzī, and as many others who have derived their information from him have added variants of their own, it may be of interest to the student to have a literal translation of the original passage. After describing a cleverly executed painting of a rainbow, which

[1] Mutanabbī, ed. Dieterici, p. 379.
[2] Maqrīzī, *Khiṭaṭ*, Vol. I, p. 419 (l. 13).
[3] H. Lavoix, *Les arts musulmans* (*Gazette des Beaux-Arts*, 2ᵉ période, t. XII (1875), pp. 212–13).

excited the admiration of other painters, who tried in vain to imitate it, the author goes on to say:

'And this case is similar to that of al-Qaṣīr and Ibn 'Azīz in the time of Yāzūrī, the chief minister of Ḥasan b. 'Alī b. 'Abd ar-Raḥmān (i.e. the Caliph Mustanṣir), for he often used to incite them and stir up one against the other, since he was especially fond of an illustrated book or anything like a picture or gilding. Thus he invited Ibn 'Azīz from 'Irāq and excited his evil passions, for (the wazīr) had sent for him to contend with al-Qaṣīr, because al-Qaṣīr demanded extravagant wages and had an exaggerated opinion of his own work—and it really merited so high an estimate, for in painting he was as great as Ibn Muqlah was as a calligraphist, while Ibn 'Azīz was like al-Bawwāb. I have already given a detailed account of the matter in the book I have written on this subject—namely, the classes of painters, with the title "The light of the lamp and the amuser of company in respect of the annals of artists". Now Yāzūrī had introduced al-Qaṣīr and Ibn 'Azīz into his assembly. Then Ibn 'Azīz said, "I will paint a figure in such a way that when the spectator sees it, he will think that it is coming out of the wall." Whereupon al-Qaṣīr said, "But I will paint it in such a way that when the spectator looks at it, he will think that it is going into the wall." Then (every one present) cried out: "This is more amazing (than the proposal of Ibn 'Azīz)." Then Yāzūrī bade them make what they had promised to do: so they each designed a picture of a dancing-girl, in niches also painted, opposite one another—the one looking as though she were going into the wall, and the other as though she were coming out. Al-Qaṣīr painted a dancing-girl in a white dress in a niche coloured black, as though she were going into the painted niche, and Ibn 'Azīz painted a dancing-girl in a red dress in a niche that was coloured yellow, as though she were coming out of the niche. And Yāzūrī expressed his approval of this and bestowed robes of honour on both of them and gave them much gold.'[1]

Had Maqrīzī's history of painters survived, we should know more of the art treasures accumulated by the Fatimids of Egypt. As it is, we owe such knowledge as we do possess to the special interest which this indefatigable historian took in such matters; he exhibits an assiduous eagerness in the collection of all possible kinds of information connected with the culture of his native land, and gives long lists of the precious objects found in the palace of Mustanṣir; among them was a peacock of gold studded with precious gems, with eyes of rubies and a tail made of enamel in imitation of the varied colour of the living bird—a huge cock, also of gold, covered with jewels, and a number of other animals. Of these costly treasures of the Fatimid court,[2] nothing remains except a few crystal vessels. At the site of their earlier capital, Mahdiyyah, before they added Egypt to the Fatimid dominions, there has recently been found a marble bas-relief, representing a prince, with a cup in his hand, listening to a girl playing a flute.[3]

[1] Maqrīzī, *Khiṭaṭ*, Vol. II, p. 318. [2] Maqrīzī, id., Vol. I, p. 416 (ll. 6–7).
[3] This is now in the Bardo Museum: see Georges Marçais, *Manuel d'art musulman. L'Architecture*, Vol. I, pp. 176–7 (Paris, 1926).

In Spain also the precepts of the theologians were often as frankly dis-
regarded, and after the examples given above, it is unnecessary to suggest, as
Ibn Khaldūn does,[1] that the love of pictorial art among the Muhammadans
of Spain in the fourteenth century was to be explained by the fact of their
subjection to Christian rule, seeing that their ancestors, when themselves
paramount in that country, had cultivated exactly similar tastes. The twelve
marble lions in the courtyard of the palace of Alhambra remain to show
what degree of attainment sculpture could reach under Muhammadan
patronage; but there must have been many other examples that have dis-
appeared, such as the fountain with human figures carved upon it, said to
have been brought from Constantinople, which ʿAbd ar-Raḥman III set
up in his palace at Madīnat az-Zahrā; to this he added twelve figures of gold
inlaid with pearls, which he had had made in Cordova—a lion with a gazelle
beside it, a crocodile, a serpent, an eagle, an elephant, a dove, a falcon, a
peacock, a hen, a cock, a hawk, and a vulture; they were so placed that the
water came out of their mouths.[2]

Some examples of the pictorial decoration of the palaces of the Muham-
madan kings of Spain have survived in the Alhambra. Though the well-
known pictures painted on leather in the Hall of Justice are now recognized
to be the work of Italian artists of the fourteenth or fifteenth century, the
frescoes discovered in 1908 in the Torre de las Damas[3] were undoubtedly
painted by Muhammadan artists, and several characteristic features suggest
that these came from the East. Many other paintings have perished, like
those with which the luckless ʿAbbādid king of Seville, Muʿtamid, adorned
his palace.[4]

Some of the ivory caskets carved with hunting scenes and figures of
musicians, from the palaces of the Muslim kings of Spain, also survive, as
examples of their use of animal forms for decorative purposes. All kinds
of mechanical devices, such as water-clocks, musical instruments, &c., were
also manufactured in the shape of human figures or had little human figures
attached to them—some of them being made for scientific purposes and others
intended merely as toys.[5] Sweetmeats were also fashioned in the shape of
human beings and animals, and were distributed during the public feasts
given on festival occasions by the Fatimid Caliphs of Egypt,[6] but out of
respect for the exponents of the Sacred Law such objects were not placed

[1] *Muqaddima*, p. 129 (l. 8) (Beirut, 1882). [2] Makkarī, *op. cit.*, Vol. I, p. 374.
[3] M. G. Moreno, *Pinturas de Moros en la Alhambra* (Granada, 1916).
[4] Makkarī, *op. cit.*, Vol. I, p. 321 (ll. 10–11).
[5] Carra de Vaux, *Les Penseurs de l'Islam*, Vol. II, chap. 6 (Paris, 1921).
[6] Qalqashandī, *Ṣubḥ al-Aʿshà*, Vol. III, pp. 527–8.

before the chief Qāḍī and his assessors.[1] Such perishable articles were probably regarded with a certain amount of indulgence, as obviously not being likely to become objects of idolatry, as was also the case with the waxen figures, made in the shape of men or angels or animals of various kinds, that were used in the eighteenth century in Constantinople for decorative purposes, on the occasion of the wedding festivities of persons of high rank.[2]

But statues of living persons, since for them no possible excuse could be found, are exceedingly rare, as clearly coming under the condemnation of the law. Yet statues, even though they most flagrantly suggest the idolatry which Islamic theology is ever eager to combat, have not been unknown in the history of Muslim art. Khumārawayh (883–895), the son of the founder of the Ṭūlūnid dynasty of Egypt, had in his palace near Cairo a room called the House of God, to the walls of which were attached statues of himself and his wives and singing-girls, wearing crowns of gold and attired in costly jewelled robes.[3] 'Abd ar-Raḥman III (912–961), the greatest monarch in the history of Muhammadan Spain, set up a statue of Zahrā, his favourite wife, over the gateway of the magnificent palace he built for her in the neighbourhood of Cordova, and called after her name.[4]

Under the tolerant rule of the Saljuq princes of Asia Minor it was even possible for a school of sculpture to blossom forth for a brief period. When 'Alā ad-Dīn Kay-qubād (1219–1236) built the walls round his city of Konia, he set up on each side of one of the great gates a winged figure,[5] such as appears in many of the paintings in Persian MSS., especially in representations of Muhammad's ascension to Paradise. In the Museum of Konia there are still preserved several other examples of sculptured figures, in low relief, testifying to the disregard by the Saljuq princes of the strict ordinances of their faith; among them are one or two human figures, but most of them are animals, e.g. the antelope, the elephant, and fantastic beasts such as the winged unicorn and the winged sphinx.[6]

In the Qara Sarai of Mosul, a palace built by the Atābeg Badr ad-Dīn Lu'lu' (1233–1259), there was a frieze of plaster figures, probably originally 100 in number, representing men looking out of niches, so that only the upper part

[1] Maqrīzī, *Khiṭaṭ*, Vol. I, p. 479 (l. 6).

[2] M. d'Ohsson, *Tableau de l'empire othoman*, Vol. VI, pp. 438–9 (Paris, 1791).

[3] Maqrīzī, *Khiṭaṭ*, Vol. I, p. 316 *ad fin.* (Cairo, A.H. 1270).

[4] Makkarī, *Nafḥ aṭ-Ṭīb*, Vol. I, p. 344. For an account of the recent excavations on this site, see R. Velázquez Bosco, *Medina Azzahra y Alamiriya* (Madrid, 1912).

[5] F. Sarre, *Erzeugnisse islamischer Kunst*, Teil II (Plate I) (Leipzig, 1909).

[6] Id., pp. 8–17, 44. See also H. Glück, *Die beiden 'sasanidischen' Drackenreliefs* (*Grundlagen zur seldschukischen Skulptur*), Konstantinopel, 1917.

of the body is visible, with the hands crossed in front of the body; each had a halo behind the head; but all that remain have been mutilated and the features obliterated.[1]

But such examples are exceedingly rare, and it is not until modern times that any Muhammadan ruler has dared so to outrage public opinion as to erect a statue in any open space outside the precincts of his palace; but the Egyptians have by now become accustomed to the statues which Ismāʿīl Pasha (1863–1882) erected to his ancestors—that of Muḥammad ʿAlī in Alexandria and of Ibrāhīm Pasha in Cairo; since then other statues have been set up in Cairo, among them one of the founder of the National Party, Muṣṭafà Kāmil Pasha, and schools of both painting and sculpture have been established.

To a separate group of their own belong the animals that are found carved on bridges, city gates and towers, and other public buildings, and on palaces as well as private houses; they served as talismans and were intended to ward off evil, especially the approach of an enemy. Such a usage represents a survival from pre-Muhammadan times and indicates a demand on the part of popular superstition so urgent as to thrust the prohibitions of the theologian aside. The figures generally take the form of a terrible beast of prey, such as a lion or an eagle or dragon; of rarer occurrence is a human figure, e.g. the carved relief of a man whose head is surrounded by a halo over a gate of a Khān or caravanserai erected on the road between Sinjār and Mosul some time between 1233 and 1259; the man is thrusting a lance into the mouth of a scaly dragon and probably represents Khwājah Khiḍr, the patron saint of travellers, and was set up over the entrance of this caravanserai to serve as a talisman to ensure the safety of those who frequented it.[2]

To these scanty notices of such breaches of the Sacred Law within the dominions of the Arab empire in the days of its greatness, and in the Muhammadan West, may now be added some examples of the encouragement of the painter's art by the princes who rose to power in the Muhammadan East after the break-up of the Abbasid empire. One of the earliest of these dynasties that succeeded in establishing itself with any permanence in Persia was that of the Samanids (874–999), under whose rule Bukhārā and Samarqand became centres of civilization and learning; one of these enlightened

[1] *Archäologische Reise im Euphrat- und Tigris-Gebiet* von Friedrich Sarre und Ernst Herzfeld, Vol. II, pp. 241 sqq.

[2] F. Sarre und E. Herzfeld, *op. cit.* (*Arabische Inschriften* von Max van Berchem), Vol. I, pp. 13, 37–8 (Berlin, 1911).

princes, Naṣr ibn Aḥmad (913–942), is said to have ordered the poet Rūdagī to make a metrical version of the fables of Kalīlah and Dimnah, and he was so delighted with this poem that he had it adorned with pictures by Chinese artists.[1]

The Samanids disappeared before the rising power of the Turks, and one of the princes who helped in the final destruction of their rule, the great conqueror Maḥmūd of Ghaznī (998–1030), sought to gratify his pride in his own prowess by having his palace decorated with pictures of himself, his armies, and his elephants. It is characteristic of the fortuitous mention of such works of art by Muslim authors that this information is derived from a biography of the great Sufi saint, Abū Saʿīd ibn Abiʼl-Khayr; the painter of these pictures was the father of the saint, who at the time was a mere child, but he rebuked his father for thus glorifying the name of Sultan Maḥmūd instead of that of God; the story goes on to tell that the pious admonition of the child caused the painter to repent, so that he destroyed the pictures he had painted.[2] What view the choleric Sultan took of such proceedings is not recorded, for this aspect of the matter was naturally of no interest to the hagiographer.

In considering the attitude of the Muhammadan annalists towards the painters and their art it must be borne in mind that historical science in the Muslim world owed its birth to theology, and may almost be regarded at the outset as a branch of exegesis; the first impulse to the writing of history came from the need of a biography of the Prophet and of elucidations of the numerous historical references in the Qurʼān; consequently some of the greatest historians in the Muhammadan world have at the same time been theologians. Such men of course sympathized with the orthodox condemnation of the art of painting and had no desire to sully their pages with the record of the doings of such godless folk. It was not until the changed attitude towards the art of painting, to which reference will be made below, found expression in literature about the beginning of the sixteenth century that the historian could record the activities of the painter without drawing a moral lesson or giving some expression to his disapproval.

Had the historians deemed such matters worthy of their pen, we should have had accounts of the pictorial decoration of the private apartments of Muslim monarchs such as the Abbasid Caliph Muhtadī (869–870)[3] or Sultan Fīrūz Shāh Taghlaq of Dihlī (1351–1388), but it only finds mention

[1] *Notices et Extraits*, Vol. XLI (1923), p. 219.
[2] ʿAṭṭār, *Tadhkiratuʼl-Awliyā*, ed. R. A. Nicholson, Vol. II, pp. 322–3.
[3] Masʿūdī, *Murūj adh-Dhahab*, Vol. VIII, p. 19.

when these pious princes give orders for the destruction of such pictures as being condemned by the Sacred Law. The latter had various garden scenes painted in their place.[1] More valuable still would it have been if there had been preserved some description of the decoration of the palaces of the Timurid princes, for with their love of art they must have beautified their dwelling-places with the same lavish embellishment as they allowed their painters to give to the adornment of their manuscripts. All that the historian of the achievements of the founder of the dynasty tells us of the palace which Tīmūr built in a garden to the north of Samarqand, early in 1397, is that it was decorated with frescoes which put to shame the famous book of Mānī and the picture gallery of China.[2] Bābur visited this North Garden during his brief occupation of Samarqand a century later, in 1497–8, but makes no mention of any paintings; he records, however, the existence of another garden, the Bāgh-i-Dilkushā, which Tīmūr laid out to the east of the city, in which he erected a great kiosk, painted inside with pictures of his battles in India.[3] As Tīmūr did not invade India till 1398, this must have been a later construction than the North Garden. Tīmūr's son, Shāh Rukh (1404–1447), also erected a garden house in Harāt and had it decorated with pictures,[4] and the miniatures in the manuscripts of this period suggest that such mural decorations were common. Bābur also mentions a small, two-storied building outside the city of Harāt, which his grandfather, Sultan Abū Saʿīd (1452–1467), had ordered to be decorated with pictures of his own campaigns and encounters.[5] Of these wall-paintings nothing whatever remains, but of their general character some conception may be formed from the scanty traces of the frescoes painted for a grandson of Bābur in Akbar's palace at Fathpūr-Sīkrī. Though these were painted a century later (about 1570) and exhibit the characteristics of the eclectic Hindu-Persian style which Akbar encouraged, they conform to the tradition of the frescoes painted for Akbar's ancestors in Samarqand and Harāt.[6]

The monarchs of the Safavid dynasty in Persia, who were for several generations contemporaries of the Timurids in India, likewise decorated their palaces with frescoes, but it was not until European travellers began to describe them that we come to know much about them. Sir William

[1] Shams-i-Sirāj ʿAfīf, *Taʾrīkh-i-Fīrūzshāhī*, p. 374 (Calcutta, 1891).
[2] Sharaf ud-Dīn ʿAlī Yazdī, *Zafar Nāmah*, Vol. I, p. 802 (Calcutta, 1887).
[3] The *Bābur-nāma*, translated by A. S. Beveridge, p. 78 (London, 1921).
[4] ʿAbd ar-Razzāq, *Matlaʿ as-saʿdayn* (*Notices et Extraits*, Vol. XIV (1843), Part I, p. 191).
[5] The *Bābur-nāma*, p. 302.
[6] Edmund W. Smith, *The Moghul Architecture of Fathpur-Sikri*, Part I, Plates XI, XII, CIX–CXX (Allahabad, 1894).

Ouseley in 1812 saw one of the palaces which Shāh 'Abbās had built in 1612 at Ashraf, near the southern shore of the Caspian Sea, before it had entirely perished. 'I examined it,' he tells us, 'ascending to the third story through many spacious apartments, formerly ornamented with gilding, Arabesque devices, richly carved woodwork, and mirrors, of which numerous fragments still remained in several tákchehs (طاقچه) "niches", or recesses. The walls of some chambers had been completely painted, and in three or four compartments I traced the vestiges of an European pencil.[1] Diana with her nymphs at the fountain; near her a large urn, and dogs; and some portraits, almost of the natural size. But from the admission of damp air (all doors and windows having been broken or removed) and from the smoke of fires kindled on the floors of the sumptuous rooms, both the outlines and the colours had suffered so considerably that it was difficult to ascertain the subjects designed. Those injuries also extended to some pictures of the best Persian school, in which had been delineated (for they were discernible, though faintly) very graceful forms and handsome faces of women, besides various representations of men richly clothed as in illuminated Persian manuscripts of the sixteenth or seventeenth century.'[2] These palaces have now gone to utter ruin,[3] but Professor Sarre, a century after Sir William Ouseley, could still make out some traces of the paintings, though much damaged by smoke and damp.[4]

Not all the wall-paintings of the period of Shāh 'Abbās, however, have perished thus; some still remain in the Chahil Sutūn or Hall of Forty Pillars at Isfahan.[5] A later monarch, Fath 'Alī Khān (1797–1834), had a number of his palaces decorated in a similar fashion; the Hasht Bihisht and the Imārat-i-Nau in Isfahan[6] still remain, and the Nigāristān in Tihrān.[7] But the Kulah Farangī, in a garden near Shiraz, which Sir William Ouseley described as

[1] Jonas Hanway speaks of 'several portraits, which seem to have been done by a Hollander, but no masterly hand' (*An historical account of the British trade over the Caspian Sea: with the author's journal of travels from England through Russia into Persia*, Vol. I, p. 200, London, 1754).

[2] Sir William Ouseley, *Travels in various countries of the East; more particularly Persia*, Vol. III, pp. 272–3 (London, 1819–23). [3] Curzon, *Persia*, Vol. I, p. 377 (London, 1892).

[4] F. Sarre, *Denkmäler Persischer Baukunst*, pp. 108–9 (Berlin, 1910).

[5] Curzon, *Persia*, Vol. II, pp. 34–6.

[6] Id., Vol. II, pp. 36–7. The latter appears to be the same as the palace of Fathābād, described by Sir William Ouseley as having been built for Fath 'Alī Khān, by his second minister, Amīn ad-Dawlah Ḥājī Muḥammad Ḥusayn Khān. 'The portraits of many ancient kings, represented of the natural size, contribute to embellish this palace. They have been painted within ten or twelve years by a celebrated artist, Mihr Ali, of Tehran, who has not only marked each picture with his own name, but considerately added the title of each illustrious personage whom he intended to delineate. This alone enables the spectator to distinguish Feridun, Nushirvan, and others from Iskandar, whose face, dress, and arms are, most probably, the same that Mihr Ali's imagination would have assigned to any Persian prince of the last fifty or a hundred years' (*Travels*, Vol. III, p. 27).

[7] Curzon, *Persia*, Vol. I, pp. 338–9.

decorated with hunting scenes and the story of Khusrau and Shīrīn,[1] is now in ruins.[2]

Such are the scanty records, scattered throughout the literature of more than a thousand years, of the encouragement that Muhammadan monarchs and nobles gave to workers in the pictorial and plastic arts, despite the disapprobation which their theologians expressed for all representations of living beings. Most of these works of art have perished; but a certain number of the carpets, ivories, crystals, metal-work, and wood-carving have survived the various cataclysms that from time to time have swept over the Muhammadan world, and they are now safely guarded from iconoclastic zeal in public museums, private collections, and—strangest fate of all—in the sacristies of Christian churches and cathedrals.

But almost all the wall-paintings have perished; the exceptions are the frescoes of recent date in Persia, to which reference has just been made, and two examples of a much earlier date, one of the Umayyad and the other of the Abbasid period, which have only come to light in recent years. The first of these two was discovered in 1898 in the desert of Transjordan to the east of the northern end of the Dead Sea, in a kind of shooting-box called Quṣayr 'Amra;[3] this pleasure-house, erected in the desert by one of the Umayyad princes early in the eighth century, is built of limestone and consists of a main rectangular hall with a few rooms attached; on the walls and vaulted ceilings of all but one of these rooms are the much-damaged remains of paintings. Among the subjects represented are six royal personages, standing for the chief enemies of Islam who had been defeated by the Umayyads; to these reference will be made later on;[4] some symbolic figures representing the ages of man, and Victory, Philosophy, History, and Poetry; a number of nude figures, some of them men engaged in gymnastic exercises; dancers, flute-players, and other musicians; various animals, particularly gazelles and antelopes, together with hunting scenes; a row of figures representing different trades; and a number of heads in medallions surrounded by foliage also form part of the varied decoration of this building. Opposite the entrance of the main hall is a painting of a dignified figure seated on a throne, placed in a niche supported by four columns; over the niche are the scanty fragments of an Arabic inscription which invokes the blessing of God over some person whose name has entirely perished. This painting is undoubtedly intended to represent the prince for whom the building was erected, and much speculation has been devoted to the problem

[1] Ouseley, *Travels*, Vol. II, p. 2. [2] Curzon, *Persia*, Vol. II, p. 105.
[3] A. Musil, *Kusejr 'Amra* (Wien, 1907). [4] See below, chap. VIII.

of his identification. The most plausible solution is that put forward by Max van Berchem, namely, that it is intended for a portrait of the Umayyad Caliph Walīd I (705–715), whose victorious armies had added Spain to the Arab empire and had extended the domination of Islam to the shores of the Atlantic in the West and into India and the borders of China in the East. This identification is based on the decipherment of the bilingual inscriptions above the heads of four of the six royal personages mentioned above. The inscriptions make it clear that these monarchs are arranged in order from left to right, according to the relative geographical position of their kingdoms from West to East; moreover, they are not all set in one line, but stand in two rows, three a little behind the other three. Max van Berchem[1] has acutely recognized that those standing in the front row are emperors, those standing a little farther back are rulers of kingdoms of lesser importance.[2]

Professor Herzfeld has given cogent reasons for thinking that this group of the various monarchs of the earth is copied from some Sasanian original, in which the Khusrau had been represented as receiving the homage of rival princes.[3]

It is characteristic of the place which pictorial art was destined to fill in Islamic culture that the earliest memorial of it that has survived should illustrate the luxurious habits of the pleasure-loving Umayyad princes, devoted to women, music, and the chase, and contemptuous of the austere ideals of the new faith that their fathers had so recently adopted. Further, since the new religion did not encourage such artistic efforts, foreign painters had to be employed by those who in this manner flouted the admonitions of their own theologians; and thus the first example of painting in the Muhammadan period is one of the last creations of profane art surviving from the Hellenistic age.

The examples of fresco decoration that have survived from the Abbasid period were discovered in Sāmarrā by Professors Sarre and Herzfeld in the course of the excavations which they carried out during the years 1911–13. The founding of this new capital of the Abbasid empire was prompted by the constant disturbances that arose between the population of Baghdad and the Turkish soldiery, whose insolence made the life of the inhabitants unbearable; so the Caliph Mu'taṣim resolved to move the capital to Sāmarrā, about sixty miles north of Baghdad, and settled here in 838. The new city

[1] Max van Berchem, *Aux Pays de Moab et d'Édom* (*Journal des Savants*, N.S. 7, pp. 367–9, 1909).
[2] More detailed descriptions of these figures will be found in Chapter VIII.
[3] *Die Malereien von Samarra*, pp. 5–6 (Berlin, 1927).

owed its magnificence mainly to the building activity of his two sons, who successively succeeded him. Its glory began to pass away after the year 883, when the Caliph Mu'tamid abandoned his grandfather's capital and moved the seat of government back again to Baghdad. The site is now a vast area of ruins, and no buildings are left standing except the great mosque. Remains of frescoes were found on the site of the palace and in a few private houses, but in very few cases had they remained *in situ*; most were scattered in broken fragments on the floor. The subjects of these frescoes must in many instances have been similar in character to those of Quṣayr 'Amra; there are nude female figures, dancing-girls, hunting scenes, animals, and birds.[1] Whoever may have been the painters of these pictures—and from the signatures it appears that both Christians and Muslims were employed[2]—we have independent evidence that one of the palaces, named al-Mukhtār ('the chosen'), built by Mutawakkil (847–861) in Sāmarrā, was decorated by Greek painters, and that the subject of one of their pictures was a Christian church with monks praying in it.[3] Greek signatures were actually found by Professor Herzfeld in the ruins of this city.[4]

Such creations were of course an abomination in the sight of the theologians, though they were not always so bold as Qāḍī Mughīth ad-Dīn[5] in standing up to rebuke what they considered to be wickedness in high places. If opportunity presented itself they would of course be unlikely to refrain from using fire or knife for the destruction of the offending handiwork of the artist, but for the rest they behaved like the theologians described in a document about the middle of the eighteenth century: 'The 'ulamā ponder over this state of affairs; they weep and groan in silence, while the princes who have the power to repress these criminal abuses merely shut their eyes. But we are God's, and unto Him do we return!'[6]

The influence of these theologians was, however, strong enough to exclude figure-painting out of all buildings devoted to religious purposes and keep the general body of orthodox believers uncontaminated by such abominations, and it is no doubt largely in consequence of their teaching that painting in the Muslim world has always remained, for the most part, a courtly art and has never become an integral part of Muslim culture, as has been the case with the culture of Christendom.

But apart from these deliberate and conscious examples of a flouting of

[1] E. Herzfeld, *Die Malereien von Samarra, passim.*
[2] Id., pp. 90–1.
[3] Yāqūt, *Mu'jam al-buldān*, Vol. IV, p. 44.
[4] *Op. cit.*, pp. 96, 99.
[5] p. 18.
[6] Fetoua relatif à la condition des zimmis, et particulièrement des Chrétiens, en pays musulmans, traduit de l'Arabe, par M. Belin (*Journal Asiatique*, IVme série, Tome XIX, p. 125, 1852).

the Sacred Law, there is evidence to show that by the fifteenth century the compelling influence of many of the ordinances embodied in the Traditions of the Prophet had ceased to be operative in the Eastern dominions of the Muhammadan world, and that it was felt by the theologians to be useless to appeal to them against the tyranny of accepted facts. The teaching of the Traditions as corroborated by the authority of the accepted exponents of Islamic jurisprudence was perfectly clear as regards the institution of the Caliphate, viz. that the Caliph must be a member of the tribe of the Quraysh, to which the Prophet himself had belonged; but by the fifteenth century it had become quite common for monarchs with no pretensions to Arab descent to assume the exalted title of Khalīfah, though this had in previous centuries not only been thus restricted but had been regarded as unique and capable of being conferred only on the one head of the Muslim community. So many foreign and non-Arab races had become absorbed into the fold of Islam, so many barbarians such as Mongols and Turks had after their conversion taken rank among the most powerful of contemporary Muhammadan sovereigns, that academic considerations tended to decline in influence and the individual predilections of the ruler brushed aside any appeal to the Traditions as theological pedantry. Even after the Mongol conquerors of Persia and Transoxania had accepted Islam they still for some generations followed the Yāsāq, the customary law of their heathen ancestors, in spite of the effort of the accepted exponents of the faith to make the Sharīʿah or Sacred Law operative. As is well known, the prescriptions of the Sharīʿah had always remained in large measure theoretic and, in the practical concerns of life, to a very considerable degree inoperative; but there was a great difference between the scrupulous desire of a despot such as Hārūn ar-Rashīd to keep within the letter of the law and his frequent consultations with the great legist of his reign, Abū Yūsuf, on cases of conscience,[1] and on the other hand the self-assertiveness of one of the monarchs of the new type, whose ancestors had helped to break up the Arab empire and had bequeathed to their Muslim descendants institutions and ideals that had taken firm root before the faith of Islam had been superimposed upon them.

Among the many traditional judgements of Islam which thus received fresh consideration was that which had hitherto been passed upon the art of painting. Bābur, the Chagatai Turk, descended through his mother from the Mongol Chīngīz Khān, was interested in painting and probably saw no reason why he should suppress his tastes in such a matter at the bidding of

[1] E. H. Palmer, *Haroun Alraschid*, pp. 155 sqq. (London, 1881).

V. King Bahrām Gūr shooting the dragon

a theological pedant, whose text-books his own adventurous life had left him no leisure to study.[1] There is no evidence that Bābur himself ever acquired any practical knowledge of art, but a Mongol prince of an earlier generation, Sultan Aḥmad, of the Jalā'ir dynasty of 'Irāq (1382–1410), had practised the art of painting as well as that of gilding.[2] Whether any of the sons and grandsons of Tīmūr, who were such generous patrons of art, ever themselves studied painting, does not appear to be recorded, but a later member of the family, Baysunqur Mīrzā (*ob.* 1499), a descendant of Tīmūr in the fifth generation, who was himself for a short time ruler of Samarqand, is mentioned with commendation by Bābur, his cousin, as not only an excellent calligraphist, but 'in painting also his hand was not bad'.[3] In those days when, as in contemporary Europe, the cultivation of knowledge tended to become encyclopaedic, it was considered that some acquaintance with the art of painting might very fittingly be added to other accomplishments. Of Ḥaydar Mīrzā, the talented author of the *Ta'rīkh-i-Rashīdī* (1499–1551), his cousin, Bābur, wrote: 'He had a hand deft in everything, penmanship and painting, and in making arrows and arrow-barbs and string-grips; moreover he was a born poet.'[4]

Such royal interest in the painter's art was doubtless ultimately to his advantage, but it must often have been embarrassing, especially when his exalted patron formed too high an estimate of his own achievements, as when the rough Uzbeg conqueror of Harāt (in 1507), Muḥammad Shaybānī Khān, took upon himself to correct the drawing of Bihzād, just as he would touch up the handwriting of Sulṭān 'Alī of Mashhad, the greatest calligraphist of his day, and teach exegesis to professed theologians.[5]

Even a descendant of a saint, whose family had risen to power largely on a wave of religious enthusiasm—Ṭahmāsp, the Safavid Shāh of Persia (1524–1576)—is said to have taken lessons from the famous painter, Sulṭān Muḥammad, and was praised by his annalist as 'an incomparable artist, a delicate painter with a fine brush, whose work was like magic'.[6]

[1] Bābur's attitude towards the customary law of his heathen ancestors is of interest here. In his Memoirs he writes: 'Our forefathers through a long space of time had respected the Chīngīz-tūra (ordinance), doing nothing opposed to it, whether in assembly or Court, in sittings-down or risings-up. Though it has not Divine authority so that a man obeys it of necessity, still good rules of conduct must be obeyed by whomsoever they are left; just in the same way that, if a forefather have done ill, his ill must be changed for good.' *Bābur-nāma*, translated by A. S. Beveridge, pp. 298–9.

[2] Dawlatshāh, *Tadhkiratu' sh-shu'arā*, ed. E. G. Browne, p. 304 (l. 9).

[3] *Bābur-nāma*, p. 111.　　　　[4] Id., p. 22.　　　　[5] Id., p. 329.

[6] Iskandar Munshī, *Ta'rīkh-i-Ālamārā-yi-'Abbāsī* (India Office Library, Ethé 549, fol. 74 b). The list of such royal amateurs comes up to modern times, inasmuch as Nāṣir ad-Dīn, Shāh of Persia from 1848 to 1896, used to amuse himself with drawing, and some of his sketches—an ass, a wild goat, and a greyhound—are to be found in an album in the British Museum (Or. 4936).

A contemporary ruler, of lesser importance, 'Abd ar-Rashīd, who was Khān of Kashgar from 1533 to 1570, is also said to have had a great aptitude for arts and crafts. 'Once, for example, he cut a tree out of paper, and painted all the branches, the leaves, and the trunk in their proper colours; he did it so skilfully that even the masters of that craft were astounded.'[1]

The Persian historian, Khwāndamīr, gave expression to this new-born appreciation of the art of painting, in a preface which he wrote for an album of pictures by the great master, Bihzād. This Khwāndamīr, born about 1475, was the grandson of a still more eminent historian, Mirkhwānd, the author of the *Rawḍat aṣ-Ṣafā*, a universal history from the creation of the world to the author's own time, and he compiled an abridgement of his grandfather's work under the title of *Khulāṣat al-Akhbār* or 'Compendium of History'; when he was only twenty-three years of age, he was placed in charge of the library of that great patron of letters, Mīr 'Alī Shīr,[2] to whom he gratefully dedicated this compilation, acknowledging that had it not been for the considerate kindness of his patron, he could not have completed in six years a tenth part of what he had succeeded in finishing in as many months. In the reign of the luckless Badī' az-Zamān, who only managed to retain his father's kingdom for a year, Khwāndamīr held the office of a judge in Harāt, and drew up the conditions of surrender when in 1507 the Uzbeg leader, Muḥammad Khān Shaybānī, captured this city; he had to endure great indignities from these uncouth conquerors, and breathed a sigh of relief when they were defeated by Shāh Ismā'īl in 1510. After the death of Shāh Ismā'īl in 1524 he left Harāt, and after a long and perilous journey succeeded in reaching Agra, where he paid his respects to the Emperor Bābur in 1528; after this monarch's death, he entered the service of Humāyūn and died about 1535 or 1537.

The document translated below occurs in a collection of official papers, drawn up by Khwāndamīr and entitled *Nāmah-i-Nāmī*. It is of interest not only for the appreciation it reveals of the work of Bihzād, but also for the high place it assigns to the art of the painter. Though written in a highly rhetorical and artificial style of mixed poetry and prose, it is obviously inspired by feelings of genuine sympathy for painting and altogether ignores the hostile attitude of the older generation of theologians. The album must have contained specimens of both painting and writing, and by weaving the praise of the two arts together Khwāndamīr endeavours to secure for the former

[1] Muḥammad Ḥaydar Dughlāt, *Ta'rīkh-i-Rashīdī*, translated by E. Denison Ross, p. 147 (London, 1895).
[2] The talented minister of Sultan Ḥusayn Bayqarā, and like his master a patron of men of letters and artists; he was himself a writer both of prose and verse; *ob.* 1501.

the consideration which (as we have already seen) was universally accorded to the latter.

'A description of an album put together by the Master Bihzād, in whom have been made manifest the (divine) guidance and leading.

> The Eternal Painter[1] when he made the sun
> Adorned an album with the sky for leaves.
> Therein He painted without brush or paint
> The shining faces of each beauteous form.[2]

Since it was the perfect decree of the incomparable Painter and the all-embracing wish of the Creator "Be and it was"[3] to bring into existence the forms of the variegated workshop, the Portrait-painter of eternal grace has painted with the pen of (His) everlasting clemency the human form in the most beautiful fashion in accordance with the verse "And He has fashioned you and has made your forms most beautiful",[4] and has adorned the comeliness of the condition of this company (i.e. mankind), endowed with such charming qualities, by decking them out with various wondrous branches of knowledge and marvellous arts,—in accordance with His gracious words, "We have favoured them beyond many of Our creation".[5]

> God's grace and art became revealed in men,
> When with His pencil He designed their forms.
> When God displays His skill, His art adorns
> The course of time, like pages in a book.
> Sometimes His pen's point, redolent of musk,
> Draws lines whose excellence is unsurpassed.
> Sometimes a moon-faced beauty stands revealed
> Whene'er He mixes colours with His brush.
> Sometimes His art doth cause a stream of gold
> To flow within the garden of fair speech.
> Sometimes He raiseth up a lofty tree
> Whose fruit gives comfort to the troubled heart.
> Sometimes His magic pen makes roses blow
> In all the flower-beds of the written word.
> Whene'er He decorateth words with gold,
> Each tiny fragment puts the sun to shame.
> God's writing and His draughtsmanship amaze
> The wise man by their magic loveliness;
> The eye rejoices at the curving line
> Although the mind may fail to grasp the sense.
> God's form and meaning both create delight
> And shed illumination on man's eye.

"By the pen and what they write."[6] This verse is a sign of the perfection of the super-excellence of writing. And the verse, "He has taught with the pen"[7] expresses the abundant merits of penmanship.

> Imagination cannot grasp the joy
> That reason draweth from a fine-drawn line.

It is impossible to express the delight of the soul of man at a design and a picture made in such a way that it represents an amīr and a wazīr and rich and poor, and it is

[1] i.e. God. [2] i.e. the stars. [3] Qur. iii. 52. [4] Qur. xl. 66.
[5] Qur. xviii. 72. [6] Qur. lxviii. 1. [7] Qur. xcvi. 4.

impossible to describe with the help of pen and fingers a particle of the beauty and grace and delight and reposefulness of this marvellous art.

From the beginning of the world the most distinguished of the sons of Adam (on whom and on our Prophet be peace so long as writing is formed by ink and pen!) have busied themselves in these two noble tasks, and they have carried off the palm of superiority over their like and their equals on the field of perfection and superiority and on the plain of skill and excellence. Accordingly, the distinguished names of some of these persons have been mentioned in the preface to this album, and the fine specimens of their handwriting and their famous pictures, executed with their marvellous pens, have been given a place in these pages.

Among these perfect painters and accomplished artists is the compiler and arranger of the pages of this album, the producer of wonderful forms and of marvellous art, the marvel of the age, whose faith is unsullied, who walks in the ways of love and affection, Master Kamāl ad-Dīn Bihzād.

> His brush, like Mānī's, wins eternal fame;
> Beyond all praise, his virtuous qualities;
> Bihzād, acknowledged as supreme in art,
> The master of the painters of the world,
> Unique among the artists of his age,
> Has turned the name of Mānī to a myth.
> Hairs of his brush, held in the master's hand,
> Give life unto the forms of lifeless things.
> His talent is so fine that 'tis no boast
> If we maintain, his brush can split a hair.
> If still you doubt that in the painter's art
> His mastery has reached perfection's height,
> You need but look with an impartial gaze
> And contemplate the marvel of these forms,
> Wherewith he has adorned these beauteous leaves
> And perfected the marvels set therein.
> For never yet has any page received
> Pictures so fair or writing so refined.

For without taint of flattery or risk of pride, it may be maintained that ever since the cheeks of rosy-cheeked beauties have been adorned with musk-like down, no pen has ever set down upon the surface of any paper specimens of writing such as are written in this album; and since the album of the sky has been fashioned with the light-scattering form of moon and sun, the rays of the intelligence of no expert draughtsman have ever fallen on the like of the forms which decorate these pages.

Every drop that the pearl-scattering pen, like a diver, has brought up from the sea of the inkstand to the shore of these leaves is a most precious pearl. Each figure which intelligence becoming a painter, leaving marvellous memorials behind it, has transferred from the tablet of the heart to the pages of this book, is a houri enchanting the soul.

> Within the sea each pearl is to be found
> That love has fostered 'neath the waves of joy.
> All eyes flash out with radiant loveliness,
> Each heart is joyous as a lover's tryst.

But since the praise of the delicacy of these precious pearls and the description of the fineness of these unique figures is not the office of any one who has no store of ability,

and is not the function of any one who is without due provision, my musk-diffusing pen must content itself with a quatrain which has been recited in praise of the Master,— and it is this:

> Thy brush, albeit set with hairs so small,
> Has wiped out Mānī's face past all recall;
> What lovely forms have other pens produced,
> But thy good genius[1] has surpassed them all.

Praise and thanks be to God, the Painter of the forms of His servants, and blessing and benediction be on our Lord Muḥammad, so long as a line is written by the pen and the ink, and on his family, who are the manifestation of the form of right guidance and righteousness, and on his household, who are our intercessors on the day of the summons.'[2]

One of the most remarkable characteristics of this document is the fact that the gravamen of the old theological complaint against the painter, viz. that he attempted to bestow the gift of life, is put forward in order to express the highest praise that Khwāndamīr can bestow, nor does he hesitate to compare the painter with God Himself.

A theological defence of the painter on somewhat different lines was put forward a little later by the Emperor Akbar,[3] who, according to the report of his devoted minister and panegyrist, Abu 'l-Fazl, declared on one occasion, 'It appears to me as if a painter has quite peculiar means of recognizing God; for a painter in sketching anything that has life, and in devising its limbs, one after the other, must come to feel that he cannot bestow individuality upon his work, and is thus forced to think of God, the Giver of life, and will thus increase in knowledge'.[4] Such a defence obviously has in mind the condemnation embodied in the Traditions, discussed above,[5] and attempts to refute it by suggesting that, so far from the art of painting being regarded as blasphemous, it may serve as a stepping-stone towards advance in divine knowledge.

It is characteristic of the mental attitude of Muhammadan thinkers at that period, as during most others, that this new appreciation of the art of painting should find for itself expression in the language of theology, and seek to confute the unfavourable judgement of the older theologians with their own weapons. In Muhammadan literature no attempt has ever been made to work out any independent system of aesthetics or arrive at any appreciation of art for its own sake.

[1] A pun on the name of the painter, Bihzād 'of good birth'.

[2] Mīrzā Muḥammad Qazwīnī et L. Bouvat, *Deux documents inédits relatifs à Behzâd* (*Revue du Monde Musulman*, Vol. XXVI, pp. 155–7, Paris, 1914).

[3] Akbar in his youth had taken lessons in drawing (Abu 'l-Fazl, *Akbarnāmah*, translated by H. Beveridge, Vol. II, p. 67).

[4] *Ā'īn-i-Akbarī*, translated by H. Blochmann, Vol. I, p. 108, Calcutta, 1873. [5] p. 5.

But this new evaluation of the art of painting never succeeded in displacing the earlier condemnation, for the latter was too firmly rooted in popular sentiment and was too decisively set forth in theological text-books, whose authority had been recognized for centuries, to make way for any more modern speculation, and it has continued to hold sway in the greater part of Muhammadan society up to recent times. When Sultan Maḥmūd II (1808–1839) tried to force Western manners and customs on the people of Turkey and had his portrait hung up in all the barracks, the inhabitants of Constantinople, stirred up by the ʿulamā, rose in revolt, and four thousand corpses were thrown into the sea before the rising was quelled.[1]

In considering the strong hold which this hostility towards the painting of figures had upon the consciences of orthodox Muslims, it is instructive to recognize how many instances may be quoted from Turkish history to show that those who indulged in a taste for pictorial art generally kept their pictures hidden, and the wild speculations that were spread abroad, when after the death of the Wazīr Qara Muḥammad in 1644 it was discovered that in a secret room he had kept portraits of himself and some of his contemporaries, show how rare it was (at least at that period in Turkey) for any persons but those highly placed to dare to flout the fanatical opinion of Muhammadan society.[2] D'Ohsson gives an account of a picture, representing the repulse of an attack upon Algiers by the Spanish, which Ghāzī Ḥasan Pasha, Grand Wazīr in the reign of ʿAbd al-Ḥamīd I (1773–1789), had had painted for himself; but he did not dare expose it in his palace in Constantinople, but kept it in his country house, to which his Christian and European friends would resort to see this picture,—as also sometimes the Sultan himself. For the exalted position of the sovereign made him safe from the risks that a commoner would run; and consequently we find that many of the Sultans of Turkey, from Muḥammad II, who summoned Gentile Bellini from Venice, onwards, kept painters in their service, but they generally took care not to excite the prejudices of their subjects by letting the knowledge of such predilections get abroad. So well was the secret kept, that even up to the sixteenth century European visitors to Constantinople used to refer to the Muhammadan detestation of pictures as universal, so that even Sulaymān's (1520–1566) interest in pictorial art was not generally known to his contemporaries.[3] Muḥammad IV (1648–1687) was also a patron of painters, but he took care to keep his pictures shut up in a private

[1] De la Jonquière, *Histoire de l'Empire ottoman*, Vol. I, p. 422 (Paris, 1914).

[2] J. von Hammer, *Geschichte des osmanischen Reiches*², Vol. III, pp. 235–6.

[3] J. von Karabacek, *Suleimân der Grosse als Kunstfreund* (*Vienna Oriental Journal*, Vol. XXVI (1912), pp. 5 sqq.).

room.[1] Even the famous collection of the portraits of the Ottoman Sultans, which has frequently been published, was said in the eighteenth century to have been kept concealed, not only from the knowledge of the general public, but also from all the officers of the court who did not enjoy the intimate confidence of the Sultan.[2] Even when Salīm III (1789–1807) made up his mind to disregard the prejudices of his fellow countrymen and conceived the idea of having the portraits of his ancestors engraved in England, a Greek peasant, with a talent for painting, was employed to copy them in the seclusion of the palace, and the copies were sent to England in 1806 with express instructions that every possible secrecy was to be observed during the progress of the work.[3]

D'Ohsson relates an interesting story which shows how impressive was the influence of this oft-repeated prohibition on the mind even of a Muhammadan tempted to disregard it; he was once asked by a high official in the court of Sultan Muṣṭafa III (1757–1773) to employ on his behalf a European painter to make sketches of the most picturesque views of Constantinople. This official accordingly received four such pictures and put them away carefully in a private room. Then, under promise of profound secrecy, he expressed a wish to have his own portrait taken, and the painter visited him in the pretended guise of a physician. But when the portrait was finished, he said to D'Ohsson: 'After thinking the matter over, I am sorry that I have had my portrait painted; the sight of it offends my eyes and gives a shock to my conscience; it may even some day expose me to disparaging judgements in the minds of my family, even in those of my own children. Allow me to make you a present of it; keep it in memory of me, but do not let any one know that it is a portrait of me or that it was made by my orders.'[4]

Such prickings of conscience even served as the basis of much opposition to photography, when this began to make its way into Muslim countries. Many devout persons felt conscientious scruples against being photographed, in spite of the sophism that was put forward for the salving of tender consciences, that the operation in no wise resembled the painter's blasphemous attempt to imitate the Creator's production of human forms, since the photograph was really brought about by the agency of the sun and was consequently a result of the operation of divine activity itself. The likeness of the photograph to the portrait made by the painter was too close to prevent the new invention from falling under the same condemnation as had for nearly

[1] D'Ohsson, *op. cit.*, Vol. IV, p. 439. [2] Id., p. 456.
[3] John Young, *Portraits of the Emperors of Turkey*, pp. 2–3 (London, 1815).
[4] D'Ohsson, *op. cit.*, Vol. IV, pp. 446–7.

thirteen centuries depressed the older art. There were even cases like that of the photographer in modern Dihlī, who, after he had for many years been in great request as a successful operator, especially in taking groups, repented of his evil ways and destroyed all the plates he had accumulated; he then attempted to gain a livelihood by photographing ancient buildings, since here there would be no imputation of an attempt to create life, but through ignorance of the laws of perspective his results were always bad.

Similarly, pious hands have carried on the work of destruction and mutilation up to recent times. One of the most lamentable incidents in the annals of such destructive activity is recorded by Professor von Le Coq, who learned on his arrival in Qarakhoja, in Turfan, where he found the Manichaean pictures which are so important for the early history of Persian art, that only a few years before—about 1897—a peasant had found a number of Manichaean MSS. with pictures decorated in gold and colours and had thrown five cart-loads of them into the river, as unholy things.[1]

[1] A. von Le Coq, *Auf Hellas Spuren in Ost-Turkistan*, p. 44 (Berlin, 1926).

II

DIFFICULTIES IN THE WAY OF THE STUDY OF MUSLIM PAINTING

THE student of the art of painting in the Muhammadan world is faced with peculiar difficulties. The subject-matter of his interest is so widely scattered that fortunate indeed must be the individual who can succeed in gaining access even to the most important examples. The great public collections in London, the University Libraries of Oxford and Cambridge and Edinburgh, furnish abundant material, but some of the most noteworthy achievements in Muhammadan painting are to be found in the Asiatic Museum in Leningrad and the Bibliothèque Nationale in Paris; the Libraries of Berlin, Munich, and Vienna also, though not so rich, cannot be neglected. Apart from these public institutions, access to which is not hard to obtain, there are numerous private collections which are in some instances jealously guarded, and no publications have yet revealed the contents of them. Like many other treasures of art that were once available in Europe, a considerable number of some of the finest paintings produced by Muhammadan artists have crossed the Atlantic to America, and must be studied in Boston or New York. The Muhammadan East itself parted with some of its most magnificent treasures of pictorial art at a time when their beauty was not appreciated by their oriental owners, but some still remain in Persia and India. A *Shāh Namāh* decorated for Baysunqur, the prince to whom the authoritative recension of this epic in its present form is attributed, still exists in the palace of the Shah of Persia, and must contain some of the delicate and charming work of the school of Harat; but it has never been described, and shares this obscurity with other treasures of the same kind.[1] The fall of the Ottoman Imperial House and the confiscation of its inherited works of art by the new government has revealed the unsuspected existence of a number of Persian paintings of the best period, but we still await an adequate account of the contents of the Museum of the Evkaf and other places in which they are now stored. For India, some account has been published of the illuminated MSS. in the Patna Oriental Public Library,[2] and the Government of Bihar and Orissa has had photographic reproductions made of the miniatures in three manuscripts; but no account is yet available of the contents of the Library of H.H. the Nawab of Rampur, and there are

[1] E. Herzfeld, *Einige Bücherschätze in Persien* (Leipzig, 1926).
[2] V. C. Scott, *An Eastern Library* (Glasgow, 1920).

doubtless other private collections in India which will in time add to our knowledge of Muhammadan art.

But apart from the fact that the existing materials are difficult of access or, as being still undescribed, are practically unknown, or at least not available for purposes of study, the student is faced by a further difficulty in that examples that have thus survived form but a very small part of the total number of works of art that once existed. Consequently there are great gaps in his knowledge—a whole school of painting can only be guessed at through the survival of a single example; the sources of such schools or groups of painters as can be distinctly recognized often remain obscure; the advent of new influences can be observed, without its being possible to trace them to their source. These and similar difficulties are in great measure the result of the enormous destruction that has deprived us of all knowledge of hundreds, if not of thousands, of pictures; more particularly is this the case with regard to the earliest examples of this art. With the exception of frescoes upon the walls of palaces, practically all the Muhammadan pictures of which we have any knowledge were painted on paper—a material so easily damaged or destroyed, especially in the East. Manuscripts and paintings require special care and watchfulness in countries where the ravages of white ants and other insects can be so successfully achieved in an incredibly short space of time, and where semi-tropical rain may ruin by damp the painted page within the space of a few minutes. When due precautions are relaxed, or carelessness neglects to take the requisite amount of care, irretrievable ruin may result. The fact that so many royal volumes have survived to us in stately bindings, and in a wonderful state of preservation, is due to the care that has been bestowed upon them by generations of librarians, for the written page has generally been regarded with respect by devout persons in the Muhammadan world, and when some royal patron has bestowed his favour upon artists, calligraphists, painters, workers in gold, and binders, the resulting work of art has often been guarded with jealous care in the palace of his descendants, so far as political conditions have permitted the continuity of such precautions. But there have been lamentable exceptions. The late Sir Sayyid Aḥmad Khān, famous alike as theologian, social reformer, and man of letters, used to relate that in the days when there was still a Mughal Emperor living in the Fort at Dihlī, he once entered the Royal Library and, noticing a confused heap of loose leaves lying in a corner of the room, began turning them over with a stick; among much that deserved no particular notice, he came across a finely written page, illuminated with rich gold work, and after further diligent search he managed to recover out of this rubbish heap the

complete manuscript of the Memoirs of Jahāngīr, the copy that had been written out for the Emperor's own use, when he had had copies made for distribution among contemporary Muhammadan princes. He carried the recovered volume away to his own house in the city of Dihlī, but nothing has ever been heard of it since the mutineers sacked his house in 1857. If such an incident could occur in a royal palace that had had a continuous history since Shāh Jahān built it in the Fort of Dihlī in 1638, it may easily be imagined how the loss or damage of manuscripts might occur in places less closely guarded.

But such sporadic destruction has been trifling when compared to the ruin effected by the plundering of captured cities, when libraries were involved in the horrible fate that befell the inhabitants exposed to the savageries of a victorious army. To the fact that Nādir Shāh in 1739 stripped the Royal Library of Dihlī of some of its finest treasures, we owe the preservation of the best examples of the work of Akbar's painters; safe in Persia, they escaped the fate that befell the manuscripts that Nādir Shāh did not consider it worth his while to include among the rich booty which he carried away with him from India, and so were not doomed to be looted by an ignorant soldiery at a later date, as were the remnants of the Imperial Library in Dihlī and the Royal Library in Lucknow. Nādir Shāh's stolen volumes, after their long journey across the plains of India and the mountains of Afghanistan, safely reached their destination in Harāt;[1] but how often did such good fortune befall the precious manuscripts that formed part of the loot of other armies? Abandoned by the wayside, or thrown carelessly away, many a precious manuscript must have perished in this fashion, while those that were left behind in the ruined castle or palace suffered such a fate as befell the MSS. of the monastery of Pantocratoras, as described by Robert Curzon in his *Monasteries of the Levant*.[2] 'I went', he says, 'to look at the place, and leaning through a ruined arch, I looked down into the lower story of the tower, and there I saw the melancholy remains of a once famous library. . . . It was indeed a heart-rending sight. By the dim light which streamed through the opening of an iron door in the wall of the ruined tower, I saw above a hundred ancient manuscripts lying among the rubbish which had fallen from the upper floor, which was ruinous, and had in great part given way.' He managed to extricate two or three, 'but found that the rain had washed the outer leaves quite clean: the pages were stuck tight together into a solid mass, and when I attempted to open them, they broke short off in square bits like a biscuit. Neglect and damp and exposure had destroyed them completely.'

[1] Sir Percy Sykes, *History of Persia*, 2nd ed., Vol. II, p. 263. [2] pp. 360-2 (4th ed., London, 1851).

Such a report might have been given of many a Muhammadan library, if any observer had cared to record its fate. The history of most Muhammadan countries is filled with the record of continuous warfare; one dynasty succeeds another, and the founder of a new kingdom has to reward his victorious army by giving over the conquered capital to plunder.

The destruction of perishable works of art on such occasions, which occur throughout the course of Muhammadan history with monotonous frequency, must have been enormous. What treasures must have perished when Maḥmūd of Ghaznī in A.D. 1029 destroyed the greater part of the Buwayhid library at Rayy! For since the founder of the dynasty, Buwayh, is believed to have been a descendant of the ancient kings of Persia, national sentiment may even have conserved examples of Sasanian art in this royal library. What he did not destroy, Maḥmūd carried off to his own capital, but all his accumulated treasures perished when Ghaznī was in its turn plundered and burnt in 1150 by the Ghorid chief, 'Alā ad-Dīn Ḥusayn, who earned his nickname of Jahānsūz, 'the burner of the world', by this exploit.

But there are two conquerors whose devastations were above all others responsible for the wholesale destruction of Muhammadan manuscripts—Chīngīz Khān, and his grandson, Hulāgū. A Muhammadan soldiery might possibly have been able to understand that a manuscript had some commercial value, but the savage Mongols had the same contempt for Muhammadan books as they had for Muhammadan men of learning, and it is characteristic of their attitude to all that the followers of Islam held most sacred, that when the Mongols sacked Bukhārā in 1220 they stabled their horses in the great mosque and tore up the manuscripts of the Qur'ān to serve as litter for their horses.[1] The thoroughness of the destructive methods of the Mongol conquerors has seldom been equalled in history; after massacring the inhabitants and burning the city of Jurjāniyyah in 1219, the Mongols opened the dikes and submerged the site under the waters of the Oxus. They so utterly destroyed the city of Bāmiyān, that for a hundred years afterwards it remained deserted and uninhabited. In 1220 they razed the city of Nīshāpūr, one of the most populous in Khurasan, to the ground, and sowed the site of it with barley. A similar fate befell Baghdad when Hulāgū captured it in 1258; 800,000 of the inhabitants were ruthlessly massacred, and the city was given over to the savage soldiery for a whole week to be plundered.

Baghdad had been the capital of the Abbasid Caliphs for nearly five centuries, and though for a long period it had grievously fallen from its former

[1] Professor Browne gives a long list of the cities which were destroyed by the Mongols (*Literary History of Persia from Firdawsī to Saʿdī*, p. 446).

high estate, still, of the treasures that had at one time poured into it from all parts of the vast Muslim empire, much in the way of pictures and manuscripts may well have survived up to the middle of the thirteenth century, and in the sack of the city by the Mongols many treasures of art must have perished. Another wave of calamity poured over such centres of Muhammadan culture in Persia and Central Asia as had managed to emerge into new life after the storm of the Mongol invasion, when in the latter part of the fourteenth century Tīmūr set out on his career of conquest, inflicting on a new generation the miseries that had marked the devastating progress of the Mongols. Such wholesale methods of destruction implied the loss also of those wall-paintings which appear from certain historical indications to have been a distinctive feature of the decoration of the palaces of Muhammadan sovereigns at that period.

But even when the works of the painters had managed to escape from the catastrophic ruin that accompanied the convulsions of political life, there was still another peril, more intimate and persistent even in times of profound peace, namely, the bigotry of pious owners or others who had an opportunity of destroying the pictures which current orthodox opinion regarded with detestation. Many a picture has met its doom at the hands of some Muhammadan Savonarola and been condemned to perish in a 'bonfire of vanities', especially when they have been works of erotic art, to which the stern puritanical feeling of orthodox Islam has been more persistently hostile than has been the case in Christian Europe. The widely prevailing condemnation of pictorial representations of living beings (to which reference has been made in the preceding chapter), taught by every theologian and accepted by the majority of the faithful in most parts of the Muhammadan world, must be held responsible for the total destruction or partial mutilation of countless works of art. Sultan Fīrūz Shāh, one of the noblest figures in the history of Muslim India of the pre-Mughal period, has put on record, in his *Victories* (an autobiographical sketch of such of his achievements as he regarded as redounding to his credit), how he ordered all pictures and portraits which had been painted on the doors or walls of his palaces to be effaced, and 'under the divine guidance and favour' even had all figured ornaments removed from such objects as saddles, bridles, and collars, from censers, goblets, and cups, from dishes and ewers, and even from tents, curtains, and chairs.[1] Such action on the part of this pious monarch of the fourteenth century is doubtless typical of many an instance of pricking of conscience in Muslims who have suddenly waked up to the realization of the fact that

[1] Sir H. M. Elliot, *The History of India as told by its own Historians*, Vol. III, p. 382.

they were harbouring in their houses the unclean thing. Some were even ready to go farther, if we may believe the story told of the pious Umayyad Caliph, ʿUmar ibn ʿAbd al-Azīz (717–720), who, finding a picture in a bathroom, had it rubbed out, adding, 'If I could only find out who painted it, I would have him well beaten'.[1]

Even when pictures have not been entirely destroyed, their beauty has often been spoiled by a similar fanatical iconoclasm; e.g. features are frequently found to be erased, while the rest of the picture is left untouched, regardless of the fact that the beauty of the whole has thereby been ruined. In the collection of the illustrations of the Amīr Hamzah Romance in the Indian section of the Victoria and Albert Museum, the faces of men and women—in some cases also those of animals—have been roughly scored through, to the great damage of these imposing compositions. Such examples of fanatical mutilation are of frequent occurrence. Generally it is the human countenance as such for which such cruel treatment is reserved, but sometimes the iconoclast is more selective and expresses his righteous indignation in regard to the representation of particularly holy personages; e. g. in the MS. of al-Berūnī's great work on *Systems of Chronology*, in the Library of the University of Edinburgh, any excision of human faces would have implied the mutilation of every single picture in the book, but the wrath of some former possessor or reader must have been excited by the sight of a portrait of the Prophet (fol. 111)—which, for obvious reasons, is rare in Muhammadan art—so he scraped off all the paint from the face, down to the white surface of the paper, though (strangely enough) there are two other portraits of the Prophet in the same MS. (foll. 7ᵇ and 193) which have escaped such rough treatment, as well as portraits of other Prophets such as Adam, Abraham, Isaiah, and Jesus. A curious instance in which a sense of property has exercised a certain restraint upon religious zeal occurs in a Persian MS. in the India Office Library (no. 1129 (Ethe 982), fol. 29). This book contains a selection of passages from Nizāmī's writings, dealing with the theological and ethical virtues, and is calculated to make an appeal to a devout mind having a tendency towards mysticism; this particular copy is a fine piece of calligraphy, and each page of the manuscript is beautifully decorated with gold and colours, among which a pale blue predominates. Unfortunately for the tender conscience of the whilom owner the manuscript contained one picture (and only one) representing a group of persons seated in the open on a piece of ground dotted about with scattered flowering plants, each with a single flower or two. To cut out the picture would have

[1] Ibn al-Jawzī, *Manāqib ʿUmar ibn ʿAbd al-ʿAzīz*, ed. C. H. Becker, pp. 46–7 (v. Appendix B).

implied the destruction of a portion of the text, nor could the picture be erased without spoiling the aesthetic appearance of the page of which it formed a part; so the owner salved his conscience and got out of his difficulty by employing a painter to render the picture harmless by continuing the landscape over the heads and faces of the men forming the group, so that only a number of headless trunks remains, and where heads might have been expected, nothing but flowers and leaves is to be seen (Plate VII).

Such mutilation of the artist's work has not always been prompted by so devout a motive, and the dirty smear of colour over what is otherwise a masterpiece of the painter's art is sometimes the result of a wer finger being drawn over the painted surface. For such wanton injury the women of the household are probably to be held responsible. In Persia and India it has often been a practice to keep precious manuscripts in the zenana,[1] as being the most inviolable part of the building, and the women have not always proved to be the wisest guardians of these irreplaceable treasures. To such profane hands is probably also due damage of another kind, namely, the clumsy addition of black lines, to indicate the features and outlines of a form, such as often mar the beauty of an early masterpiece.

But even when the Muhammadan picture has succeeded in escaping the various forms of destruction that threaten its existence, or the many ways in which the beauty of its delicate surface may be injured, the student of this art is still faced with many difficulties peculiar to the special circumstances of the case. It is probably largely due to the prevailing attitude of contempt with which orthodox society in the Muhammadan world viewed the painter and his work, that the modern student has so little material beyond the pictures themselves for determining the date and place of origin, for assigning a picture to any one particular school or to the activity of any one particular artist—even in such cases in which there are some means of ascertaining the names of any painters at all for the period or country concerned. For though biography is one of the earliest manifestations of literary activity in the Muslim world, it was not until the beginning of the tenth century of the Muhammadan era that any attempt was made to provide biographical details regarding the painters; before that period we have the names of one or two isolated painters, but know nothing whatever about them except their names.

If the painter happened at the same time to be a calligraphist or chanced to indulge in the common recreation of the cultivated Persian gentleman

[1] Even some of the manuscripts of the Emperor Akbar's library were kept in the harem (Abu 'l-Fazl, Ā'īn-i-Akbarī, translated by H. Blochmann, Vol. I, p. 103).

and have written verses, he might thereby find mention in some collection of notices of poets or fine writers, and thus win for himself a fame that his paintings would never have succeeded in gaining for him. To the later sources for the biographies of Muhammadan painters reference will be made in Chapter X.

Some historical indications are occasionally to be found on the pictures themselves, but the signatures are often forged and the ascriptions to particular artists can only be accepted after all the evidence of style, colouring, &c., have been carefully weighed. This is particularly the case when the picture occurs on a separate piece of paper by itself or in an album along with others; but an equal amount of care has to be observed even when the pictures are found as illustrations of a manuscript. At first sight it might appear that some indication would be given by the date of the manuscript, if (as often happens) the copyist has written in the colophon the year in which he completed his task, or even added the name of the city in which he worked (though this added information occurs more rarely), or, in the case of an undated manuscript, by such indications as to date and provenance as are supplied by the character of the handwriting or the peculiar nature of the paper. But the large number of MSS. to be found in every oriental library containing blank spaces for pictures that were never painted, shows how rash it is to assume that the date of a manuscript is sufficient by itself to determine the date of the pictures that may be found in it.[1] Any length of time may elapse between the writing of the manuscript and the filling up of the blank spaces left for pictures, and since the time when wealthy collectors have begun to manifest an interest in Persian painting, modern forgers have got hold of manuscripts with such empty spaces and have filled them in with imitations of earlier work—in some instances with a considerable amount of skill, but in others it is clear that the modern imitator has had neither the time nor the patience of his predecessors, for his work lacks the delicacy and the marvellous detail of the earlier work which it lays claim to represent.

Fortunately, many manuscripts which would have provided opportunities for such fraudulent proceedings had been safely deposited in public collections, long before high prices tempted the modern dealer. An example may be taken from the British Museum, in which there is a beautiful MS. of the Turki Dīwān of Nawā'ī[2] (Or. 1374), which there is reason to believe was a copy made for presentation to his royal master; there is on fol. 40 three-

[1] Moreover, the date in the colophon of a MS. may sometimes be that of the original MS., which the calligrapher has faithfully copied out to the last letter.

[2] The poetical name of Mīr 'Alī Shīr: see p. 34.

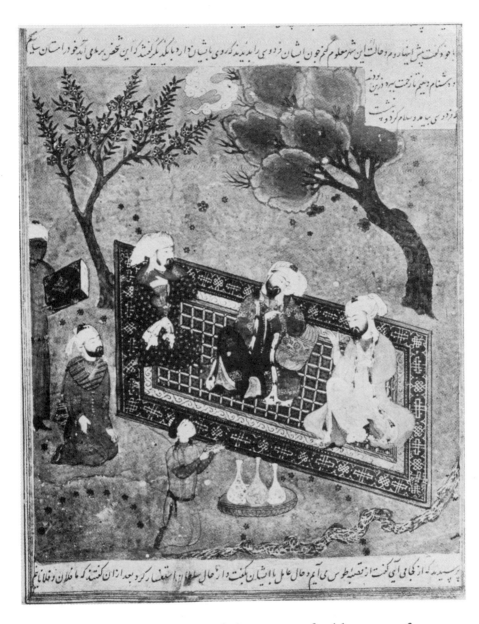

VI. Prince Baysunqur being presented with a copy of
the *Shāh Nāmah*

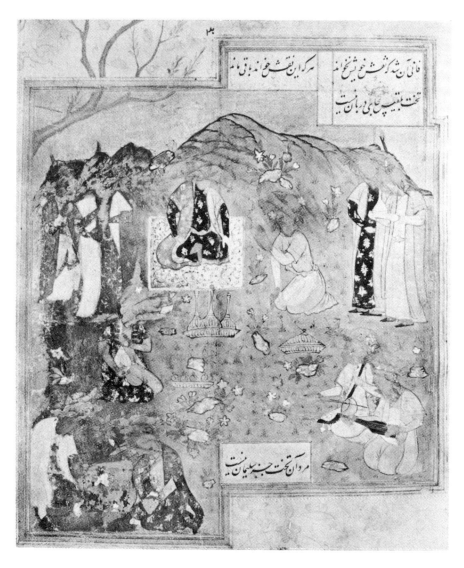

VII. Picture mutilated by an owner troubled by religious scruples

quarters of a page left blank for a picture; at any time in the four centuries that have intervened since the copyist completed his task, a painter might well have been asked to fill up the vacant space. Such an opportunity was given to Muḥammad Zamān in 1675, to put some of his workmanship side by side with the pictures by the greatest masters of the reign of Shāh Ṭahmāsp (1524-1576); in the superb copy (Or. 2265) of the _Khamsah_ of Nizāmī, the copying of which occupied the great calligraphist Shāh Maḥmūd Nishāpūrī from 1539 to 1543, there were three blank spaces left unfilled for over a century. The difference in colouring, style, and composition between the later work by Muḥammad Zamān, fresh from his training in Rome, and that of the genuinely Persian work of his predecessors strikes the eye at once. In this manuscript, both Muḥammad Zamān and some of Shāh Ṭahmāsp's artists have dated their pictures, but how frequently work of different periods in the same manuscript lacks any such indications.

But even when pictures have written upon them the name of an artist, the difficulties of the student are not at an end. The paintings of Bihzād may serve as an illustration. Having got hold of the name of an outstanding personality, the student might delude himself with the expectation that, so far at least as this master's work is concerned, he can occupy himself with the study of some definite body of material; but now comes in the puzzling problem of determining which are the genuine works of Bihzād. He appears to have sprung into fame at once, and to have received the enthusiastic recognition of his contemporaries, for it is to them that we owe—rather than to any Vasari of a later epoch—practically all that we know about this master. He soared to such heights of renown that his name came quite early to be used as a familiar term of praise applied to any painter of distinction, and the phrase 'with a brush like that of Bihzād' came into as common use as the earlier phrase 'with a brush like that of Mānī'. Consequently every prince with a taste for painting wished to possess examples of the work of this great master, and could easily find a complacent librarian who would add to some fine miniature in his royal patron's library the honoured name of Bihzād. So, just as every self-respecting picture-gallery in Europe in the eighteenth century liked to boast that it possessed some canvas painted by Michelangelo, so in the Muhammadan East the royal collector, whether Persian, Uzbeg, Turk, or Indian, was proud in the possession of a picture bearing the name of the most famous painter that Persia has ever produced.

As may easily be expected, there were not wanting numerous persons ready to satisfy such a demand, and the name of Bihzād is consequently one of the commonest found on paintings from the sixteenth century onwards;

and this forging of his signature is not confined to a period close to the life-time of the painter or to pictures that bear some resemblance to the products of his brush, but can be illustrated through each succeeding century down to the twentieth; and not in the case of Persian pictures merely, but forgers could so confidently assume a lack of any critical faculty or of any acquaintance with the true characteristics of Bihzād's work, that even late Indian painting of execrable quality has been fathered upon him. His name has sometimes even been written at the bottom of a picture, though the real artist had taken the trouble to sign his name at the top. The clumsiness of these forgeries and the lack of any intelligent appreciation of the real qualities of Bihzād's art are demonstrated not only by his signature being foisted on work that is entirely undeserving of notice, but also by the fact that no single forger appears to have taken the trouble to study the undoubted examples of Bihzād's signature. For it was the practice of this painter, on the rare occasions when he did sign his work, to write his name in microscopical characters in some obscure part of the picture, e.g. the flap of a saddle, in the water of a duck-pond, &c.[1]

The difficulties that present themselves owing to the lack of the signatures of the artists are paralleled by the absence in most cases of any indication as to the subject-matter of a picture. It was not customary for a Persian painter to write any title under his painting, even if it occurred in a separate and detached form on a single piece of paper; if it was in a manuscript, presumably the reader of the text was expected to be able to connect the pictorial representation with what he was reading, and in the case of an epic like the *Shāh Nāmah* or the romantic poems which were most commonly illustrated, little difficulty was likely to occur; but, when the picture had been painted on a separate piece of paper, there was often no clue whatsoever as to the subject which it was the intention of the painter to illustrate. Similarly, there are innumerable portraits of nameless historical personages, the identification of whom is now impossible, or at least has not up to the present been achieved. Such separate pictures have in a large number of instances been put together in albums—a practice which is as old as the end of the fifteenth century, as is evident from the preface[2] that Khwāndamīr wrote to the album of paintings by Bihzād. In some instances a later owner has become dissatisfied with the anonymity of the contents of his album and has had titles invented for them, and as these in the majority of cases appear to have been selected on no other principle than that of enhancing the value and importance of the collection,

[1] A. V. W. Jackson and A. Yohannan, *Catalogue of the Collection of Persian Manuscripts, Metropolitan Museum of Art, New York*, p. 78 (New York, 1914). [2] See pp. 35–7.

the result has been a source of perplexity, if not of amusement, to the modern student. One of the most ludicrous examples of such arbitrary denomination is that of a picture in an album[1] in the Royal Library, Cairo, which received the title 'Adam and Eve', and was attributed to Mānī, a court painter of Shāh 'Abbās, and as such has been reproduced in several publications; but the picture refuses thus to come within the circle of Islamic orthodoxy, and to any one acquainted with the characteristics of Indian painting it reveals itself as the god Krishna with his wife Rādhā standing under a mango tree in the rainy season. In another album (Bibliothèque Nationale, Arabe 6075) there are similarly misleading denominations derived from a desire to enhance the value of the collection by assigning to the pictures a much earlier date than they originally claimed for themselves; e.g. a group of Indian grandees of the sixteenth century is designated 'Hārun ar-Rashīd, Ma'mūn, and the Barmecides', and is attributed to Bihzād, though centuries had elapsed between the two periods.

One of the most urgent desiderata in the history of Muslim painting is the settlement of the problem as to which of the pictures bearing the name of an artist are authentic, and the definition of the main characteristics of his style. At present much confusion exists in regard to such matters, and there is no agreement even among the highest authorities. A critic is needed who will do for Muslim pictures the work that Morelli did for the Italian galleries in the nineteenth century.

[1] Al. Gayet, *L'art persan* (Paris, 1895), p. 293.

III

THE ORIGINS OF PAINTING IN THE MUSLIM WORLD

FOR the reasons set forth in the preceding chapters, examples of pictures from the earlier periods of the Muhammadan era are exceedingly rare, and there is no distinct evidence that any artist of native Arab birth made any contribution whatsoever to painting. The Arabs appear to have had very little feeling for either plastic or pictorial art. The wandering life of the desert was certainly uncongenial for the activities of either the sculptor or the painter, and the culture of the dwellers in such few towns as Arabia could boast of was largely influenced by the artistic and intellectual outlook of the Bedouins. The scanty remains of Sabaean and other pre-Islamic art in Arabia show how crude were the representations of their divinities, though in some of their bronze work lively representations of animal forms were achieved.

The gods of the Arabs at the period of the birth of Muḥammad received little in the way of artistic treatment, for the Arabs at this period seem to have been content with shapeless blocks of stone as symbols of the divinities they worshipped, and whenever they did spend any artistic effort upon them, it was of a meagre character. The image of Dhu 'l-Khalaṣa, which stood seven days' journey south of Mecca, was a white stone with a kind of crown worked upon it.[1] Al-Fals, who was worshipped by the Banū Ṭayy, was a mere projection in the middle of a hill, bearing a rough resemblance to the figure of a man.[2] Al-Jalsad was a white stone like a human trunk with a kind of head of black stone; if one looked closely at it, one could make out some slight resemblance to a human face.[3] One of the idols in the Ka'bah at Mecca, named Hubal, was of red carnelian in the form of a man. This deity was an importation, and indeed two of the three [4] Arabic words used in the Qur'ān for an idol—*wathan* and *ṣanam*—are foreign words, and it is probable that such artistic activity as was devoted to the plastic representations of them was likewise of foreign importation.

But when in the seventh century the Arabs poured out of their deserts over the centres of a culture new to them, in the Roman and the Persian empires, they found gratification in painting as in other novel experiences which appealed to the frankly pagan spirit with which many of them were still animated, in spite of their conversion to Islam. Their conquests of

[1] Wellhausen, *Reste arabischen Heidentums*, p. 45 (Berlin, 1897).
[2] Id., pp. 51–2. [3] Id., p. 54. [4] The third is *timthāl* (likeness).

Syria, Mesopotamia, Persia—of Egypt, North Africa, and Spain—brought them into contact with races that had inherited an ancient artistic tradition, and the new rulers soon learned to appreciate the abilities of their subjects and to make use of their talents, not only in forms harmonious with the spirit of the faith of Islam, but also in ways directly opposed to its teachings. For, devoid of any creative artistic activity of their own, the early Muslim Arabs had to seek the help of others, and consequently the beginnings of what is commonly called Arab art are of foreign origin and derive their source from centres of artistic activity unconnected with Arab culture. To artists among the subject races the Arab aristocracy in the seventh century must have turned when they wished to decorate their houses with frescoes,[1] and when mention is made of a portrait of a Persian king or of an icon of the Virgin Mary[2] being found in the house of one of the new rulers, it may safely be assumed that the painter was no Arab. Again, when in the eighth century the Caliph Walīd (705–715) wished to rebuild the mosque in Medina, he had to ask the Emperor Justinian II to send him workmen competent for such an undertaking, together with materials for mosaic work;[3] and in Mecca the porticoes round the sacred enclosure of the Ka'bah, erected by the Caliph Mahdī (775–785), were decorated with mosaics by workmen who were specially imported from Egypt and Syria for the purpose, and their signatures were still to be seen on their handiwork towards the end of the tenth century.[4]

The artists that contributed most to the production of the works of art of the Muhammadan period are, first, the foreign workmen called in from Byzantine territory, and, next, such subjects of the Muslim empire as had inherited from their ancestors methods and forms of artistic activity cultivated before the advent of the Arabs. To the latter group belong the Christian subjects of the conquered provinces and such of their descendants as after their conversion to Islam may have carried with them into their new faith the aesthetic traditions of their fathers; the Persians, who likewise cherished as part of their national inheritance the artistic traditions of their ancestors, in spite of the fact that they had passed under an alien rule; the Manichaeans, who for special reasons connected with the history of the foundation of their

[1] Maqdisī, *Aḥsan at-taqāsīm*, ed. De Goeje (*Bibliotheca Geographorum Arabicorum*, Vol. III², p. 73 (ll. 4–5), Leiden, 1906).

[2] Ibn Ḥanbal, *Musnad*, Vol. I, p. 375 (ll. 8–6 *ad fin.*): 'Muslim ibn Ṣabīḥ said, I was with Masrūq in a house in which there was a representation of Mary, and Masrūq said, That is a representation of Khusrau. But I replied, No! it is a representation of Mary. Then Masrūq quoted the saying of Muḥammad that those who will be most severely punished on the Day of Judgement will be the painters (or image-makers).' [3] Maqdisī, *op. cit.*, p. 81. [4] Id., p. 73 (ll. 4–5).

faith and their peculiar religious observances, cultivated the art of painting; and, finally, the people of Transoxania, who had an art of their own long before the faith of Islam was brought across the Oxus, and had cultural relations with the East and especially with the Buddhism of Central Asia. Each of these gave its own contribution to the sum total of what is known as Muhammadan painting, for this art was no creation of any specifically Islamic culture, but was a development of the forms of art cultivated under the systems of civilization prevailing before the Arab conquest or still cultivated after that period by some of the conquered communities as part of their corporate culture, and now adapted to the special needs and circumstances created by the new faith, with its distinctive outlook upon life.

The Christian subjects of the Arab empire played an important part in the development of Muslim culture. Von Kremer and Tor Andrae have pointed out their influence on the development of Islamic dogma, and Goldziher and Snouck Hurgronje have shown how largely dependent upon them were the early beginnings of Muslim law. Their influence in the realm of art is not so easy to determine, inasmuch as the material is neither so obvious nor so abundant; but evidence has already been quoted to show that Christian artists worked for their Muhammadan masters in the early days of Islam, and they doubtless continued to do so in succeeding generations. The Mosul workers in bronze, of a later period, appear also to have been mainly Christians.[1]

Unfortunately, statistics are almost entirely lacking for the extent of the Christian population of the Muslim empire, but some estimation of its great numbers throughout the Umayyad and Abbasid periods may be formed from a consideration of the large native Christian populations which the Crusaders found upon their arrival in Muhammadan territories, and from the predominant position the Christians assumed in several cities after the Mongol conquests in Mesopotamia and Syria had depressed the former Muslim governments. In the tenth century there were between 40,000 and 50,000 Christians in the city of Baghdad,[2] and many other cities in the empire contained flourishing Christian communities. The majority of the officials in the government offices—even down to modern times—were Christians,[3] and though complaints were violently expressed from time to time that the Muslims were ruled by the Christians even in their own empire, and though attempts were made to deprive them of all official appointments, yet their

[1] E. Diez, *Bemalte Elfenbeinkästchen und Pyxiden der islamischen Kunst* (*Jrb. d. Kgl. Preus. Kunstsammlungen*, Vol. XXXII, p. 140).
[2] A. Mez, *Die Renaissance des Islams*, p. 35 (Heidelberg, 1922). [3] Id., p. 40.

superior aptitude always led to their being reinstated, and there have been occasions when Christians have been found among the highest officers of the Crown. The long lists of metropolitan sees and bishoprics belonging to the rival Churches of the Jacobites and the Nestorians give some indication of the extent of the Christian population, and the enormous expansion of the Nestorian Church after the period of the Mongol conquests is significant of the vigour and, presumably, wealth which this Church had preserved during the six previous centuries of its existence under Muhammadan rule; e. g. the Nestorian Patriarch, Yaballaha III (1281–1317), had under his jurisdiction as many as twenty-five metropolitans in Persia, Mesopotamia, Khurasan, Turkistan, India, and China.[1]

There must have been a considerable art activity connected with the life of ecclesiastical systems so widespread and so well organized, and there is evidence to show that large sums of money were sometimes spent on the decoration of churches; e. g. in 759 the Nestorian bishop, Cyprian, expended a sum of 56,000 dinars (gold coins) on the building of a church in Nisibis,[2] and when in 924 the mob in Damascus plundered a Christian church of that city the value of the loot, in the shape of crucifixes, chalices, censers, &c., amounted to the vast sum of 200,000 gold dinars.[3] In a church into which such enormous wealth had been poured in the shape of articles made of precious metals, painters must also have been employed to exercise their art either upon wall decoration or upon the adornment of service books. It is not easy to obtain historical evidence as to the extent of the wealth of the Christian community, but the protests of Muhammadan travellers against the ostentatious exhibition of wealth by Christians in the cities they visited provide some indirect information on the matter, and we happen to have some figures as to the income of a distinguished Nestorian Christian, named Gabriel, who was the personal physician of the Abbasid Caliph Hārūn ar-Rashīd (786–809); he derived a yearly income of 800,000 dirhams from his private property, in addition to a salary of 280,000 dirhams a year in return for his attendance on the Caliph. The second physician, also a Christian, received 22,000 dirhams a year.[4]

The most flourishing Churches in the Muhammadan East under the Abbasid Caliphate were the Nestorian and the Jacobite, as was natural in a period when adherence to the Orthodox Eastern Church, the Church of

[1] A. Fortescue, *The Lesser Eastern Churches*, p. 98 (London, 1913).
[2] F. Baethgen, *Fragmente syrischer und arabischer Historiker* (*Abh. für die Kunde des Morgenlandes*, Vol. III, no. 3, p. 128).
[3] A. Mez, *Die Renaissance des Islams*, p. 50.
[4] A. von Kremer, *Culturgeschichte des Orients unter den Chalifen*, Vol. II, p. 181.

the ancestral enemy over the western border, the Roman empire, might excite a suspicion of disloyalty to the Caliph. But this latter Church was undoubtedly also represented within the borders of the Muslim empire, and among the many captives brought in after the annual raids of the Caliph's troops into Byzantine territory, there may quite possibly have been some painters who found in the exercise of their art a means of winning the favour of their captors. In the reign of Mahdī (775–785) a church was erected in Baghdad, merely for the use of the Christian prisoners who had been taken captive in the constant campaigns against the Roman empire,[1] and the fact that they needed a church of their own would seem to suggest that they belonged to the Orthodox Church, since there were Jacobite and Nestorian churches in abundance in Baghdad, and monasteries in almost every quarter of the city.[2] Barhebraeus, the great Jacobite bishop (ob. 1286), employed artists belonging to the Orthodox Church to work for him,[3] and Muslim princes and nobles may well have extended to them a similar patronage. What enthusiasm might be felt for Byzantine art may be judged from a passage in the *Kitāb al-Buldān*, by Ibn al-Faqīh al-Hamadhanī, who wrote just at the beginning of the tenth century; speaking of the Romans, by whom of course he meant the Byzantines, the people of the Eastern Roman empire, he describes them as the most skilful painters in the world: 'One of their painters can paint a man in such a way as to leave out nothing; he is not content until he has made it clear that it is a youth or a man of mature age or an old man; even then he is not content until he has made him handsome and attractive; then he goes on to make him look joyful or weeping; further he makes a difference between the grin of a man who is rejoicing over the affliction of his enemy and the giggle of one who is ashamed, between one who is plunged in sorrow and one who is smiling, between gladness and the grin of one who is talking nonsense; and in this way he varies the composition of his pictures.'[4]

But the most obvious intermediary through which the classical traditions embodied in Christian art passed into the painting of the Muhammadan East is the pictorial art of the Nestorian and Jacobite Churches, and the painters who first worked for the Muhammadan conquerors were probably members of one of these two Churches which had attracted to themselves the main body of the oriental Christians living under Muhammadan rule, and had indeed even before the coming of the Arabs counted among their adherents the majority of the Christian populations of the oriental provinces of the

[1] Yaqūt, *Mu'jam al-Buldān*, Vol. II, p. 662. [2] A. Mez, *Die Renaissance des Islams*, p. 40.
[3] A. Fortescue, *The Lesser Eastern Churches*, p. 331.
[4] Ed. De Goeje (*Bibliotheca Geographorum Arabicorum*, Vol. V, pp. 136–7).

Roman empire, as a result of their detestation of the foreign ruler in Constantinople and of their abhorrence of the heresies taught by the State Church.

No separate study has yet been devoted to the paintings produced by the adherents of these two Churches, and such scanty remnants of their pictorial art as can with absolute certainty be assigned to them belong exclusively to ecclesiastical art, and naturally the subjects of such pictures are not such as could be immediately transferred to the secular art of the followers of another faith. But it seems more than probable that either Nestorian or Jacobite painters were among those who were employed by the Muhammadan conquerors to produce those earliest works of art that have come down to us. To this group would seem to belong the artists who painted the frescoes at Quṣayr ʿAmra; they certainly could not have been Arabs, since the Arabs had no artistic traditions capable of reaching such a degree of attainment in the beginning of the eighth century. It has been supposed that they were Greeks, or at least subjects of the Byzantine emperor, for they wrote the names of the historical and allegorical personages that formed part of the pictorial decorations of this building in Greek; thus (according to Professor Becker's reading[1]) we have

[ΚΑΙ]ϹΑΡ ΡΟΔΟΡΙΚΟ(Ϲ) ΧΟϹΔΡΟΙϹ ΟΝΑΓ . . .

i.e. Caesar . . . Roderic . . . Khusrau . . . the Negus (of Abyssinia) . . . representing contemporary monarchs, and

ΝΙΚΗ ϹΚ[Ε]ΨΗ[Ϲ] [Ι]ϹΤΟΡΙΑ ΠΟΙΗϹΙϹ

as symbolical figures.[2] But the same eminent scholar is of opinion that the painters knew Arabic better than Greek, for the inscriptions over the heads of the historical figures are bilingual, and while the Arabic letters are obviously formed by some one accustomed to write Arabic, and in the case of one name كسرا the scribe has written the word as he heard it pronounced, not as strict orthography and consistent usage demand that it should be spelt, the Greek letters, on the other hand, appear to have been first traced in a different colour, and to have been copied from some pattern set before the artist. Professor Becker therefore concludes that the painters belonged to some Aramaic stock, coming either from Mesopotamia or settled in Syria.[3] Though the influence of Hellenistic art is obvious throughout the whole building, there are other elements that are distinctly oriental, especially the style of the ornament, the hunting scenes, and the type of some of the female figures.[4]

[1] C. H. Becker, *Das Wiener Quṣair ʿAmra-Werk* (*Zeitschrift für Assyriologie*, Bd. XX, p. 369) (Strassburg, 1906).　　[2] Id., p. 361.　　[3] Id., pp. 362–3.　　[4] Id., p. 378. (See also below, Chap. VIII.)

Similarly, the frescoes of Sāmarrā, painted between A.D. 836 and 883, suggest the workmanship of Christian painters, not only because of the Christian priests which form the subject of the design, but also because of the signatures of the artist.[1]

To such Christian painters are probably also ultimately to be traced the illustrations in thirteenth-century manuscripts of *Kalīlah wa Dimnah* and of the *Maqāmāt* of Ḥarīrī. The group of stories which is embodied in the first of these two has probably had a wider circulation and has been translated into more languages than any other work of secular literature in the ancient world; it was known to Christian readers nearly two centuries before it passed into the literature of the Muhammadan world, for it was translated into Syriac about A.D. 570 by a Nestorian ecclesiastic, whereas the first Arabic translation was not made until 750 by Ibn al-Muqaffaʿ. From this Arabic text a later Syriac version was made by another Nestorian priest either in the tenth or eleventh century. This collection of stories had therefore been well known in Christian circles for a long time before their Muhammadan rulers wanted to have it illustrated. The other book, though the work of a Muhammadan writer who was at pains to vindicate his orthodoxy, was likewise a collection of stories, mostly of a frivolous character, and capable of attracting educated Christian readers as much as Muslims. For the illustration of both of these books, therefore, Christian artists might well have been employed, without prejudice to their faith, and their artistic conventions and illustrative methods might well have passed on to such of their descendants as entered the pale of Islam, or even to such Muslims who themselves cared to adopt the profession of the painter. The artistic style would remain unaffected by change of faith. These pictures have often been described as belonging to the Baghdad or to the Mesopotamian school, but such a geographical designation has scanty warrant and fails to recognize the distinctive character of the style of painting. A comparison of them with illustrations in the service books of the Nestorian and the Jacobite Churches reveals the existence of a number of common features. In the first place, mention may be made of a curious convention, which occurs in the Schefer MS. of Ḥarīrī,[2] of indicating the outline of the nose by a prominent line of white paint; the same convention occurs also in a copy of the Gospels in Arabic in the British Museum (Add. 11856, fol. 95 b). In a Lectionary of the Jacobite Church, probably written in the thirteenth century (B.M., Add. 7170, fol. 145), there is a picture of Christ before Pilate, in which there

[1] E. Herzfeld, *Die Malereien von Samarra*, p. 91.
[2] Bibliothèque Nationale, Arabe 5847.

is a group of persons whose type of features, with large prominent noses and a heavy cast of countenance, exactly corresponds to that of the figures in these Ḥarīrī MSS.; in both cases the attitudes and the costumes represent a similar type (Plates VIII and IX). In the same Lectionary (fol. 7) as well as in an Arabic Evangeliarium (B.M., Add. 7169, fol. 12 b), probably of the twelfth century, we find the same conventional representation of a tree, probably intended for a cypress, as occurs in the Schefer MS.

Similarly, from the rough drawings given in a description[1] of an Arabic MS. (dated 1299 and of Mesopotamian provenance) of the Apocryphal Gospel of the Infancy of Jesus which is preserved in the Laurentian Library, Florence, there would appear to be several characteristics common to the pictures in this Christian MS. and the contemporary illustrations of the *Maqāmāt* of Ḥarīrī; e. g. there are robes covered with the same large patterns, made up of convoluted, conventionalized flowers and stems, and the angels have long pointed wings, which are very narrow at the end where they are joined on to the shoulder-blade[2]—in striking contrast to the broader base usual in Western religious art.

Seeing that the relations of the Jacobites and the Nestorians with their Muhammadan rulers were much more intimate than were those of any other group of Christians, it seems much more plausible to look for the origin of this form of Christian art, as applied to Muhammadan book-illustration, in these Christian communities that lived in the midst of the Muslim population, spake the same language, and were often of the same ethnic stock, rather than in Byzantine art, though ultimately both forms of Christian art might be traced back to the same original source.

The use which the Arab rulers made of the Christian artists who were their subjects was probably much greater than can be illustrated by the meagre amount of the survivals. Of frescoes, only those in Quṣayr 'Amra, and the fragments recovered by Professor Herzfeld from the ruins of Sāmarrā, have survived. Of paintings in manuscripts, the illustrations of at least the earlier copies of such books as the *Maqāmāt* of Ḥarīrī, *Kalīlah wa Dimnah*, and various works on mechanical science, astronomy, and botany, may with some degree of probability be traced back to Christian sources—though it is not necessary to assume that the actual painting was in every case done by Christians, since the traditional forms of representation may well have been carried on by the Muslim descendants of Christian converts to Islam or have been copied by later imitators of an entirely different stock.

[1] By E. K. Redin (*Imperatorskoe Russkoe Archeologicheskoe Obshchestvo, Zapiski*, Vol. VII, pp. 57–71, St. Petersburg, 1895). [2] *Op. cit.*, pp. 61, 64, 71.

As regards carpets, a Christian origin may with some degree of certainty be claimed for the so-called carpets of Ḥīra—once a city with a large population of Nestorian Christians—on which were woven patterns of elephants, horses, camels, lions, and birds.[1] Another form of artistic activity may also very possibly have been in part at least the creation of Christian workmen, namely, the paintings on the pottery of Rayy,[2] which in the tenth century was said to have been the finest city in the whole East, with the exception of Baghdad. Like the capital, it probably contained a considerable Christian population;[3] it was at one time the seat of a Nestorian metropolitan, but in the eleventh century it was for purposes of ecclesiastical administration joined to Ḥulwān, and after 1175 to the metropolitan see of Hamadān, which was much nearer to Rayy. The abundant output of the pottery of Rayy, with its figured decoration of princes, knights, singing-girls, dancers, and musicians, at a period when orthodox Muslim opinion was so powerful and there is little evidence of the existence of any Muhammadan artist engaged in painting figures, makes it difficult to ascribe these charming designs to the workmanship of any follower of the faith of Islam. On the other hand, there are striking points of likeness between the figured decoration of the pottery of Rayy and the illustrations of the manuscripts of the *Maqāmāt* of Ḥarīrī, for which a Christian origin has been claimed above.

There is still another possible source of artistic influence that may have offered its contribution to the beginnings of Muhammadan painting, namely, the heathen city of Ḥarrān, in Mesopotamia, between Edessa and Ra's ʿAyn. Here was an ancient temple of the moon-god, which had received the patronage of the Assyrian kings, but the immigration of a number of Macedonian and Greek settlers caused the primitive polytheism of the city to take on a Greek veneer, and the deities worshipped there accordingly received Greek names. Up to the Muslim period, the inhabitants retained a mixture of Babylonian and Hellenic religion, and they specially cultivated the worship of the planets. When, under the Abbasid Caliphate, the desire to acquire the learning of the Greeks stimulated the work of translation, it was the pagans of Ḥarrān who showed special activity in transmitting to the Muslims the treasures of Greek wisdom which they had so long assiduously cherished. Special attention had been given in Ḥarrān to mathematical and astronomical studies, and from these were probably derived the figured

[1] A. Mez, *op. cit.*, p. 437.

[2] As this pottery belongs to the sixth or to the beginning of the seventh century of the Muhammadan era, it is difficult to understand why this city is commonly referred to under its ancient Greek name of Rhages.

[3] See p. 54.

representations of the heavenly constellations, which are among the earliest examples of pictorial art in the Muhammadan period that have survived to us. Whether the pagans of Ḥarrān cultivated the art of painting in any other form is unknown, but it is more than likely that they cherished this legacy from classical culture along with other arts.

Another source is undoubtedly the art of the Manichaeans, and of this our knowledge is more ample. This religion, which had so remarkable an expansion not only in the East but also along the coast of North Africa and the south of Europe, and withstood for centuries the utmost severity of persecution by Sasanian Zoroastrians, and by Christian and Muhammadan governments, all of whom endeavoured by every possible means to extirpate it, cultivated the art of painting as a recognized means of religious instruction. Its founder, Mānī, who was put to death by the Persian king Bahrām about A.D. 274, was himself a painter and had illustrated his own writings with coloured pictures. His followers enjoyed some respite from persecution for a few generations after the Arab conquest of Persia, and during this period appear to have won a considerable number of adherents to their own faith under Muhammadan rule; but towards the latter part of the eighth century they were again exposed to fierce persecution, and in the reign of Muqtadir (908–932) most of them took refuge in Khurasan, so that by the middle of the tenth century only three hundred Manichaeans were left in Baghdad. The importance that the Manichaeans attached to the art of painting must have led to the establishment of an active school of painters, who may well have been willing to work for such Muhammadan patrons as cared to employ them. The richly decorated bindings of their religious books attracted the attention even of their theological opponents, both Christian and Muhammadan, and the lavishness of the expenditure upon these works of art may be judged from the fact that when in the year A.D. 923 fourteen sacks full of Manichaean books were burnt in Baghdad, trickles of silver and gold ran out from the fire.[1] What the Manichaean paintings were like remained quite unknown until Professor von Le Coq in 1904 discovered some Manichaean manuscripts with pictures, and some frescoes on the walls of what had once been a Manichaean temple, in a ruined city near Turfan. Both in colouring and design these paintings suggest analogies with the work of later Persian painters, and it may be conjectured that the descendants of the Manichaean painters left behind in Muhammadan territory when the main body of the persecuted sect moved eastward, to spread their doctrines among the Uighurs of Central Asia, carried on for new masters the traditional methods of their

[1] A. Mez, *op. cit.*, p. 167.

ancestors, or possibly those who had grown up in the new home in Takhari-stan contributed to that powerful stream of artistic influence, which left such abiding traces upon Persian painting after the Mongol conquest had brought with it into the Muhammadan world a revived interest in the art of painting.

The possibility of the survival of the traditions of Manichaean art in Muslim territories even after the public exercise of the faith of Mānī had been forbidden is suggested by the mention of the preservation of one of their religious books up to the close of the eleventh century. A reproduction of the famous picture-book made by Mānī himself and known by the name *Arzhang*, which so frequently finds mention in Persian literature, is reported by the author of a work on the various systems of religion, who wrote in the year 1092, to be still in the treasury of the capital city of Ghaznī.[1] It must have owed its preservation to its magnificent illumination and artistic qualities, but if one such copy escaped destruction, there may well have been others also, to serve as models for later painters.

Our investigations have so far been pursued in a realm of inquiry uncertain and obscure from lack of material, but a consideration of the survivals of Sasanian art into the Muhammadan period brings to light a sufficiently abundant mass of material to remove all doubt as to the transmission of definite artistic traditions. Though such examples of the art of the Sasanian period as have survived are not numerous, still they are marked by charac-teristics of a sufficiently distinctive character to be easily recognizable when they reappear even after an interval of several centuries. These examples of Sasanian figured art consist of the rock-cut sculptures found in various ancient sites in Persia, and of the embossed or incised silver-work, now preserved mainly in the museums of London, Paris, and Russia. To the latter class belongs a silver dish, found in the Gouvernement Perm in Russia, covered with Christian designs, such as Daniel in the Lions' Den, the Denial of Peter, the Crucifixion, the Marys at the Sepulchre, and the Ascension.[2] This dish affords evidence of the existence of either Christian workmen or Christian influence in the artistic activity of Persia before the Muhammadan conquest, even as was the case in Syria and Mesopotamia, and such activity might well have been carried on into the Muhammadan period in the one case as in the other.

It is true that of actual painting during the Sasanian period nothing has

[1] Abu 'l-Ma'ālī Muḥammad ibn 'Ubayd Allāh, *Kitāb Bayān al-Adyān* (*Chrestomathie Persane*, publiée par Ch. Schefer, Vol. I, p. 145) (Paris, 1883).

[2] *Imperial Archaeological Commission. Materials for Russian Archaeology*, Part 22, II, p. 44 (St. Peters-burg, 1899).

survived, with the exception of the frescoes recently discovered at Kūh-i-
Khwājah by Sir Aurel Stein and those found at Bāmiyān in Afghanistan by
M. Hackin, but there are several literary records that bear evidence to the
cultivation of pictorial art. According to the poet al-Buhturī (ob. A.D. 897),
some of the original paintings in the palace of the Sasanian kings in Ctesiphon
still survived up to his time; he describes one that represented the fighting
between the Persians and the Romans at the siege of Antioch by Khusrau
Anūshirwān in A.D. 538; he even mentions the colours used—green, yellow,
and red—the warriors, some charging with their spears, others protecting
themselves with their shields, appear to him so life-like that he cannot
believe that they are merely pictured until he feels them with his hands.[1]

Mas'ūdī speaks of a history of the kings of Persia, which he had seen in
the year A.D. 915 in the possession of a noble Persian family in the city of
Iṣṭakhr, near the site of the ancient capital, Persepolis; it contained pictures
of each of the Sasanian kings as he appeared at the time of death, with his
crown upon his head and attired in his royal robes.[2] About the middle of
the tenth century, a geographer named Abū Isḥāq al-Fārisī, commonly
known as Iṣṭakhrī, describes a similar manuscript, which he had seen in
the castle of Shīz, in the north of Persia, near one of the most famous fire-
temples of the Zoroastrians. The traditions of Sasanian pictorial art were
probably preserved among those Persians who remained true to the faith of
their fathers, and might in consequence of the strong national sentiment that
continued to animate this race continue to receive encouragement even among
those who had accepted the faith of the conquerors. Of the rock-cut
sculptures and silver-work of the Sasanian period, enough has escaped
destruction to show what the motifs and characteristics of Sasanian art were.
These reappear on the paintings of Sāmarrā in the ninth century, in which
we find not only such an arrangement of figure-decoration as is presented in
Sasanian art, but also the same types of face, both of men and women, and
a similar costume and disposition of the folds of drapery; and dancing-girls
and female musicians correspond to the earlier convention, and the numerous
animals can be traced back to the same source.[3] In the Persian miniatures
of a later date similar survivals can be recognized. The fact that the Muslim
Persian painters took the subject-matter of their romances, just as Firdawsī
did for his *Shāh Nāmah*, from the legendary history of their early kings
before the Arab conquest, testifies to the vitality of their national traditions,

[1] *Dīwān*, pp. 108–9 (Constantinople, A.H. 1300).
[2] *Kitāb at-tanbīh* (*Bibl. Geograph. Arab.*, Vol. VIII, p. 106).
 E. Herzfeld, *Die Malereien von Samarra*, pp. 105–7 *et passim*.

and in a similar spirit the illustrators of such manuscripts were naturally influenced by the work of their predecessors. Such hunting scenes as those depicted in the sculptures of Tāq-i-Bustān, near Kirmānshāh, in which Khusrau Parvīz (590–628) hunts the stag and the wild boar, constantly reappear in Persian paintings, after an interval of seven or eight centuries. Especially in the representation of certain favourite incidents, these painters followed the traditional manner of the earlier artists in Sasanian times, e. g. when they depicted Bahrām Gūr, seated on his throne with his two lions before him, or exhibiting his skill in shooting the deer, accompanied by his favourite lutist, who afterwards performs the feat of carrying an ox on her back up a flight of stairs; in one of the palaces of Sāmarrā Professor Herzfeld found a painting of this last incident, which is entirely Sasanian in character.[1] Another favourite picture in later Persian art which can be traced back to Sasanian times is that of Kai Kā'ūs being lifted towards heaven by eagles, which fly up in their efforts to reach the lumps of flesh attached to the upper part of his car. Besides such representations of the heroes of Persian national history, there are a number of details of costume—helmets, armour, long streamers, &c.—which reproduce in the miniatures of the sixteenth and seventeenth centuries similar features of Sasanian silver-work of the seventh century.

But it is not only in paintings that the traditions of Sasanian art have been preserved, for it is well known that the Persians applied their skill in pictorial design to the weaving of carpets also. One of the earliest descriptions of such a carpet is recorded on the occasion of the sack of the palace of the Persian king in Ctesiphon by the Arabs in 637. It is said to have been made of silk, decorated with gold and silver, with pearls and precious stones; the design represented a garden in spring-time, intersected with paths and runnels of water, and filled with fields of flowers and trees whose fruits were made of jewels.[2] The tradition of such of a design seems never to have been lost by the carpet-weavers of Persia, and this great garden-carpet of Khusrau was the prototype of the later carpets of a similar design, made in the Muhammadan era and now preserved in Vienna and elsewhere, though none other ever approached the same degree of elaboration and costliness. The oldest of such carpets with pictorial designs, still preserved, does not go back to a date before the sixteenth century; but there are occasional historical records of carpets of an earlier period in the Muhammadan era, such as that which is said to have stirred feelings of self-reproach in the mind of Muntaṣir, who was Caliph for less than six months in A.D. 862 after having compassed

[1] *Die Malereien von Samarra*, pp. 88–9.　　　[2] *Ṭabarī*, Vol. I, pp. 2452–3.

a

b

d

c

e

VIII. Examples of similar types in Christian and Muslim MSS.

a

b

c

d

IX. Examples of similar types in Christian and Muslim MSS.

X. Christ among the doctors in the temple at Jerusalem

a

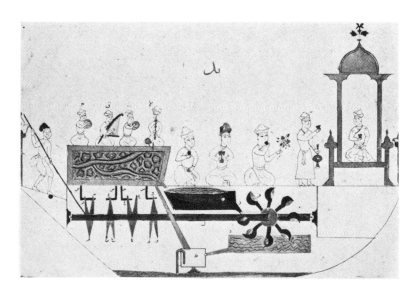

b

XI. Mechanical devices

the death of his father Mutawakkil; he had some carpets brought out of
his father's treasury for a convivial gathering and saw on one of them the
figure of a Persian with a crown on his head and round it a Persian inscrip-
tion; the Caliph sent for a man who could read Persian and he translated
the writing as follows: 'I am Shīrūyah, the son of Khusrau, the son of
Hurmuz; I slew my father, but did not enjoy the sovereignty for more than
six months.' Whereupon Muntaṣir changed colour and ordered the carpet
to be burnt.[1] On such carpets the early Sasanian hunting scenes reappear,
with galloping horsemen and wild beasts fleeing from their arrows; another
motif also occurs on these carpets, one that has a long history, going back
to a period much earlier than that of the Sasanians, namely, the lion leaping
on to the back of a deer and burying its teeth in the shoulder of the unfor-
tunate beast, lying crushed under its weight. This motif occurs frequently
in the decorative margins of Persian manuscripts also.

More hard to determine are the exact nature and limits of the influence
exercised by Chinese art on Muslim painting, and this problem has formed
the subject of much violent controversy. Commercial relations between
China and the Arab empire began at an early period; during the first century
of the Tang dynasty (620–720), vessels from China used to put in at the port of
Sīrāf, on the east coast of the Persian Gulf, and exchanged their merchandise
for goods from Baṣrah, Oman, and other parts. In the first half of the ninth
century they began to come more rarely, but the Arab vessels went more
frequently to China.[2] The objects of Chinese art imported into Muslim
territories undoubtedly served as models for imitation. Professor Sarre, in
his explorations at Sāmarrā, not only found specimens of Chinese pottery,
but also local imitations of the same ware;[3] and for the historical reasons set
forth above,[4] none of these can be later than the year 883. A cultural
influence of still greater importance and of far-reaching result was the intro-
duction of the art of making paper, which is said to have been taught to the
people of Samarqand for the first time in Muslim history by a Chinaman, who
had been brought there as a prisoner of war by the governor of that city,
Ziyād ibn Ṣāliḥ, who died in 752.[5]

When the Muslims first came to have any knowledge of Chinese paintings
is uncertain. The record of the activity of the Chinese artists who illustrated

[1] Suyuṭī, Ta'rīkh al-Khulafā, p. 143 (Cairo, 1888).
[2] W. Heyd, Histoire du commerce du Levant au Moyen-Âge, Vol. I, p. 29 (Leipzig, 1923).
[3] F. Sarre, Wechselbeziehungen zwischen ostasiatischer und vorderasiatischer Keramik (Ostasiatische Zeit-
schrift, Vol. VIII, p. 338).
[4] p. 31.
[5] Tha'ālibī, Laṭā'if al-ma'ārif, ed. P. de Jong, p. 126.

the poems of Rūdagī for the Sāmānid prince, Naṣr ibn Aḥmad, about A.D. 920, is an isolated phenomenon in the history of oriental art,[1] and it is impossible to assert with any degree of certainty whether or not these paintings exercised any influence on the course of the later development of Muslim pictorial art, because no examples have survived from that period or from any of the succeeding centuries until after the lapse of three hundred years, and what we get then are the illustrated MSS. of the *Maqāmāt* of Ḥarīrī, which (as pointed out above) are connected with the tradition of Hellenistic art, and from the circumstances of the case were unlikely to admit any foreign influences. In this matter, as in so many others, it appears therefore impossible to prove a negative. The more important fact is the profound impression which Chinese painting made upon the greatest exponents of Muslim art, the Persians, for it became a commonplace in Persian literature to express admiration for artistic skill by a comparison with that of the Chinese.[2] What knowledge they actually had of Chinese painting we do not know, but the language with which Thaʿālibī (961–1038) praises the skill of the Chinese artists suggests either personal acquaintance with their work, or information derived from some one who had seen it; a Chinese painter, he says, 'can represent a man with such fidelity to nature as to make him seem to be breathing; and not content with this, the painter can represent a man as laughing, and even all possible varieties of laughing, each in its own peculiar way'.[3]

But what Chinese painting really meant to the Persians in this early period before the Mongol conquest we have no means of ascertaining. Nizāmī, who might have enlightened us on this matter, when he wrote his famous account of the trial of skill between the Rūmī and the Chīnī[4] painter, leaves us unfortunately in the dark as to the real artistic characteristics of these rival schools of painting. But as any mention of painters and their work is so exceedingly rare in the literature of this early period, and as this contest between the two painters has often been referred to, but has hitherto not been translated into English, it is here given in full. It occurs in the poet's romance of the

[1] See p. 26.

[2] Jāmī even makes Potiphar's wife send for a Chinese painter to make pictures of herself and Joseph (*Yūsuf u Zulaykhā*, ed. Rosenzweig, p. 102, Wien, 1824).

[3] *Op. cit.*, p. 127.

[4] The geographical position of Rūm is as indeterminate as that of Chīn; it may mean Rome itself (i.e. New Rome, Constantinople), or the land of the Romans, i.e. Christians generally, whether Greeks or Latins, or it may mean Asia Minor, which at the time of Nizāmī was under the rule of the Saljūq Turks. In the present instance it may be taken to mean Westerner, while Chīnī may mean little more than Easterner, for Chīn was used not only to indicate China proper, but also what is now known as Chinese Turkistan, or more vaguely the country to the east of Northern Persia.

legendary adventures of Alexander, which he probably completed about the year 1200.

One happy day, the brightest of the spring,
The Lord of China was Sikandar's guest.
Wine banished care from every gladdened face
Of men from Rūm, 'Irāq, and Chīn and Zang.
As wine and gladness loosed the pearls of speech,
The talk went round with—Who should bear the palm
For skill, among the craftsmen of the world?
What rare attainment could each country show,
And which the art wherein it did excel?
One praised the land of Ind, for magic lore:
Another, Babylon's wise sorceries,
Whose spells have power to curb all evil fate.
'The finest singers come from Khurāsān,'
Said one, 'and 'Irāq sends the sweetest lutes.'
So each, as best he could, set forth his case.
At length, it was agreed, as test of skill,
To hang a curtain from a lofty dome,
In such a manner that on either half
Two painters should essay their skill, unseen.
This vault should show the Rūmī's work of art,
While on the other the Chinaman should paint;
Neither should look upon his rival's work,
Until the hour of final judgement came;
Not till their work was done, should any draw
The curtain that was hung between them twain.
Then the beholders would adjudge the prize,
And weigh the merits of the finished work.
So, still in secret did the painters strive
Each in his vaulted contour of the dome,
Until, their task complete, they drew aside
The curtain that concealed each masterpiece;
But,—strange to see!—no difference was found
Between the two, in colour or in form.
Such likeness filled the spectators with amaze,
And none knew how to make the riddle plain.
How had it happened that here these limners twain
Could make two pictures, of the same design?
The King between the pictures sat him down,
And scrutinized with care, now this, now that,
But not a whit of difference could he trace,
Or find solution of the mystery.
He gazed and gazed, but still no clue appeared;
The likeness stayed mysterious as before.

Yet 'twixt the two a difference there was,—
The one reflected what the other gave.
This stirred the wonder of the sage of Greece,
As soon as he beheld the painted walls.
Here was a clue; he followed up the thread,
Until he tracked at last the hidden truth.
He bade the men of Rūm again hang down
The curtain which divided this from that.
When once again the curtain hung between,
One picture faded, while the other glowed.
With lustrous colour shone the Rūmī's forms;
Rust overgrew the Chīnī's mirror,—dimmed.
The King, amazed, beheld the Chīnī's work
Lose semblance of all form and ornament.
Again he bade them draw the curtain up,
And lo! both pictures shone forth as before.
Now saw he that it was through polishing
That shining arch had gained its coloured forms.
For when the painters started on their task,
And hid themselves behind the curtain's screen,
The Rūmī showed his skill by painting forms,—
The Chīnī worked at naught save polishing.
The polished wall reflected every line
Of form and colour which the other took.
The judges, weighing well each rival's skill,
Gave credit for the insight each had shown:
In painting, none the Rūmī could excel;
The Chīnī was supreme in polishing.[1]

With the Mongol invasion in the thirteenth century the intrusion of Chinese influences becomes clearer; the conquerors carried along with them to the West Chinese artists, and a Chinese monk who travelled through Central Asia to Persia in the years 1221 to 1224, speaking of Samarqand, wrote, 'Chinese workmen are living everywhere'.[2]

The creation of a great empire, which brought Persia and China under a single administration and facilitated communications to a degree hitherto unknown in the history of either country, was not without its influence in the domain of art. Even after Persia attained a separate political status, the connexion with China was still maintained by means of diplomatic relations. Tīmūr (1369–1404) sent as many as three embassies to the Emperor of China, and his son, Shāh Rukh (1404–1447), maintained still more active relations with the court of China and received Chinese envoys in his court three times

[1] Nizāmī, *Sikandar-nāmah*, Vol. II, pp. 197–200 (Dihlī, A.H. 1316).
[2] E. Bretschneider, *Mediaeval Researches from Eastern Asiatic Sources*, Vol. I, p. 78 (London, 1881).

between the years 1413 and 1419, and the importance of these relations in their connexion with the history of Persian painting is emphasized by the fact that among the ambassadors sent from Harāt to the Emperor of China was a painter named Ghiyāth ad-Dīn, who received instructions from Shāh Rukh to record all the facts of interest that he might meet with on his journey.[1]

This lively interest in Chinese painting continued to find expression in literature, and left permanent traces on Persian painting and on the Indian painting which copied it. For the literary references two examples may suffice: a geographer, Ibn al-Wardī, about the middle of the fifteenth century, enumerates among the arts in which the Chinese excelled their porcelain and pottery, their carved figures, their marvellous paintings and drawings of trees, animals, birds, flowers, fruits, and human beings in various situations and shapes and forms, so that they lacked nothing except soul and speech;[2] in the latter part of the same century, in a Persian translation of *Kalīlah wa Dimnah*, the skill of a painter is described as being so marvellous that 'when his brush drew faces, the souls of the painters of China were bewildered in the valley of amazement, and through the genius of his colouring the hearts of the artists of Khatā[3] were overwhelmed in the desert of bewilderment'.[4]

While mention is made in these and similar passages of the painters of China only, the loose use of this word makes it possible to include the eastern territories of Turkistan and the neighbouring country bordering on China. The discoveries of Sir Aurel Stein in the Taklamakan Desert, of Professor von Le Coq in Turfan, and of other explorers in these regions, have revealed the existence of a pictorial art that had been cultivated over a long period of many centuries in the territories lying between the eastern borders of Muhammadan principalities and the empire of China. In this art Buddhists, Christians, and Manichaeans took part, and the receptiveness of these painters to influences both from the East—from China—and from the West, as exhibited in affinities with the traditions of Hellenistic art transmitted through that of the Oriental Churches—and also from India, illustrates the active interchange of artistic conventions which was taking place in Central Asia during the Middle Ages.

Accordingly, whether directly from China or from some country nearer the Persian border, the Persian painters, and after them the Indians, adopted certain conventions which became permanent characteristics of their pictorial art. Among these was the flame-halo, which they borrowed from Chinese and Central Asian statues of Buddha; the fantastic dragons, of which the

[1] *Notices et Extraits*, Vol. 14, I, p. 308. [2] *Kharīdat al-ʿajāʾib*, p. 168 (Cairo, 1904).
[3] i.e. China. [4] *Anwār-i-Suhaylī*, ed. J. W. J. Ouseley, p. 185 (ll. 18–19) (Hertford, 1851).

Chinese painters were so fond, and other animal and bird forms of an imaginative character; and the Chinese 'Tai' or cloud form, with its sinuous, undulating shape, which may be found in Persian paintings even when no other trace of Chinese influence is recognizable.

It appears, therefore, that the chief sources from which Muhammadan painting derived its origin were the schools of Christian, Sasanian, and Manichaean painters that had been working long before the rise of Islam; and Chinese influence was superadded at a later period. Since, therefore, Islam did not itself stimulate the rise and development of any distinctive school of painting, any examples of pictorial art, in its earliest manifestations at least, were necessarily foreign to this faith, and can in most cases be traced to the artistic genius of one or other of the countries conquered by the Arabs and incorporated in the Muslim empire, or in later periods to influences brought in from nations with whose culture the Muhammadans came in contact through commercial or political conditions.

IV

THE PAINTERS AND THEIR MANNER OF WORKING

ANY account of most of the schools of painting in Christian Europe (with the exception of the Primitives) comprises more or less ample biographies of the painters concerned, and a detailed description of the various works attributed to each. But for the painters of the Muhammadan world, biographical details are entirely lacking before the sixteenth century; the historian has ignored them, and in none of the great cities of Islam are to be found those accumulations of documents of local interest, such as have yielded up precious results to the patient and industrious research of the historians of Flemish and Italian art. Further, up to the same period most of the examples of the work of Muhammadan painters which have survived to us are anonymous. Isolated exceptions are the drawing of the horseman, found in Egypt, which forms part of the collection of papyri made by the Archduke Rainer, and bears the signature of the artist, Abū Tamīm Ḥaydara, and dates from the tenth century;[1] in the Schefer MS.[2] of the *Māqāmat* of Ḥarīrī, dated 634 (=A.D. 1237), the copyist of which claims at the same time to have painted the pictures;[3] in the same library a MS. (Arabe 2583) of Abū Ma'shar's treatise on the conjunctions of the stars contains drawings by a painter, Qanbar 'Alī Shīrāzī, about the middle of the thirteenth century. So far as Persian painters are concerned, Bihzād, who lived in the latter part of the fifteenth and at the beginning of the sixteenth century, appears to have been one of the first to add his signature to his paintings, and he used to conceal it in minute characters in some obscure part of the picture.[4] The signature of one of his pupils, Maḥmūd, is written on a tambourine held by one of the female musicians.[5] From the sixteenth century onwards the practice of signing pictures became more common, though it may with some assurance be asserted that the majority of Persian paintings, even after that period, lack the signature of the artist. To this modesty or self-suppression, the enigmatical personality of Riżā 'Abbāsī presents a notable exception; this artist was particularly fond of signing his name on his drawings; and not only does he give his name, but sometimes also the date and the circumstances under which he made the picture.

[1] J. Karabacek, *Papyrus Erzherzog Rainer. Führer durch die Ausstellung*, pp. 251–2 (Wien, 1894).
[2] Bibliothèque Nationale (Arabe 5847).
[3] Yaḥyà ibn Maḥmūd ibn Yaḥyà ibn Abi'l-Ḥasan ibn Kuwwarīhā al-Wāsiṭī.
[4] Jackson and Johannan, *Catalogue of the Persian Manuscripts, Metropolitan Museum of Art, New York*.
[5] Bibliothèque Nationale (Supplément persan 1416, fol. 81 b).

To reasons other than this vigorous self-assertiveness is to be assigned the contemporary practice in the atelier of the Mughal emperor in India of writing the names of the artists under the pictures in the manuscripts prepared for the library of the Emperor Akbar. These inscriptions are for the most part in the same handwriting, and appear to have been added by some functionary of the imperial library rather than by the painters themselves. It may be conjectured that we have here an indication of the personal interest which Akbar took in his court painters, for the account which Abu 'l-Fazl gives of them in his *A'īn-i-Akbarī*,[1] and his enumeration of their names, doubtless reflect the feelings of the emperor himself towards these masters of the pictorial art, whose achievements he so highly valued; for we are told that their works were submitted to his inspection every week, and he granted rewards or increased their monthly salaries according to excellence of work-manship.

It is regrettable that the practice of signing pictures did not become general until shortly before the decline of the art of painting in the Muhammadan world. But even when the name has been given, in the majority of cases no information whatsoever is forthcoming as to the life and personality of the painter, and (as will be shown in Chapter X) the biographical notices of such painters as attracted the attention of the historian are meagre in the extreme. This neglect by the historian fits in with the common depreciatory attitude of the orthodox towards the painter's art.[2]

We have as little certain knowledge of the way in which these painters worked, as we have of the details of their biographies. The most famous masters, who enjoyed the patronage of some monarch, must have worked in the royal atelier, in which the expensive materials they needed for their work were provided for them; the gold, which was so lavishly expended not only in the general decoration of illuminated manuscripts, but also in very many cases filled an important place in the colour scheme of the pictures themselves, was far too costly for a simple craftsman to acquire through his private resources; the lapis lazuli which formed the material out of which they made the marvellous blue which lends such lustre to their paintings, must have been worth almost its weight in gold, and other colours were probably equally beyond the reach of such scanty incomes as the painters enjoyed. Further, the highly polished hand-made paper, on which they painted their pictures, had to be provided for them out of the revenues of the monarch they served. The painters, therefore, were paid servants of the

[1] Translated by H. Blochmann, Vol. I, pp. 107–8 (Calcutta, 1873).
[2] As has been shown in Chapter I, Akbar and Mīrkhwānd were exceptions to this general rule.

a

b

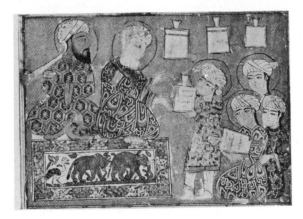

c

XII. Pictures from the *Maqāmāt* of Ḥarīrī

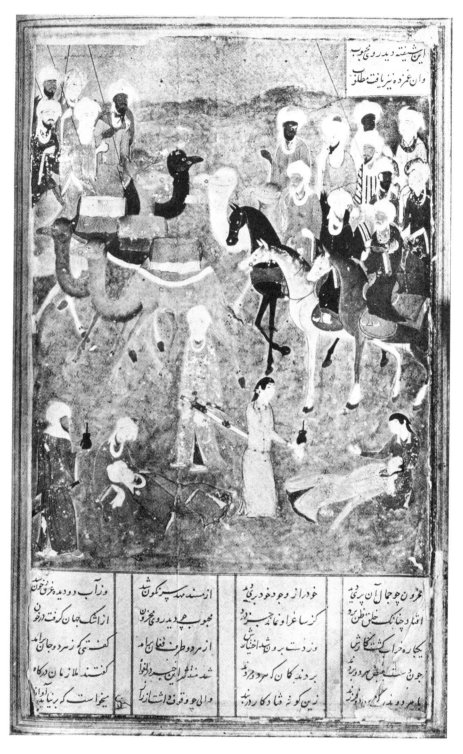

XIII. Laylā and Majnūn fainting

State, drawing such scanty salaries as befitted their low social status, and taking rank below the calligraphers and the gilders. We have the important evidence of Abu 'l-Fazl that the court painters of the Emperor Akbar received monthly salaries,[1] and this relation of the artist—whether painter or other craftsman—to his patron, as a salaried servant, survived in India up to the nineteenth century; indeed, without such regular support and an ensured subsistence, the artist could not have produced such highly finished works of art, or have devoted such lengthy periods of time to the elaboration of the minute details of miniature painting. Work of this kind could not be done in a hurry, and the painter had to be kept alive while engaged on such laborious tasks. A manuscript of Anwār-i-Suhaylī (B.M., Add. 18579), illustrated for the most part by Akbar's court painters, contains a picture (fol. 36) dated A.H. 1013; but as the date of the completion of the manuscript as given in the colophon is A.H. 1019, the painters must have had the work in hand for at least six years. Bernier (about the year 1663) saw in India a painting of the exploits of Akbar which had occupied the painter's efforts for seven years.[2] Mīrzā Bābā, the chief painter of Fath 'Alī Khān, Shāh of Persia from 1797 to 1834, spent seventeen years on the picture and other decorations of the copy of this monarch's Dīwān, which was presented to the Prince Regent.[3] The painters probably had to come daily,[4] except for scanty holidays, to the royal atelier, situated in some building connected with the royal library within the precincts of the palace. Chardin, who spent ten years in Isfahan from 1666 to 1676, states that there were as many as thirty-two kārkhānah (or ateliers) in various parts of the Shāh's palace; he mentions only a few of these, such as the library, in which the binders worked, the great wardrobe, in which the robes of honour were made, and separate establishments for pipes, candles, and wine, &c.[5] He says nothing about painters in the royal palace, and possibly there were none employed by 'Abbās II or Sulaymān I, who reigned at this period. But his contemporary, François Bernier, who was in Dihlī in 1663, mentions the atelier of the painters among the workshops in the vicinity of the royal palace, assigned to the embroiderers, goldsmiths, tailors, shoemakers, &c.[6] This was during the reign of Aurangzeb, whose rigid adherence to the precepts of his faith made him unsympathetic to painters; but when any art-loving monarch cared to encourage painting, it may be seen from the terms of the warrant appoint-

[1] Op. cit., p. 107. [2] Travels in the Mogul Empire, pp. 254–5 (Oxford, 1914).
[3] Sir William Ouseley, Travels in Various Countries of the East, Vol. III, pp. 372–3 (London, 1819–32).
[4] Ob. cit., p. 259.
[5] J. Chardin, Voyages en Perse, Vol. V, p. 499; Vol. VII, pp. 372–5 (Paris, 1811).
[6] Travels in the Mogul Empire, p. 259.

ing Bihzād director of the royal library how vast could be the extent of such an establishment.[1] The various members of the staff then included calligraphers, painters, gilders, margin-drawers, gold-mixers, gold-beaters, washers of lapiz lazuli, and others. That the calligraphers should have been placed at the head of the list, even in the warrant of appointment of a painter as their superintendent, is significant of the high respect with which their calling was regarded, as explained above.[2] The painters are mentioned before the gilders (*mudhahhib*, or workers in gold), though there is reason to doubt whether this was always the order of estimation in which the two callings were held. It was quite a common practice for a painter, when he signed his name to a picture, to append the appellation *mudhahhib* (gilder), even when no gold at all may have been used in the picture—in place of the more exact description *musawwir* (painter)—as though the former designation gave him a higher status.

Some conception of the extent of such an establishment may be formed from the arrangements made in the city of Tabriz by Rashīd ad-Dīn, the great prime minister of two successive Mongol princes of the Ilkhān dynasty in Persia—Ghazān Khān (1295–1304) and Uljaytu (1304–1316). Eight years before his death in 1318 he added a suburb to the city, called after his own name Bāb-i-Rashīdī (the Rashīdī quarter), and richly endowed it for learning; it provided accommodation for as many as six to seven thousand students; he bequeathed to it a library of 60,000 volumes of works on science, history, and poetry, including a thousand Qur'āns copied out by some of the most famous calligraphers. Fifty physicians were brought from India, China, Syria, and Egypt, each of whom was bound to give instruction to ten students, and allowances in kind and money were made to all of them. For the perpetuation of his own writings, which were numerous and dealt with theology, history, and a number of other subjects, he made special provision; all facilities were granted to any one who desired to copy them, and he assigned a separate sum from the endowment in order that two copies of each of his works, one in Arabic and one in Persian, might be made every year, and presented to one of the chief towns in the Muhammadan world. The copyists were to be carefully chosen and were to be provided with lodgings in the precincts of the library.[3] The copy of his *Jāmi' at-Tawārīkh*, or Universal History, referred to below,[4] must have been one of the volumes thus provided, since it bears the date A.H. 714, four years before his death, and its

[1] Translated in Appendix C. [2] pp. 1–3.
[3] E. G. Browne, *A History of Persian Literature under Tartar Dominion*, pp. 77–86.
[4] pp. 93–4.

abundant illustrations make it clear that painters also were among the recipients of Rashīd ad-Dīn's bounty, though there is no specific mention of them in his charter of endowment. But this elaborate establishment in the suburb of Bāb-i-Rashīdī, which is said to have contained as many as 30,000 houses, 1,500 shops, and 24 caravansaries, did not long survive, for after the murder of his son and successor in 1336, the whole of it was plundered and the revenues that had been assigned to it by Rashīd ad-Dīn were confiscated by the State.[1]

Of similar establishments of a later date and of more importance in the history of Persian art, we have scantier information. The libraries of the Timurid princes must have been provided with a large staff of calligraphists and painters, but details appear to be lacking. Of one of them, Bāysunghur (1399–1433), a son of Shāh Rukh, it is said that forty calligraphists were constantly employed in his library, with Mawlānā Ja'far Tabrīzī at their head;[2] his father's establishment must, of course, have been much larger.

Sultan Ḥusayn Mīrzā, the patron of Bihzād and of the celebrated calligrapher Sulṭān 'Alī Mashhadī, during his long reign of thirty-six years in Harāt from 1470 till his death in 1506, according to the evidence of Mīrzā Ḥaydar (who was a child when this enlightened prince died), 'encouraged all the arts and crafts of the world to such a degree that in every separate profession he produced an unsurpassed master'.[3]

The atelier of the Emperor Akbar must also have formed a vast establishment, but unfortunately, though his biographer gives us a certain number of details regarding the calligraphers and painters, he tells so little about it that he does not even mention in which of Akbar's capitals it was situated, whether in Dihlī, Agra, Fathpūr Sīkrī, or Lahore. He mentions only 17 painters,[4] though the names of as many as 145 painters have been found in the pages of the manuscripts prepared for Akbar's library.

How such establishments of painters were organized we do not know. The diploma appointing Bihzād director of the Royal Library of Shāh Ismā'īl says nothing on the matter except that his orders were to be obeyed, and that the other functionaries of the State were to give due recognition to his position. But the study of such a MS. as the Jāmi' at-Tawārīkh of Rashīd ad-Dīn and the various MSS. from the Library of Akbar show that such a director was in much the same position as the founder of a school of

[1] *Histoire des Mongols de la Perse, écrite en persan par Raschid-eldin*, publiée par M. Quatremère, pp. lii, lxxxi (Paris, 1836).
[2] Dawlatshāh, *Tadhkiratu'sh-Shu'arā*, ed. E. G. Browne, p. 350.
[3] *Ta'rīkh-i-Rashīdī*, translated by E. Denison Ross, p. 193.
[4] Abu 'l-Fazl, *Ā'īn-i-Akbarī*, Vol. I, pp. 107–8.

painters in the cinquecento in Italy. It is certainly clear that he could impose his will on the painters who worked under his direction, for there is such a similarity in the draughtsmanship and colouring of the various pictures in any one of Akbar's MSS., that difference of name appears in the majority of cases to indicate but slight difference in style. The work of Farrukh Beg certainly stands apart from that of his fellow artists and exhibits closer affinities to the design and colour scheme of the Persian school; but the result is much the same whether a picture is painted by Mādhū or Mukund or any other.

In the execution of such a work of art as one of the superb manuscripts made for the Safavid Sultan or for the Mughal Pādishāh, the calligraphist must first have completed his part of the task, after receiving instructions as to the gaps to be left for the insertion of pictures. This procedure is indicated by the large number of instances in which the pictures in a manuscript have only partially been completed and blank spaces still remain throughout the rest of the volume. In modern times the forger has not infrequently taken advantage of the incomplete state of such a manuscript, and the blank spaces left between lines of early calligraphy have been filled in with modern imitations of paintings of the same period as the text. The written pages appear then to have been handed over to the margin-drawer, and his contribution to the total result is likewise often imperfect, probably through sheer neglect or inadvertence. As he frequently cut his lines too deeply into the paper, his activities have in a very large number of cases brought about the ruin of fine manuscripts; the paper has split from end to end of the margin lines and the whole volume has had to be reset in fresh margins at some later period, often with the loss of valuable indications as to date and previous ownership, and in every instance with the destruction of the original character of the book. The skill and care with which these pages in their diminished size have been reset in new margins at some later date are, however, often deserving of the highest praise, the line of joinage being sometimes hardly recognizable, or being cleverly concealed by a newly drawn margin line.

For the reasons given above it would appear that the work of the painter came last; consequently, the illustrations of a manuscript frequently belong to a much later date than that of the calligraphy, and the colophon of the text gives by no means trustworthy evidence as to the date of the pictures. One of the most remarkable examples of variation in the date of the illustrations of a manuscript is found in the famous copy of the *Khamsah* of Nizāmī in the British Museum (Or. 2265), decorated by the court painters

XIV. Khusrau at the castle of Shīrīn

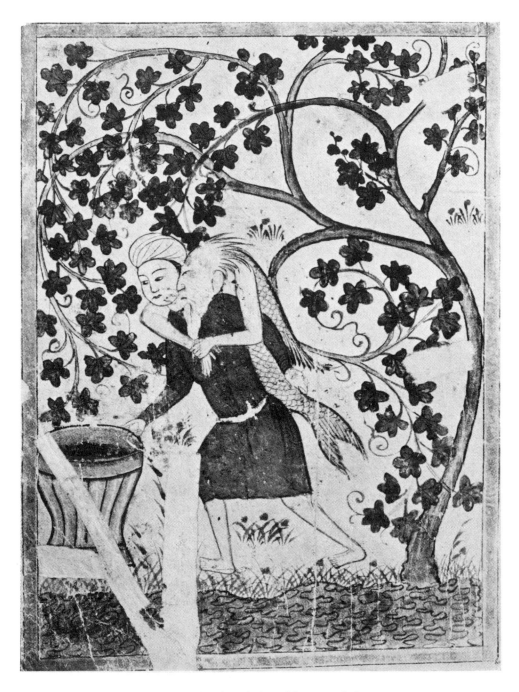

XV. Sindbad and the old man of the sea

of the Shāh Ṭahmāsp (1524–1576); for some unknown reason they left blank spaces in three places (foll. 203 b, 213, and 221 b), and these were filled up a century later, in 1675, by Muḥammad Zamān, a painter, an account of whom will be given later.[1]

As to the stipends assigned to the court painters or any special emoluments they may have received, no information appears to be forthcoming. There are no stories of extravagant gifts being bestowed upon them, as fell to the lot of the poets who won the favour of a generous monarch by some appropriate verses or flattering eulogy; nor does the annalist mention that the painter ever received such rich rewards as were occasionally bestowed upon the more appreciated calligrapher.[2]

As already stated,[3] Akbar's painters were paid every month and received special rewards for excellence of workmanship; in Persia, according to Chardin,[4] in the latter part of the seventeenth century, payments were made to the Shāh's workmen only once a year, in the form of demand notes on the treasury. He adds some details as to the procedure of their employment, which was probably followed in the case of painters also: the artisan who wished to enter the royal service submitted a specimen of his workmanship to the head of the atelier concerned; if his work and the terms of service he proposed were approved, he was then taken to the superintendent of the palace, with whom the final decision appears to have rested, though this officer submitted the specimens of work to the Shāh, or might even arrange an interview for the artisan, after which the terms of his appointment were finally settled.

Dr. F. R. Martin[5] states, on the authority of Mr. A. G. Ellis, that Shāh Ṭahmāsp on one occasion declared that he was not sufficiently wealthy to monopolize Bihzād's services, and he therefore permitted the painter to accept private orders. But this statement must have been based on a misunderstanding, for Mr. Ellis assures me that he has no knowledge of Shāh Ṭahmāsp ever having given expression to such an opinion.

But whatever may have been the financial condition of the painters who lived on the bounty of such great patrons of art as Sultan Ḥusayn Mīrzā, Shāh Ṭahmāsp, and Akbar, or received such titles of honour from Jahāngīr as Marvel of the Age (Nādir az-Zamān),[6] their condition in a later period, when they had to depend on occasional fees from private persons, was wretched indeed. Bernier, who travelled in India from 1659 till 1667 and was

[1] pp. 148–9. [2] p. 3, n. 1. [3] p. 73. [4] Op. cit., Vol. V, p. 500.
[5] Miniature Painting and Painters of Persia, pp. 41, 139 (n. 42).
[6] Memoirs of Jahāngīr, translated by A. Rogers, Vol. II, p. 20.

for a time physician to Prince Dārā Shikoh, describes the painters as 'contemned, treated with harshness, and inadequately remunerated for their labour'.[1] Only those who were in the service of the emperor or of some powerful noble, and worked exclusively for their patron, could devote themselves seriously to their art; the others were only called in as occasion arose, and were grudgingly rewarded for their labour, and were fortunate if they did not receive a flogging as part payment.[2]

[1] *Op. cit.*, p. 255. [2] *Op. cit.*, p. 256.

SUBJECT-MATTER OF ISLAMIC PAINTINGS

IN view of the lack of biographical details, the student of Muhammadan painting before the fifteenth century has to devote his attention to such of the works of the anonymous painters as have survived the numerous forces of destruction. The majority of the artists of this earlier period appear to have been illustrators, and consequently their work is found in manuscripts, the text of which they undertook to illustrate, and it is not until a later period, when some historical records of painters had already become available, that separate pictures are found apart from a text to be illustrated. Within the pages of manuscripts, therefore, first Arabic and later Persian, we find the material that enables us to judge of the nature of the activity of most of the painters and of the subjects of their predilection.

The earliest works that the painters were called upon to illustrate were scientific treatises dealing with medicine, astronomy, and mechanics. The history of Arabian medicine shows that the conquerors derived their first knowledge of this science from their Christian subjects, who transmitted to them the tradition of Greek medicine, and when the great period of translation began, about the middle of the eighth century, the works of Greek physicians were translated into Arabic, either through the intermediary of Syriac versions or directly from the Greek original.

One of the most productive of these translators was Ḥunayn ibn Isḥāq, a Nestorian Christian of Ḥīra, who afterwards became court physician to the Caliph in Baghdad. In this Abbasid capital, especially in the reign of Ma'mūn (813–833), an active group of translators made Greek learning of all kinds available. These translators, who worked in Baghdad, were for the most part Christians, and some of them were sent into Byzantine territory to collect Greek manuscripts; but another intellectual centre, a depository of Greek science, especially medicine, was the ancient city of Jundī-Shāpūr, in what is now the province of Khūzistān in south-west Persia; it was in this city that Mānī had been put to death, and possibly some of his followers still survived there up to the latter part of the eighth century, but the chief exponents of the great medical school there were Nestorian Christians. Another group of translators was provided by the city of Ḥarran, between Edessa and Ra's 'Ayn; the majority of the population of this city remained pagan down to the thirteenth century, and kept alive some kind of worship of an Assyrian moon-god. The name Hellenopolis, given to it by some of

the Christian Fathers, bears testimony to the survival in it of pre-Christian Greek culture; and the great mathematician, Thābit ibn Qurrah (*ob.* 901), who was not only active as a translator from the Greek, but also as the author of independent works of his own, was a member of this strange heathen sect.

In most of the treatises on medicine there was naturally very little opportunity for the exercise of the artistic faculty, but there is evidence that in the kindred science of botany, Greek manuscripts of the work of Dioscorides were, at an early period, translated into Arabic. In 948 the Byzantine emperor, Constantine VIII, had sent a finely illustrated manuscript of Dioscorides to the Caliph ʻAbd al-Raḥman in Cordova,[1] and among the manuscripts which the emissaries of al-Maʼmūn (813–833) brought to Baghdad from Byzantine territories[2] may quite possibly have been a copy of Dioscorides containing the originals of the illustrations in the Arabic version that has survived to us.

Another early group of pictures is formed by the illustrations in treatises on mechanics, especially those dealing with water-clocks and similar mechanical toys (Plate XI), and many of these undoubtedly go back to Greek originals.[3]

An entirely different group of examples of the activity of Christians and other artists in the illustration of works of Arabic literature is found in manuscripts of *Kalīlah wa Dimnah*, the Arabic version of that cycle of Indian animal stories which, in the numerous languages into which it has been translated, has wandered over the greater part of the earth.[4]

The scientific treatises above referred to were of interest only to the small group of learned men capable of understanding them, and the treatises on mechanical toys were decorated for the use of princely patrons who wished to have such things made for the adornment of their palaces. But these animal stories, with their shrewd maxims and reflections upon the common circumstances of everyday life, made an appeal to a much wider circle of readers; and though, doubtless, copies may have been made in the libraries of Sultans and have been enriched with illustrations in a corresponding degree of magnificence, the illustrated manuscripts that have survived appear to have been prepared for the use of less exalted personages, for the execution of the drawings is generally rough and the paints used are not of the most costly character.

The artistic origin of the animals in these illustrations has not yet received adequate investigation, but they could probably be traced back to Bestiaries

[1] Carra de Vaux, *Les Penseurs de l'Islam*, Vol. II, p. 292. [2] An-Nadīm, *Fihrist*, Vol. I, p. 243.
[3] E. Wiedemann und F. Hauser, *Ueber die Uhren im Bereiche der islamischen Kultur* (Halle, 1915); id., *Ueber Trinkgefässe und Tafelaufsätze nach al-Ǧazarî und den Benû Mûsà* (*Der Islam*, Vol. VIII (1918)).
[4] See p. 58.

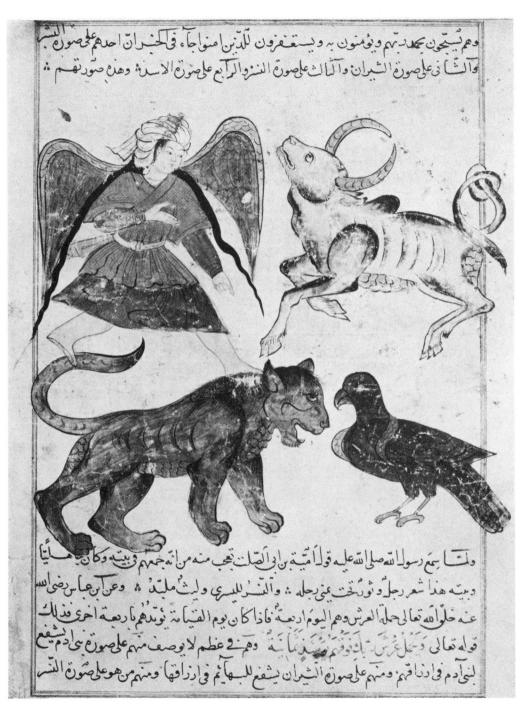

ولما سمع رسول الله صلى الله عليه قول ابي الصلت بن ابي امية تعجب منه انه من جهنم وربيه وكان ابيا
وبيته هذا شعر رجل و ثور تحت منى رجله ٠٠ والنسر اليسرى وليث ملبد ٠٠ وعن ابن عباس رضي
عنه خلق الله تعالى حملة العرش وهم اليوم اربعة فاذا كان يوم القيامة ثوبهم باربعة اخرى فذلك
قوله تعالى وعلى عرش يومئذ فوقهم ثمانية ٠٠ وهم في عظم لا يوصف منهم على صورة بنى آدم يشفع
لبنى آدم في ارزاقهم ومنهم على صورة الثيران ومنهم على صورة يشفع للبهائم في ارزاقها ومنهم من هو على صورة النسر

XVI. The symbols of the Four Evangelists

a

b

c

XVII. Frescoes from Sāmarrā

decorated by adherents of some one or other of the oriental Churches. Crude as the drawing often is, there is a vigour and liveliness of representation which claims for them a higher place than can always be assigned to more carefully finished work; and the painter often enters into the spirit of the Buddhist original of the stories, which assigned to animals the intellectual characteristics of human beings, and the jackals, particularly, who in the exercise of their cunning outwit some heedless victim, are often depicted with a sense of humour which is singularly lacking throughout the greater part of the history of Muhammadan art.

The stories of *Kalilah wa Dimnah* were of a non-Muslim origin, and their wide extension in almost every literary language gives evidence of their broad, human attractiveness. They could thus provide material for the artistic activity of a Christian painter though working for a Muhammadan patron. The case is not entirely the same with another widely read work of Arabic literature, in the manuscripts of which occur some of the earliest examples of Muhammadan painting that have survived to us. The *Maqāmāt* of Harīrī, with its preciousness of style and load of erudition, could not make so popular an appeal as did *Kalilah wa Dimnah*, but very quickly after its completion in the beginning of the twelfth century it achieved a great reputation as a masterpiece of fine writing, and though the author was an orthodox and pious Muslim the subject-matter of his work was such as to make its appeal almost as much to erudite Christian readers of Arabic as to the author's co-religionists. At any rate, it is clear from a study of the pictures in the earliest illustrated copies of this work extant that the inspiration of them is to be found in Christian art, and that the artists were either themselves Christian or were copying Christian models, or were working on the lines of a tradition that can ultimately be traced back to Christian art.

In the case of the great Persian epic, the *Shāh Nāmah*, however, illustrated copies of which exist in large numbers, the artistic influences are derived from an entirely different source. The *Shāh Nāmah* is the national epic of the Persian people, and embodies the exploits of the great heroes of their ancient history; in compiling it, Firdawsī made use of historical material that goes back to a date antecedent to that of the Arab conquest, and when the task of supplying illustrations for it was assigned to the painter it was but natural that he should look back to the same early source for his models. Though few memorials of it have survived, there is little doubt that during the Sasanian period there was a flourishing school of painting in Persia. Indeed there is reason to believe that from the fourth century onwards painting exercised a vitalizing influence upon the arts in Persia, and that the rock

sculptures, the metal-work, and the embroideries that have survived to us owed their subject-matter and their form of representation to the models provided for them by the painter.[1]

Moreover, there is literary evidence to show that the Sasanian painters concerned themselves with such subject-matter of warfare and battle as fills the pages of the *Shāh Nāmah*, and that examples of such Sasanian paintings were available to the earlier illustrators of the *Shāh Nāmah*. From the period of the tenth century, at the close of which Firdawsī completed his first version of the *Shāh Nāmah*, we have three independent references to pictures of Sasanian origin; e.g. Mas'ūdī tells us that about the year 915 he saw in a history of the kings of Persia, belonging to a noble family of the city of Iṣṭakhr, pictures of each of the Sasanian rulers depicted in their royal robes at the time of death; a similar volume is mentioned by a geographer as having been preserved in the castle of Shīz, which was near the site of one of the most sacred fire-temples of Sasanian times; another geographer, Ibn Ḥawqal, in 977, describes a vast building in the district of Iṣṭakhr adorned with statues and pictures. These survivals of the tradition of Sasanian pictorial art doubtless comprised representations of the national legend of Persia, and must have served as models for the decoration of the room in Sultan Maḥmūd's palace, which this monarch had painted for Firdawsī when the poet set to work upon the compilation of his vast epic; the kings and heroes of Iran and Turan were here depicted, with their horses and elephants and camels and all their weapons of war.[2]

So far as can be judged from the surviving illustrated copies of the *Shāh Nāmah* the great Muhammadan artists seldom devoted their genius to the illustration of this work, and, with the exception of a few royal manuscripts, the task appears to have been left to artists of mediocre talents. The subject-matter of this enormous epic tends to become monotonous, with its constantly recurring episodes of single combat and of battle. The adventures of Rustam, Alexander, and Bahrām Gūr arouse a more personal interest, of which the painters took advantage. But the historical provenance of the various types to be found in the numerous manuscripts of the *Shāh Nāmah* still await careful investigation; many different schools of painters are represented, and it remains to be ascertained which of their paintings can be traced back to a Sasanian source and which of them are new inventions.

Next in popular favour to the *Shāh Nāmah* in the great mass of the poetical literature of the Persian language comes the *Khamsah*, or Quintet, of Nizāmī.

[1] E. Herzfeld, *Khorasan* (*Der Islam*, Vol. XI (1921), p. 154).
[2] *Shāh Nāmah*, ed. Turner Macan, Vol. I, p. 34 (Calcutta, 1829).

This attractive writer, a master in the composition of poetical romances, died at the beginning of the thirteenth century, and his poems enjoyed a great reputation, especially during the periods in which painters received most generous patronage in the courts of the Persian princes. Consequently his writings have been illustrated by paintings bearing some of the greatest names in the history of Muhammadan pictorial art. For the subject-matter of two of these romances, *The Haft Paykar* (or Seven Portraits) and *Khusrau and Shirin*, the poet has flattered the national sentiment of the Persians by drawing his material from the history of the Sasanian kings; and in the earliest of the five, *The Treasury of Mysteries*, he includes a number of stories belonging to the same period of Persian history. The other two deal respectively with the favourite story of the lovers, Laylā and Majnūn, and the adventures of Alexander as the typical Muslim hero. Genuinely pious, with a tendency to mysticism, but full of keen interest in the changing vicissitudes of human life and the varieties of human character, Nizāmī made a strong appeal to his contemporaries and to each succeeding generation of readers of Persian poetry. Direct and simple in his exposition, and free from metaphysical obscurities, he found favour with simple, devout minds as with lovers of the story well told.

Next in popularity to Nizāmī, as providing material for the painters to illustrate, was Saʿdī (*ob. circa* 1291), the most popular poet in the Persian language, whose *Gulistān* and *Būstān* exist in innumerable copies and have been illustrated by an enormous number of artists. But for some strange reason the poems of Ḥāfiẓ have seldom received pictorial treatment, and though pictures that might well have served as illustrations of these poems exist in hundreds, illustrated copies of his *Dīwān* are exceedingly rare; perhaps the commonly accepted mystical interpretation of his poetry stood in the way of its being illustrated in consequence of the devout feeling with which the majority of Muhammadans read it. A number of other names of poets might be given as having had their works illustrated by the painter, but none have so commonly become subjects for pictorial treatment as those already mentioned.

Among prose works illustrated manuscripts are much rarer than books of poetry. Persian histories are generally bulky works, and the painter has seldom been called in to assist in the preparation of new copies. Yet there are notable exceptions, such as the copy of the Persian translation of Ṭabarī's *History of Prophets and Kings* belonging to Mr. Kevorkian, the copy of Rashīd ad-Dīn's *History of the Mongols* (Suppl. persan 1113) in the Bibliothèque Nationale, and a few other historical works. It appears strange that the

painters were not more frequently employed to illustrate historical writings, seeing that they had shown so much skill in the dramatic representation of feats recorded by the poets, to which the Muhammadan reader often gave the same credence as he did to more sober annals.

One of the commonest prose works containing pictures is the *Marvels of Creation* by Qazwīnī, a treatise on cosmography which has had a great vogue in the Muhammadan world and has been translated from Arabic into several languages, such as Persian, Turkish, and Urdu. It is a compendium of the natural sciences as known to the Muslims of the thirteenth century, and comprises sections on astronomy, physics, zoology, mineralogy, &c. Mixed up with much soberly recorded scientific information there are many recitals of marvels such as excited the imagination of the Middle Ages both in the West and in the East, and many strange monsters are described of which the modern scientific world knows nothing. A comparative study of the Bestiaries and other medieval representations of monsters would reveal many similarities to the Muslim illustrations to Qazwīnī's work, but this investigation still remains to be carried out. There can be little doubt but that the painters in Persia and other parts of the Muslim East have in several instances copied the work of Christian artists; e. g. in one picture in Professor Sarre's MS. of Qazwīnī are found the symbols of the four Evangelists—the angel of St. Matthew, the lion of St. Mark, the ox of St. Luke, and the eagle of St. John (Plate XVI). Some of the strange monsters—elephant-eared and dog-headed men, human beings whose trunks are supported by a single leg, and other hideous fantasies[1]—are common to these Muhammadan MSS. and to the sculptures of medieval cathedrals, and in both instances they are probably to be traced back to the same oriental source.

Illustrated prose romances and fairy stories are common in later Persian and Indian manuscripts, but they mostly belong to a period when the art of painting in the Muhammadan world was on the decline. From the nature of the subject-matter these illustrations often tend to take on an erotic character. Indeed pictures of this kind occur in every period, and it is characteristic of the prevailing courtly character of Muhammadan painting that the earliest examples of it should belong to erotic art. The hostile attitude of the official exponents of the faith of Islam deprived the Muslim painter of that encouragement and patronage which so largely determined the development and success of Buddhist and Christian art and threw around their art of painting the protecting mantle of religion. Religious art in Islam

[1] E. g. in the tympanum of the great doorway of the Abbey of Vézelay (twelfth century) (Émile Mâle, *L'art religieux du XIIᵉ siècle en France*, pp. 327–30, Paris, 1924).

there certainly was, as will be shown in the next chapter, but it came into existence in spite of the condemnation of the teachers of the faith, and represents rather a spirit of artistic self-expression which refused to be suppressed than a normal outcome of the religious life of Islam. The Muslim painter, therefore, had to look to the monarch and his court for the means of livelihood, and erotic art of some kind has generally received encouragement in wealthy courts of all creeds and countries. Like his contemporaries in other lands the painter in a Muhammadan society had to consult the tastes of his patrons, and erotic art has consequently filled as large a place in the pictorial art of the Muhammadan world as it has in that of Christendom.

There may have been Muhammadan Sultans whose piety condemned such pictures, even as Louis IX would have detested the pictures which Boucher painted for Louis XIV; so similarly Fīrūz Shāh Taghlaq would have gladly destroyed the decorations which Shāh 'Abbās had painted in his country house at Ashraf.

The fact remains that the earliest examples of painting in the Muhammadan period that have survived to us are the frescoes of the baths of Quṣayr 'Amra, which, as a pleasure house of one of the Umayyad princes, reflects the luxurious character of the majority of the Caliphs of the Umayyad dynasty.[1] From the eighth century onwards the decoration of baths appears often to have assumed this character. For the execution of such pictures the Muslim conquerors had at the outset to employ painters from among the conquered peoples of the Roman empire, and even some classical statues seem to have found a temporary refuge from the iconoclastic zeal of the Arab conquerors in such baths, for when the Umayyad Caliph, Yazīd II, in A.D. 722, gave orders for the destruction of all idols, among the statues destroyed was the so-called idol of the bath of Zabbān,[2] the Caliph's cousin; it is thus described by a poet: 'If any man hath in his heart a place for fair ladies, then let him go to the fair one in the bath of Zabbān:

> It is matchless and graceful, slim-waisted, well-proportioned,
> On its bosom are two breasts.'[3]

From the Umayyad period the only royal bath that has survived to us is that of Quṣayr 'Amra; from the Abbasid period there are only those shattered fragments which the patient excavations of Professor Herzfeld have recovered from the ruins of the palace of Mutawakkil (847–861) in Sāmarrā. The stucco which covered the walls of the baths in the women's

[1] See p. 29.
[2] This bath was probably in Alexandria (Al-Kindī, *The Governors and Judges of Egypt*, ed. R. Guest, p. 101). [3] Al-Kindī, *op. cit.*, pp. 71–2.

apartments in this palace had been decorated with paintings, which appear
to have been renewed whenever the dampness of the baths made a fresh
coating of plaster necessary, so that as many as sixteen layers of such plaster
have been found stuck together[1] (Plate XVII). Hardly any complete pictures
could be made up out of the broken fragments, but the semi-nude figures
of dancing-girls and musicians suggest that the general character of the
decoration must have been much like that of Quṣayr ʿAmra.

For our knowledge of other examples of such baths we have to depend
upon descriptions, and from the very nature of the circumstances descriptions
are rare. To the period of the decline of the Abbasid dynasty belongs the
story of how Maḥmūd of Ghaznī (998–1030) came to learn from his spies
that his son Masʿūd, who afterwards succeeded him, had had a pavilion built
in the garden of his palace in Harāt, decorated from the ceiling to the floor
with paintings taken from one of those many manuals in Arabic or Persian
based on the Sanskrit *Kāmaśāstra*. Maḥmūd sent a special messenger with
orders to insist on inspecting the pavilion and make a report; but Masʿūd,
who had his own spies at his father's court, had been warned in time and set
plasterers to work to cover up the objectionable pictures with a fresh coating
of plaster, so that when the royal messenger arrived and broke open the door
of the pavilion he found its walls bare but for some plain hangings.[2]

From the thirteenth century we have a more detailed description of a bath
in Baghdad in the palace of Sharaf ad-Dīn Hārūn, a poet and a patron of
poets; he was the son of that great statesman Shams ad-Dīn Muḥammad
Juwaynī, who was at the head of the administration of Persia during the
reigns of three successive Mongol rulers, Hūlāgū, Abāqā, and Aḥmad, but
when the last of these princes was defeated and assassinated by his nephew
Arghūn in 1284 Juwaynī was also put to death together with his sons.[3] The
palace of Sharaf ad-Dīn Hārūn appears to have been a building of great
magnificence, and the bath, containing as many as ten different rooms, was
decorated with rare and costly marbles of various colours, and the water
came out of pipes of silver or of silver-gilt, some of them in the shape of
birds, so fashioned that as the water poured forth it produced the special
note of the particular bird represented. The inner apartment of the bath was
kept locked and was decorated with pictures of various forms of sexual
intercourse.[4]

[1] Ernst Herzfeld, *Die Malereien von Samarra*, p. vii (Berlin, 1927).
[2] *Taʾrīkh-i-Bayhaqī*, pp. 135–9 (Calcutta, 1862).
[3] E. G. Browne, *A History of Persian Literature under Tartar Dominion*, pp. 20 1, 29.
[4] Makkarī, *Nafḥ aṭ-Ṭīb*, Vol. II, pp. 235–6.

Fuller details are available regarding the summer palaces which Shāh 'Abbās (1587–1629) had erected at Ashraf early in the seventeenth century. The local legend reports that one of his sons was a laggard in love, and that the Shāh ordered one of these buildings to be decorated with erotic pictures, hoping by such means to incite him to the performance of his marital duties.[1]

Such pictures were still in existence in the ruined palace of 'Imārat-i-Chashmah, which Shāh 'Abbās built at Ashraf in 1612, when Sir William Ouseley visited it two centuries later; he speaks of certain rooms in which 'the plaster had been totally or partially cut out from the wall, with a design, as it would seem, of removing certain groups, the least worthy of preservation; for, from imperfect figures still visible, the subjects were evidently most offensive to modesty, but therefore adapted to the corrupt taste of Persians; or as Hanway says of the paintings which he saw in another edifice here,[2] "such as could please only a voluptuous Mahommedan" '.[3]

The same writer makes a similar report on the palace of Jahānnumā, erected by Shāh 'Abbās at Farahābād, twenty-six miles from Ashraf, about the same date.[4]

'Abbās II (1642–1667) does not appear to have shared the opinions of his great namesake in these matters, judging from the account which Sir William Ouseley gives of the fate of some pictures which he saw on a bridge, built in the early part of the seventeenth century by Aliverdi Khān, at Julfa, near Ispahan; his account of them is as follows:

'Among the recesses of its battlements are those small chambers where several indecent pictures so much offended the delicacy of Abbas the second, that by his order the entrances were closed. But had it been the monarch's object to preserve public morals from contamination he should have totally effaced those vestiges of a licentious pencil; there, however, they remain; and the doorways of those chambers having been during a century filled up with brick and lime were opened a few years since at the instigation of curiosity; and such painted scenes of impurity are now disclosed in various compartments on the walls, as must have tended to corrupt the innocence of rusticks on their

[1] J. C. Haentzsche, *Paläste Schah Abbas I von Persien in Masanderan* (ZDMG, Bd. 18, p. 677, 1864). The present condition of this building is described by F. Sarre, *Denkmäler persischer Baukunst*, p. 109 (Berlin, 1901–10).

[2] Jonas Hanway visited Ashraf in 1744, when the palace appears to have been still in good repair; he describes this building as 'a banqueting-house, which was dedicated to a grandson of Ali; out of respect to this place we were obliged to leave our swords at the door. The solemnity with which we were conducted struck me with a kind of religious awe; but this was soon changed into contempt; for I was surprised to find the room adorned with paintings, such as could please only a voluptuous Mahommedan' (*An historical account of the British trade over the Caspian Sea: with the author's journal of travels from England through Russia into Persia*, Vol. I, p. 200 (London, 1754)).

[3] *Voyages*, Vol. III, p. 273.

[4] Id., Vol. III, p. 285. Curzon (*Persia*, Vol. I, p. 378) describes it as being now only a miserable village.

very approach towards the capital, and taught lessons of extreme depravity to the infant citizens while yet unconscious that what they learned was vice. The figures appear to have been executed in a style worthy of better subjects, and beyond the skill of modern Persian artists; but from the fading colours we may reasonably hope that these pictures will not much longer continue to excite disgust or taint the imagination.'[1]

Pictures of this kind, however severely reprobated by the godly and the scrupulous, did not fail to find defenders among the physicians; a member of this profession about the end of the fourteenth century wrote a work on various sources of enjoyment—gardens, banquets, friends, singers, fish, flesh, and fowl, books, fine literary style, &c. When he comes to speak of the ideal bath, he says that

'it should contain pictures of high artistic merit and great beauty, representing pairs of lovers, gardens and beds of flowers, fine galloping horses and wild beasts; for pictures such as these are potent in strengthening the powers of the body, whether animal, natural or spiritual. Badr ad-Dīn ibn Muẓaffar, the Qāḍī of Ba'albak, says in his book *Mufarriḥ an-nafs* ("The gladdener of the soul"): "All physicians, sages and wise men are agreed that the sight of beautiful pictures gladdens and refreshes the soul, and drives away from it melancholy thoughts and suggestions, and strengthens the heart more than anything else can do, because it rids it of all evil imaginings." Some say, If a sight of actual beautiful objects is not possible, then let the eyes be turned towards beautiful forms, of exquisite workmanship, pictured in books, in noble edifices or lofty castles. Such is also the thought that Muhammad ibn Zakariyā ar-Rāzī expresses and strongly urges on any one who finds within himself carking cares and evil imaginings that are not in harmony with the poise of nature; for he says, When in a beautiful picture harmonious colours such as yellow, red and green are combined with a due proportion in their respective forms, then the melancholy humours find healing, and the cares that cling to the soul of man are expelled, and the mind gets rid of its sorrows, for the soul becomes refined and ennobled by the sight of such pictures. Again, think of the wise men of old, who invented the bath, how with their keen insight and pene-trating wisdom they recognised that a man loses some considerable part of his strength when he goes into a bath; they made every effort to devise means of finding a remedy as speedily as possible; so they decorated the bath with beautiful pictures in bright cheerful colours. These they divided into three kinds, since they knew that there are three vital principles in the body—the animal, the spiritual, and the natural. Accordingly they painted pictures of each kind, so as to strengthen each one of these potentialities; for the animal power, they painted pictures of fighting and war and galloping horses and the snaring of wild beasts; for the spiritual power, pictures of love and of reflection on the lover and his beloved, and pictures of their mutual recriminations and reproaches, and of their embracing one another, etc.; and for the natural power, gardens and beauti-ful trees and bright flowers.'[2]

Such a defence could not win the approval of an orthodox theologian or

[1] *Travels*, Vol. III, pp. 48–9.
[2] 'Alī b. 'Abd Allāh al-Bahā'ī al Ghuzūlī, *Maṭāli' al budūr fī manāzil as surūr*, pp. 7-8 (Cairo, 1883).

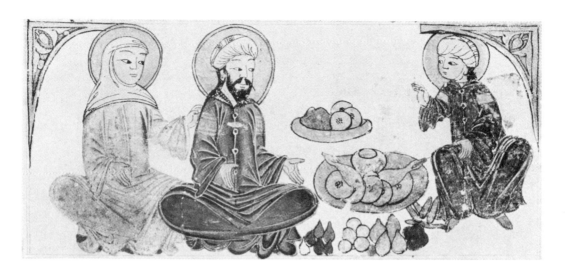

XVIII. a. Abel revisiting his parents

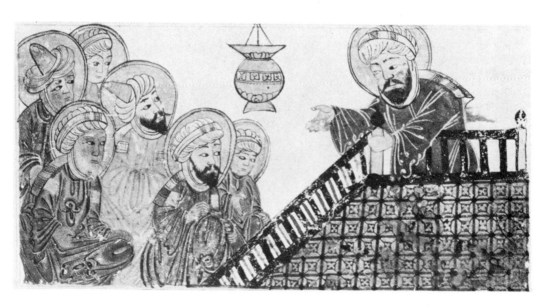

XVIII. b. Muḥammad preaching his farewell sermon

legist, though there were some who were willing to make such a concession to common custom as to permit the frequenting of a painted bath, provided that the pictures were to be found only on the outside or in the vestibule; such a permission was not, however, to be taken to imply approval of so reprehensible a practice, for it only gave reluctant acquiescence to the wicked ways of the world on the ground that the place in which such pictures were found indicated that they were regarded with contempt.[1]

In agreement with such a judgement was the common belief that the bath was a favourite resort of evil Jinn, and that neither should prayers be performed nor the Qur'ān be recited in it.[2] This reputation may explain the fact that pictures of the Devil were sometimes painted in a bath—if credence may be placed in a verse of Saʿdī in which the poet tells how a man had a vision of Iblīs as tall and handsome; surprised, he asks, 'Why have men believed you to be so horrible of aspect, and why have they painted you so hideous in the bath-room? Why have they depicted you in the king's palace with dejected countenance, twisted hand, and ugly and ruined?'[3] The answer of Iblīs is that it is an enemy who had done this. Of any such picture in a bath-room no example or even any description appears to have survived.

Another common feature of the decoration of baths was the terrible bird known as the ʿAnqā,[4] which is as old as Sasanian times and corresponds to the Sīmurgh of the later Persian poets and the dreaded Rukh of the Alf Laylah.

Even to the present day the entrances of baths are decorated with pictures in Persia and in those parts of ʿIrāq in which Persian influence has made itself felt.[5]

It is impossible to speak of Muslim erotic art without making reference to the love of boys, which was so characteristic a feature of Muhammadan culture from the ninth to the nineteenth century.[6] The poetry of the Muhammadan world from the time of Abū Nuwās (ob. circa A.D. 810) onwards has been full of love-songs addressed to boys, and the painters naturally fell in with a fashion so widespread among cultured persons. Pictures of elegant, lackadaisical youths, such as Thomas Herbert[7] saw at the court of Shāh ʿAbbās

[1] C. Snouck Hurgronje, *Verspreide Geschriften*, Vol. II, p. 455.
[2] E. W. Lane, *Manners and Customs of the Modern Egyptians*, 5th ed. (1860), p. 337.
[3] *Būstān*, ed. C. H. Graf, p. 52, ll. 216–17 (Vienna, 1858).
[4] Masʿūdī, *op. cit.*, Vol. III, p. 29. [5] E. Herzfeld, *Die Malerein von Samarra*, p. 2.
[6] The translator of Ibn Khallikān's *Biographical Dictionary* (Vol. IV, p. 83), Baron Mac Guckin de Slane, writes: 'Amongst the Muslim princes, ʿulamā, qādīs, and poets, there were probably but few who could say with Ovid: Amore puerorum tangor minus.' Cf. A. Mez, *Die Renaissance des Islams*, p. 338 ('Hoch und Nieder fröhnte dieser Sitte').
[7] *Travels into Divers Parts of Asia and Afrique*, p. 169 (London, 1638).

in 1628, whom he describes as 'the Ganimed Boyes in vests of gold, rich bespangled Turbants, and choice sandalls, their curl'd haires dangling about their shoulders, rolling eyes, and vermillion cheeks, with Flagons of most glorious mettall, [who] went up and downe, and proffered the delight of Bacchus to such would relish it', were common in the seventeenth and eighteenth centuries, and were frequently painted by Riẓā 'Abbāsī and his school.

VI

RELIGIOUS ART IN ISLAM

FROM the evidence set forth in a previous chapter it might appear that no form of religious art whatsoever would be possible in a Muhammadan society,[1] and those who have denied the existence of Muslim religious pictures[2] could adduce an abundance of literary evidence in support of such a conclusion. It is certain that the severe condemnation of the sculptor and the painter embodied in the Traditions of the Prophet had made it impossible for either plastic or pictorial art to receive the sanction of the Muslim theologian. Consequently, as explained above, Islam has never welcomed painting as a handmaid of religion as both Buddhism and Christianity have done. Mosques have never been decorated with religious pictures, nor has pictorial art been employed for the instruction of the heathen or for the edification of the faithful.

Nevertheless, despite the hostility of the theologian and the unsympathetic attitude of the main body of orthodox believers, there have been certain aspects of Islamic religious thought which have found expression for themselves in pictorial form, and the painter has been called up to depict the various scenes of Muslim religious history. He has even laid profane hands on the person of the Prophet himself, though pictures of Muḥammad are so rare that some writers have even doubted the existence of any.[3]

But these religious pictures occur sporadically only, as they were exposed to more than a double measure of the wrath which figured art excited in the minds of the orthodox; for if it was unlawful to usurp the function of the Creator by representing the forms of any living beings, how much more outrageous was it to attempt to depict such holy personages as the Prophets of the Lord! Accordingly, there has never been any historical tradition in the religious painting of Islam—no artistic development in the representation

[1] Religious art in a Muslim country, of course, finds its fullest expression in architecture—in the mosque and the tomb of the saint.

[2] E.g. 'Religiöse Themen überhaupt von figürlicher oder symbolischer Wiedergabe ausgenommen sein sollten. Gegen diese Auffassung hat man denn auch im ganzen mohammedanischen Länderbereich zu keiner Zeit verstossen: niemals ist irgend ein islamischer Glaubensatz im Bilde veranschaulicht worden' (E. Kühnel, *Miniaturmalerei im islamischen Orient*, p. 1 (Berlin, 1922)).

'Die künstlerische Verwertung religiöser Motive ist im Islam unerhört.' (Martin Hartmann, 'In Sachen der ostwestlichen Beziehungen in der Kunst der islamischen Länder', *Orientalische Litteratur-Zeitung*, Vol. IX, col. 180, 1906).

[3] 'Ce seroit pour un Musulman le plus grand sacrilège que de tracer la figure de son Prophète' (M. d'Ohsson, *Tableau de l'empire othoman*, Vol. IV, p. 444 (Paris, 1791)).

of accepted types—no schools of painters of religious subjects; least of all
has there been any guidance on the part of leaders of religious thought
corresponding to that of the ecclesiastical authorities in the Christian Church.
In Muslim literature there has never been such a manual as that compiled in
the eleventh century by Panselinos of Mount Athos for the guidance of the
Byzantine painters,[1] or the regulations laid down in the middle of the sixteenth
century by the clergy of the Russian Church assembled in the Council of
the Hundred Chapters.[2] On the contrary, the Muslim painter must always
have been hampered by a haunting sense of the disapproval of the more
devout minds among his co-religionists; he could never feel, like his Christian
contemporary, that earnest prayers would be offered before his handiwork
or that it would serve to stimulate and encourage devotion. It was impossible
for the Muslim religious painters to take such an exalted and encouraging
view of their own function as did the Sienese painters in the fourteenth
century, who, in the opening words of their statute, proclaimed themselves
'per la gratia di Dio manifestatori agli uomini grossi che non sanno lectera,
de le cose miracolose operate per virtù et in virtù de la sancta fede'.[3] Nor
were they ever called upon to illustrate the sacred scriptures of their faith;
the Bible has provided subject-matter for Christian painters from the earliest
period of Christian art, but no such thing as an illustrated version of the
Qur'ān has ever been known to exist, and indeed to most Muslim minds such
an outrage would be inconceivable; the Umayyad Caliph 'Abd al-Malik
(685–705) might close the sacred volume on hearing of his accession with
the words, 'Now you and I part',[4] and Yazīd III (744) might make the
Qur'ān a target for his arrows,[5] but no Muslim monarch, however godless,
was guilty of putting the Word of God into the hands of his court painters
for them to work their wicked will upon it.

During the earlier centuries of the Muslim era it is unlikely that any
attempt was made towards the pictorial presentation of incidents of sacred
history; at any rate none of the examples that have come down to us are of
an earlier date than the beginning of the fourteenth century. Consequently,
the painters of this and successive periods had no tradition of religious art
on which to model their own productions, and it is not clear what were the
springs of their artistic inspiration. The earliest record we have of any
pictorial representation of Muhammad is in a story told by an Arab merchant,

[1] *Das Handbuch der Malerei vom Berge Athos*, übersetzt von G. Schäfer, p. ix (Trier, 1855).
[2] N. P. Kondakov, *The Russian Ikon*, translated by E. H. Minns, p. 139 (Oxford, 1927).
[3] G. Milanesi, *Documenti per la storia dell' arte senese*, Vol. I, p. 1 (Siena, 1854).
[4] Suyūtī, *op. cit.* p. 84 (ll. 24–5). [5] Id., p. 98 (l. 10).

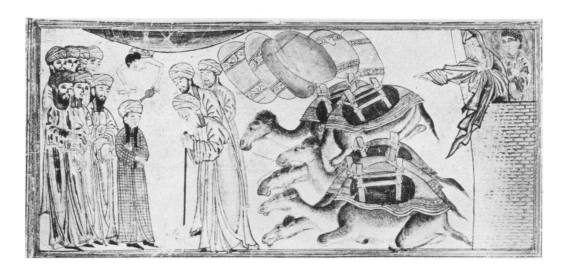

XIX.　a. The monk Baḥīrā recognizing the prophetic mission of Muḥammad

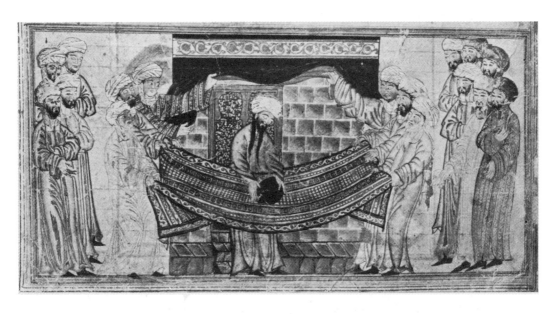

XIX.　b. Muḥammad replacing the Black Stone in the Kaʻbah

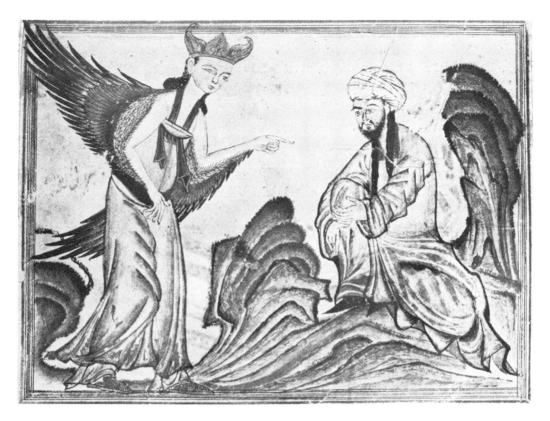

XX. a. Muḥammad receiving the message of the angel Gabriel

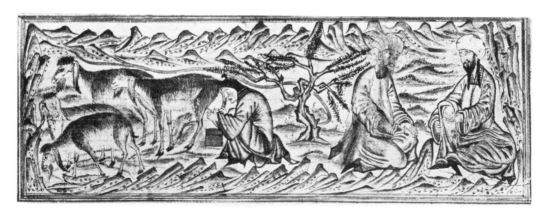

XX. b. Muḥammad and Abū Bakr on their way to Medina

named Ibn Ḥabbār, who travelled in China in the ninth century. He describes an audience that he had with the Emperor of China, who asked him whether he would like to see a picture of the Prophet; whereupon an officer of the court brought in a box containing portraits of the Prophets of Islam, e. g. Noah in the ark, Moses with the Children of Israel, Jesus seated on an ass accompanied by the twelve Apostles, and Muḥammad on a camel surrounded by his Companions.[1]

It is not impossible that such pictures may have been produced in China by adherents of the Nestorian Church, which had established itself in that country as early as the seventh century.[2] As will be shown later, there are clear indications that the Muslim or other painters working for Muslim patrons copied or adapted Christian religious pictures for their own purposes. These painters may possibly themselves have been Christians, or, if not, they may have had Christian works of art before them while they were working.

The earliest examples of portraits of Muḥammad that have survived to us are found in a çopy of the *Jāmiʿ at-Tawārīkh* by Rashīd ad-Dīn, part of which belongs to the Royal Asiatic Society in London[3] and part to the Edinburgh University Library.[4] Rashīd ad-Dīn (as already explained) made elaborate arrangements for the distribution of copies of his work, and when engaged in the compilation of his Universal History sent for two learned Chinamen, who brought with them from China a number of books dealing with medicine, astronomy, and history.[5] The subject-matter of his enormous work embraced the whole history of the world, so far as it was known to the author, who was a man of vast learning, said to have been acquainted with the Hebrew, Mongol, and Turkish languages as well as those commonly familiar to a Muhammadan scholar of his time—Arabic and Persian. His history begins with Adam and comprises the annals of the Jewish people and as much of the history of the Christian Franks as was of interest to a Muhammadan writer; especial attention is given to the early history of the kings of Persia, and (what is more unusual) there are accounts also of the Chinese and of the Hindus; and the whole of Muhammadan history is traversed up to the author's own time.

[1] Masʿūdī, *Murūj adh-Dhahab*, Vol. I, pp. 315–17 (Paris, 1861).

Mīrkhwānd (*Rauẓat uṣ-Ṣafà*, translated by E. Rehatsek, Vol. I, pp. 82–3) transferred this story to the Emperor Heraclius and Hishām ibn al-ʿĀṣ, who is said to have been sent by the Prophet on an embassy to Constantinople; and Khwāndamīr copied his grandfather's narrative into his own *Ḥabīb as-Siyar* (Vol. I, Part IV, pp. 9–10, Bombay, 1857).

[2] A. Mingana, *The Early Spread of Christianity in Central Asia and the Far East*, p. 31 (Manchester, 1925). [3] Arabic No. 26. [4] Arabic No. 20.

[5] *Histoire des Mongols de la Perse, écrite en persan par Raschid eldin*, publiée par M. Quatremère, p. lxxviii (Paris, 1836).

For the illustration of this book he probably attracted to Tabrīz from various quarters the most competent painters he could, and provided them with pictures and illustrated historical works to serve as models for their own compositions, and took as great pains in this respect as he had shown in the collection of historical materials for his text. Unfortunately, none of the illustrations in the MS. above mentioned bear the signature of any artists, so we have no indications as to their nationality or religion, but in their work it is possible to trace distinct Chinese influences, especially in the drawing of trees and the character of the landscape. The costumes of the warriors are of a Mongol type, the sovereigns wear the Mongol dress, and there are many other indications that the prevailing influence in these pictures came from the East. But the painters must also have had Christian and Hindu pictures to work from.

From what source they derived their striking type of the person of Muḥammad has not yet been determined. There are altogether as many as eight pictures in which the Prophet appears; in all of them, except the picture of his birth, he is represented with a tall, somewhat emaciated body and a melancholy expression on his countenance. This look of dejection is, however, not peculiar to this distinguished personage, but is characteristic of most of the faces that appear in the illustrations of this manuscript, for a sense of melancholy seems to brood over all of them, as though the painters were oppressed by feelings of horror at the subjects they were called upon to depict, consisting as they do for the most part of battle scenes, executions, mutilations, and various forms of torture.

Muḥammad himself is presented to us as a slim youth before whom the camels kneel down in worship and the spectators reverently bow when the monk Baḥīrā recognizes him as a Prophet (fol. 15). Again, as a young man, he stands before the Ka'bah and lifts up the Black Stone, which four prominent citizens of Mecca present to him on a long strip of carpet (fol. 46 b) (Plate XIX). As an older man, seated on Mount Ḥirā in an attitude of profound depression, he receives from the Angel Gabriel the announcement of his prophetic mission (fol. 16), and later, after his fellow townsmen have rejected his warning utterances and he has to flee in peril of his life from his enemies in Mecca, he rests in the desert on his way to Medina with one of his earliest converts, Abū Bakr, while an old woman milks a goat for the refreshment of the weary fugitives (fol. 19); there is a pathos in this picture such as the Muhammadan painters seldom succeed in putting into their compositions, and the faithful Abū Bakr gazes into the face of his venerated friend with touching devotion (Plate XX).

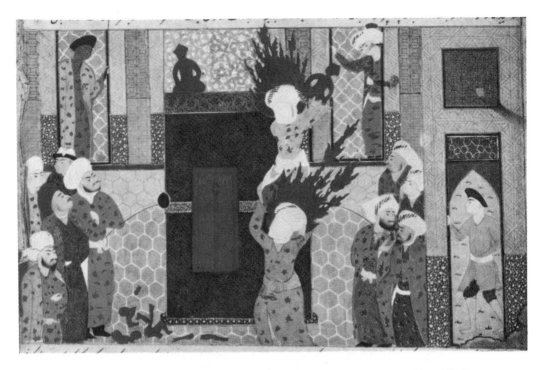

XXI. a. Muḥammad throwing down the idols from the Ka'bah

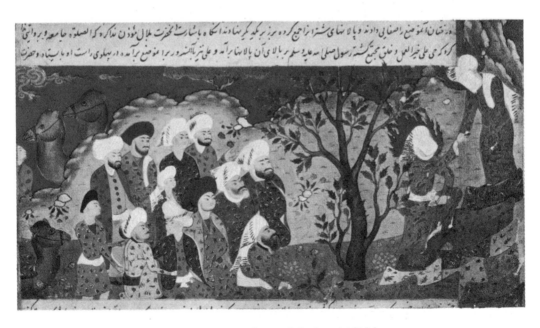

XXI. b. Muḥammad proclaiming 'Alī his successor

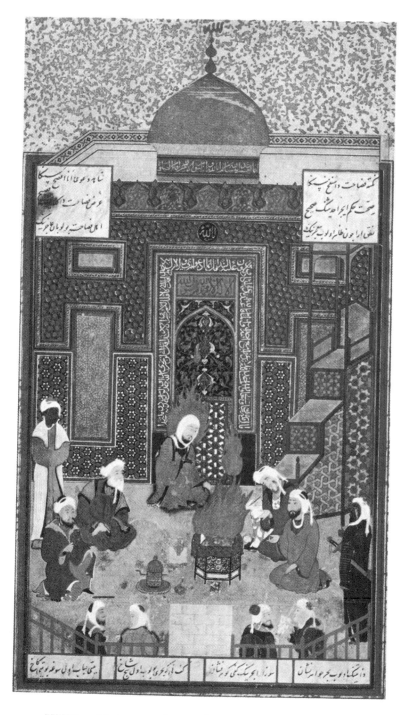

XXII. Muḥammad seated among his Companions

It is, of course, not possible for the illustrators of the life of the Prophet to omit a picture of his heavenward journey on Burāq, to which reference will be made in the next chapter, but the representation of this subject in this MS. (fol. 18) can hardly be described as successful, for the Prophet clings awkwardly to his strange steed, as if in some apprehension of falling off.

In none of these pictures is Muḥammad represented with a halo, nor is there any indication of his exalted status as the Apostle of Allah, except the prominent position he occupies in each separate picture. But in a MS. of al-Āthār al-Bāqiyah ('The abiding memorials from the generations that have passed away') by al-Bīrūnī,[1] of almost the same date—707 A.H. (\doteqdot A.D. 1307–8) —Muḥammad appears with the round halo so familiar in Christian art (foll. 11 b and 193). In the first of these[2] he is shown riding on a camel, with Jesus by his side on an ass, while the Prophet Isaiah, looking out of the window of his house, watches them approach; to this vision of Isaiah the Muslim theologian appealed when his Christian opponent twitted him with the fact that whereas the coming of Jesus was foretold in many verses of the Old Testament, no prophecy could be found predicting the mission of Muḥammad. So the Muslim controversialists quoted the Book of the Prophet Isaiah (xxi. 6, 8, 9), according to a version of their own, as follows: 'For thus hath the Lord said unto me, Go, set a watchman; let him declare what he seeth. And he cried, O Lord, I stand continually upon the watch-tower in the day-time, and am set in my ward whole nights; and behold I see a man riding on an ass, and a man riding on a camel, and one of them came forward crying, and said: Babylon is fallen, and all the graven images of her gods he hath broken unto the ground.' To the Muslim theologian he that rode on the ass was Jesus, and the rider on the camel was Muḥammad; and to whom but to Muḥammad could the destruction of Babylon be ascribed? for in consequence of the coming of the Prophet of Islam, Babylon (or its successor) had indeed fallen, its idols had been broken, and its empire had perished.

In each of the pictures in this Edinburgh MS. the Prophet's head is surrounded by a halo. But too much importance must not be attached to this mark of distinction, for not only does he share it with the other Prophets of God—as, of course, is in harmony with Muslim teaching—but also with

[1] No. 161 in the Catalogue of the Arabic and Persian MSS. in the Library of the University of Edinburgh. This work gives an account of the systems of chronology that had been adopted in various countries at different periods up to the time of the author—about A.D. 1000—and it is somewhat strange to find any pictures in it at all, but the author mentions the chief festivals and other historical events connected with each calendar and thus provides suitable subjects for the illustrator.

[2] Plate 15 in *Survivals of Sasanian and Manichaean Art in Persian Painting* (Oxford, 1924).

Ahriman, the spirit of evil, when he tempts the first man and woman[1] (fol. 49 b); the false Prophet Bihāfrīd (fol. 111 b); King Nebuchadnezzar burning the temple of Jerusalem (fol. 158); the Persian tyrant Ḍaḥḥāk (fol. 122); the executioners of Ḥallāj (fol. 113); and the woman bringing wine to the revellers at the fair of ʿUkāẓ (fol. 188).

Used in this indiscriminate manner, the halo ceases to carry with it any association of holiness and becomes merely a meaningless decoration. But the flame-halo, which superseded it in Persian art, appears to have been reserved for Muḥammad and the other Prophets, and, in Shiah pictures, for ʿAlī also. In Indian paintings, on the other hand, in which the round halo again makes its appearance, it is used to indicate sovereignty and adorns the heads of the emperor and of members of the imperial family, and also occasionally of some of the saints.

In Persian and Indian art the representations of Muḥammad that most commonly occur show him as riding on Burāq, the consideration of which demands a separate chapter. Such pictures and the majority of the other scenes in which he occurs are generally found as isolated paintings or as illustrations in poetical works where the text happens to provide suitable occasion for them. It is rare to find incidents of his life represented in works of history, and none of the standard biographies of the Prophet accepted by orthodox opinion appear to have been at any time provided with pictures. In such historical works of more general contents as happen to be illustrated —which in itself is rare—the painters seem to have felt some hesitation in inserting pictures of the founder of their faith among those of meaner folk, and it is hard to find a parallel to the frequent occurrence of the Prophet in the illustrations of Rashīd ad-Dīn's *Jāmiʿ at-Tawārīkh*. Messrs. Luzac & Co. possess a MS. of Mīrkhwānd's universal history, entitled *Rawḍat aṣ-Ṣafā* (dated 1003 A.H. = A.D. 1595), which contains several pictures of incidents in the Prophet's career, such as the mysterious event known as the splitting of the chest (fol. 15 b), the death of Abū Jahl in the Battle of Badr (fol. 44), the casting down of the idols from the roof of the Kaʿbah (fol. 83 b), and Muḥammad proclaiming ʿAlī as his successor at Ghadīr al-Khumm (fol. 97 b) (Plate XXI). But this MS. was obviously illustrated for some Shiah and was intended to subserve the glorification of ʿAlī, who is provided with as magnificent a flame-halo as the Prophet himself. Though a few other illustrated copies of this work are in existence, none appears to have pictures of this character.

There is another historical work in which portraits of the Prophet might

[1] Reproduced in *Survivals of Sasanian and Manichaean Art in Persian Painting* (Plate 15).

well be expected, namely, *Qiṣaṣ al-Anbiyā* (The Legends of the Prophets),—the title adopted by several authors for their account of the sacred annals of Islam,—but though of course a biography of Muḥammad is always included, the only incident illustrated in the MS. in the Bibliothèque Nationale (Persan 54, fol. 187) is the first meeting of Muḥammad with Khadījah, and the same is the case with the MS. belonging to Mr. Chester Beatty (fol. 273).

It is more common to find isolated pictures of what may be termed a Santa Conversazione, in which the Prophet is seated among his Companions, several of whom it is possible to identify, even when their names are not given. Such groups are undoubtedly in many instances tendentious and are intended to subserve the interests of the Shiah cause, as may be judged from the prominent or isolated position assigned to ʿAlī and his sons, Ḥasan and Ḥusayn. One of the finest of these groups is in a MS. of *Naẓm al-Jawāhir* by Nawāʾī dated A.H. 890 (= A.D. 1485).[1] The Prophet is seated in the prayer-niche of a mosque, which forms the background of the picture; it is a superb example of a building such as the painter himself may have known in the city of Harāt or Samarqand in the days of their greatness, with a green dome, and a front covered with intermingled blue and green tiles; with a similar disregard for the local conditions of Medina, the artist has set in front of the Prophet a great brazier from which rise up bright yellow flames of fire. Muḥammad is engaged in dictating either a passage of the Qurʾān or some official letter to a secretary, possibly Zayd ibn Thābit, who, seated on the ground before his master, is busily engaged in writing; by his side is another seated figure, and opposite these two other Companions of the Prophet, at whose identity it is only possible to guess, but they are possibly intended for the three devoted friends of Muḥammad, who succeeded him as leaders of the Muslim community. Standing in the left-hand corner is Bilāl, the first of the Muslims appointed to give the call to prayer; he is easily recognized by his black face, he being always thus represented on account of his Abyssinian birth. On the right stands ʿAlī, holding under his arm his famous two-pointed sword; in the foreground, just inside a slender railing, are seated four more of the Companions. The picture is a fine piece of composition, remarkable for the brilliancy and the harmony of its colouring (Plate XXII).

A picture of a much later date, probably the earlier part of the seventeenth century, has been reproduced in the *Burlington Magazine*,[2] from an Indian original. The scene is laid in the mosque at Medina; in the centre is the prayer-niche, on its right is a pulpit, and on its left a raised throne, on which

[1] Bodleian Library (Elliot 287, fol. 7). [2] Vol. XXXIV (1919), p. 249.

is seated Muḥammad, between his two grandsons, Ḥasan and Ḥusayn. In an archway, in the extreme left-hand corner, stands Bilāl, and below him are seated the first three Caliphs, Abū Bakr, 'Umar, and 'Uthman, and opposite them (in front of the prayer-niche) the fourth Caliph, 'Alī. The prominent place thus given to 'Alī clearly marks the Shiah proclivities of this picture, and supports the hypothesis that it was painted in one of the Shiah kingdoms of the Deccan. In a recess in the right hand of the background is 'Abbās, an uncle of the Prophet and the ancestor of the Abbasid caliphs of Baghdad, with his son 'Abdallāh. In the centre of the picture are the three 'pillars' of the Shiah sect: 'Ammār, one of the earliest converts to Islam, holding in his hands a copy of the Qur'ān; Qanbar, a freedman of 'Alī, with his master's famous two-pointed sword under his arm; Abū Dharr kneeling on a prayer-mat, on which lies his rosary; he is held in special reverence by the Shiah for his ascetic virtues; on his right hand stands Salmān, with his hands extended in prayer; he is said to have been a Persian Christian slave in Medina and one of the early converts in that city. Inside a marble balustrade, in the foreground, are six of the most famous Companions of the Prophet, while outside it are seated four others, each of whom is known for having come in conflict with 'Alī in more or less degree. The only figures to whom no name is attached are two men with their arms crossed, seated in a humble attitude on the right, and probably intended to represent two of the early mystics of Islam.

Such Shiah pictures designed for the glorification of 'Alī became more frequent in the eighteenth and nineteenth centuries, though at no time have they been very numerous, and attention has not been drawn to any other containing so large a number of figures; as a rule only the Prophet himself, his son-in-law 'Alī, and his two grandsons are represented.

In pictures from the sixteenth century onwards, and possibly earlier, the Prophet is distinguished, not by the round halo, which was probably of Christian origin (as in the two MSS. described above), but by the flame halo, which may certainly be traced back to the haloes of a similar form, occurring in paintings and statues of the Buddha.

Pictures of Muḥammad in which his features are visible are comparatively rare and most frequently occur in the earlier period. From the sixteenth century onwards a convention became established of hanging a short veil, from the forehead to the chin, over the face of the Prophet, so that his features were hidden. Such a concession to orthodox sentiment also occurs in representations of other Prophets, such as Abraham, &c., and the early saints of Islam, such as 'Alī and his grandson, Zayn al-'Abidīn.

XXIII. The birth of Muhammad

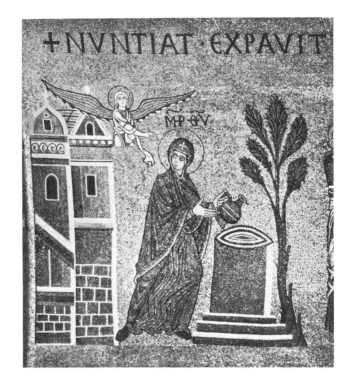

a

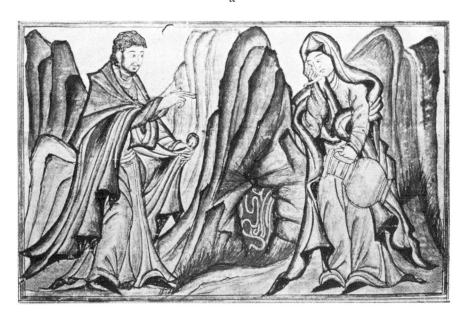

b

XXIV. The Annunciation

Later, reverence for the Prophet leads the painter to depict him merely as a flame, e.g. in a MS. of *Ḥamlah-i-Ḥaydarī*, a metrical history of Muḥammad and the first four Caliphs (Bibliothèque Nationale, Supplément persan 1078), dated 1632, the Prophet is represented in every case as a flame, without any indication of human form at all.

In an eighteenth-century copy of Saʿdī's *Būstān*, in the India Office Library (Ethé 1142, fol. 2 b), Muḥammad rides upon Burāq, enveloped in a white garment like a woman's burqaʿ, such as Indian ladies wear when they go abroad in the streets; though the Prophet is riding, not even his hands or his feet are visible (Plate LVI).

In the series of the inspired Prophets of Allāh, Islam assigns to Jesus the highest place after Muḥammad. Accordingly, in religious art, pictures of Jesus frequently occur, especially as poets, such as Nizāmī, Jalāl ad-Dīn Rūmī, Saʿdī, and others, constantly introduce anecdotes about him into their poems. The Muslim painters must in some cases have had before them Christian pictures of the life of Jesus and possibly illustrated MSS. of the Gospels. In the present shrunken condition of the Christian Churches in the Muhammadan East, it is sometimes forgotten how numerous was the Christian population under Muslim rule before the Mongol conquest and even later, as has been already shown in Chapter III, and social relations, closer and more intimate, between the adherents of the rival creeds, before the growing bitterness of later centuries estranged them, made it easier for the religious art of Islam to copy that of Christianity.

The picture of the birth of Muḥammad in Rashīd ad-Dīn's *Jāmiʿ at-Tārawīkh*[1] (fol. 43 b) is obviously reminiscent of a Christian picture of the Birth of Jesus. The angels hovering over the mother of the new-born child conform to a Christian type; in the place usually assigned to Joseph in Christian art, and in a similar attitude of bewilderment, sits ʿAbd al-Muṭṭalib, the grandfather and guardian of Muḥammad, for the Prophet was a posthumous child; and the three women who are coming to visit the mother correspond to the three Wise Men (Plate XXIII). Another illustration (fol. 23 b), which still more closely resembles the Christian type of representation for the same incident, is the picture of the Annunciation; according to the tradition of the Eastern Church,[2] the Angel Gabriel met the Virgin Mary as she was on her way to fetch water from a well, and a comparison with the mosaic in the Church of San Marco in Venice clearly shows that the Muslim painter must have attempted to copy a similar original; even the dress of the Virgin in

[1] Edinburgh University Library, No. 20.
[2] *The Apocryphal New Testament*, translated by M. R. James, p. 43 (Oxford, 1924).

the two instances corresponds, and the artist working for Rashīd ad-Dīn apparently did not understand the exact arrangement of her robe and in his endeavour to copy it produces a garment of a clumsy character, calculated to fall off as soon as the Virgin moved forward (Plate XXIV).

In the Annunciation in the MS. of al-Āthār al-Bāqiyah (fol. 166 b), though the scene is not set in the vicinity of a well, yet both the figure of the Virgin and that of the Angel suggest a Christian original, and the Virgin has a spindle and distaff in her hands and is engaged in spinning wool, in accordance with the traditional representation of her in Byzantine art.[1]

A Christian original also probably suggested the picture in this same MS. (fol. 49 b), in which, in accordance with the Zoroastrian tradition, the principle of evil, Ahriman, is represented as conversing with Mēshā and Mēshyāna, the first man and woman in the Zoroastrian legend. It would appear that the artist, finding no model to follow in such survivals of early Persian art as had come down to the fourteenth century, has adapted to his present purpose a Christian picture of God walking with Adam and Eve in the Garden of Eden.[2]

In the delineation of other incidents in the life of Jesus, the Muslim artist has had no Christian exemplar to follow—necessarily so, in cases where the Islamic account differs from that given in the Gospels; e. g. the Qur'ān does not describe the birth of Jesus as taking place in a stable, but in a remote and desolate place (Qur. xix. 22). In his presentation of the Nativity, therefore, the Muslim artist had to create his own types, and (so far as the writer is aware) the picture here reproduced is unique in Muslim art.[3] The Virgin in an attitude of exhaustion and dejection leans against the withered date-palm, which, at her touch, bursts into leafage and fruit, and from its roots a stream gushes forth; unfortunately, the silver used by the painter to depict water has, as in almost every other case in these Persian pictures, become tarnished and has turned quite black. The new-born babe, wrapped in swaddling clothes, lies on the ground, with a great flame halo of gold, which seems almost to serve as a pillow. Among the countless pictures of the Nativity to be found in the world, this one has characteristics that exist in no other, and though not remarkable as a work of art or in itself particularly beautiful, it is unique in its conception and execution (Plate XXV).

Similarly, no other Muhammadan representation of the Baptism of Jesus is known except that in al-Āthār al-Bāqiyah[4] (fol. 165 b), and though other

[1] *The Apocryphal New Testament*, p. 74.

[2] Reproduced in the author's *Survivals of Sasanian and Manichaean Art in Persian Painting* (Plate 15).

[3] From a MS. of the *Qiṣaṣ al-Anbiyā*, undated, but probably belonging to the end of the sixteenth century (fol. 225), in the collection of Mr. A. Chester Beatty. [4] See p. 95.

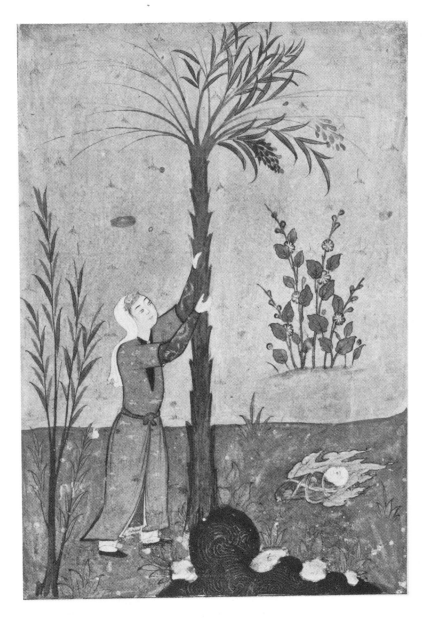

THE NATIVITY

XXV

Christian subjects in this volume suggest that the painter had some know-ledge of earlier Christian art, he has treated the Baptism in a manner peculiar to himself. The types he has selected for Jesus and St. John the Baptist are Central Asian, and peculiarly unattractive; the dress also is Central Asian, and the huge shoes which Jesus has put down in a prominent place before stepping into the water are such as are worn in Chinese Turkistan to the present day. The dove swoops down from the sky almost like a bird of prey and looks as if it were made of brass. A more unsympathetic repre-sentation of this important event in the life of Jesus it would be difficult to imagine.[1]

Other incidents in the Gospel narrative, which receive no mention in the Qur'ān, are illustrated in a MS. of Mīrkhwānd's *Universal History* in the Bibliothèque Nationale (Supplément persan 1567), such as Jesus casting a stone at the devil (fol. 155 b) and the Last Supper (fol. 163).

A variant of the parable of the Pharisee and the Publican was woven by Sa'dī into the text of his *Būstān* (ed. Graf, p. 237). Jesus is said to have been one day in the company of a devout person, when a reprobate overhearing their conversation repents him of his evil ways and resolves to amend his life. So, humbly he draws near the two holy personages; but the devout ascetic, annoyed at the interruption, wishes harshly to drive him away; whereupon Jesus rebukes him in the same spirit as in the Gospel narrative he expresses his commendation of the Publican (Plate XXVI).

One of the most beautiful stories that Muhammadan writers tell of Jesus is that one day, while walking in the bazaar with his Disciples, they passed the body of a dead dog lying in the gutter; one after another began to express his disgust at the sight; one exclaimed, 'How it stinks'; said another, 'Its skin is so torn, there is not enough left wherewith to make a purse'. But Jesus, selecting the one characteristic of the poor beast that was worthy of commendation, said: 'Pearls cannot equal the whiteness of its teeth.' This story first occurs in the literature of Islam, in the *Hadith*,[2] and was afterwards popularized by the poets, notably by Nizāmī in his *Makhzan al-Asrār*. Unlike so many of the sayings attributed to Jesus in Muslim literature, this story does not appear to be of Christian origin, as it occurs neither in the Gospels nor in Apocryphal literature. But it is told by Haribhadra,[3] a Jaina monk of the second half of the ninth century, and might well have been made known in the Muslim world by the Indian thinkers of the Sumaniyyah

[1] *Survivals of Sasanian and Manichaean Art in Persian Painting* (Plate 17).
[2] *Logia et Agrapha Domini Jesu apud moslemicos scriptores collegit Michaël Asin*, p. 365 (Paris, 1916).
[3] M. Winternitz, *Geschichte der indischen Litteratur*, Vol. II, p. 322 (Leipzig, 1920).

sect, who were holding disputations with the Muslim theologians of Baghdad and Baṣrah just at the same period.[1] The Jaina writer connects the incident with Vāsudeva, one of the names of Krishna, and the fact that his biography had more points of similarity with that of Jesus than with any other of the Prophets of Islam may partly explain why the *Ḥadīth* in which the story first makes its appearance in Muslim literature connects the story with Jesus. It was made part of the literature of Europe by Goethe in the notes to his *West-östlicher Divan.*

In a late MS.[2] of the *Khamsah* of Nizāmī, dated A.H. 1060 (= A.D. 1650), the painter has represented this incident as though it had occurred in a bazaar of his own native city and has given to the chief personages in the story the dress and appearance of his contemporaries; in the background are the shops of the baker, the butcher, the pastry-cook, and the grocer. But the composition is stiff and lacking in dignity. A higher degree of pathos is reached by an earlier painter who in A.D. 1500 illustrated a copy of Nizāmī's *Khamsah*,[3] but having a special interest in the delineation of various kinds of foliage, he has departed from the original lines of the story and has set the scene in a wood. The figure of Jesus, leaning on his staff and looking down with compassion on the dead body of the poor beast, attains a dignity such as is rare in Persian painting of this period.

In a later MS. in the British Museum (Add. 6613, fol. 19 b) all the pathos of the story is destroyed by the foolish expedient of dressing up the Apostles in the garb of Portuguese, apparently because such foreign visitors to Persia were the only representatives of the Christian world known to the artist.[4]

It is somewhat strange that no picture of the Crucifixion appears to have been painted by any Muhammadan painter, for though the Qur'ān (iv. 156) declares that a phantom was crucified by the Jews in the place of Jesus, while He Himself was carried straight up to heaven, it was still regarded as an historical event, and might therefore have well been selected as a fitting subject for pictorial representation. The Crucifixion reproduced by Professor Massignon in his learned work *Al-Hallaj, martyr mystique de l'Islam* (p. 770), is a late nineteenth-century woodcut, obviously copied from some Christian book of devotion, and is used to represent the martyrdom of Hallāj rather than the death of Jesus.

The varying types of countenance which Christian art has employed in portraying the features of Jesus—whether in the Catacombs, in Roman and

[1] M. Horten, *Die Philosophie des Islam*, p. 181 (München, 1924).
[2] Bibliothèque Nationale (Supplément persan 1111, fol. 20). (Plate XXVII a.)
[3] Bodleian Library (Elliot 192, fol. 22 b). (Plate XXVIII.) [4] (Plate XXVII b.)

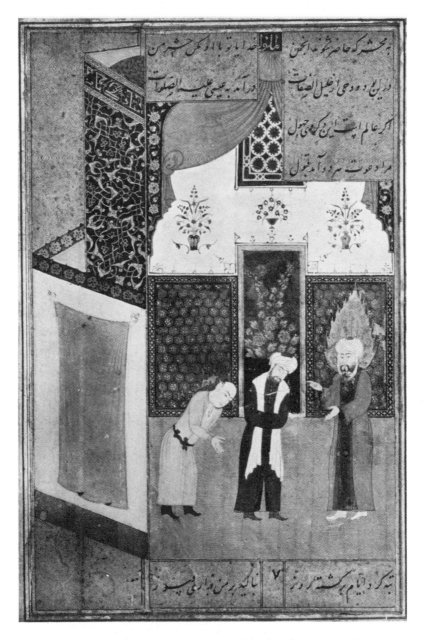

XXVI. Jesus conversing with the devotee and
the reprobate

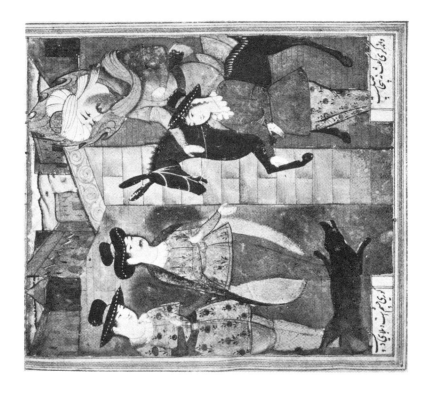

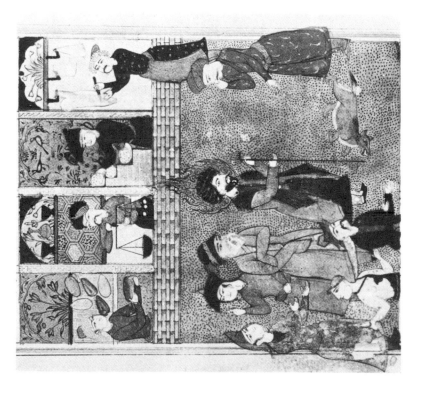

XXVII. Jesus and the dead dog

b

a

Byzantine mosaics, in the Quattrocento and Cinquecento, or in Protestant pictures—have been made the subject of special studies;[1] but none of these seems to have impressed itself on the imagination of the Muslim painters, and there is no notable similarity in their manner of depicting the personage whose name the Muhammadans never mention without invoking a blessing upon Him. As characteristic of the Muslim attitude towards Jesus, mention may be made of a portrait of Him occurring in a genealogical tree of the Ottoman Sultans, painted in the seventeenth century.[2] Jesus is specially distinguished among the Prophets of Islam as the only one among them who never married, and thus it was natural that the Muslim artist should seek for a type among the dervishes of his own time, who likewise were wont to forgo the consolations of married life. In the picture referred to, which occurs in a long series of portraits arranged like the Tree of Jesse in a medieval cathedral, and depicts all the great personages with whom the Sultan of Turkey claimed relationship, from Seth the son of Adam onwards, Jesus is depicted as seated on the ground in the humble attitude of a dervish, who has renounced all the pleasures and attractions of the world—bareheaded, as one who would not claim even the distinguishing mark of the meanest of the faithful, the turban, the crown of Islam.[3]

Jesus and Muhammad are the last in the long series of the Prophets of Islam, who from time to time delivered to their own generation, under divine inspiration, the same revelation of God's nature and of man's duties towards Him, as had been given to Adam in the beginning of the world and had to be taught anew as wickedness and idolatry obscured the knowledge of the true faith and men fell away into sin. Accordingly, in Muslim religious art a place had to be found at least for the better known of the Prophets from Adam onwards. For the majority of them, the Muslim painter could derive no guidance from the work of his predecessors and had to depend upon his own fantasy. But in the Expulsion of Adam and Eve from the Garden of Eden,[4] the long white shirts in which our first parents are clad seem to be reminiscent of the traditional representation of this incident in the art of the Oriental Churches, as may be judged from the mosaic of the history of the Creation and of the Fall in the vestibule of San Marco in Venice, in which Adam is seen standing clad in such a long shirt, while God is putting another over the head of Eve. Christian painters, probably under the influence of the

[1] Karl Pearson, *Die Fronica: zur Geschichte des Christusbildes im Mittelalter* (Strassburg, 1887); G. F. Hill, *The Medallic Portraits of Christ* (Oxford, 1920).

[2] Subhat al-Akhbār, fol. 8 (A.F. 50 (143), Nationalbibliothek, Wien). (Plate XXIX.)

[3] E. W. Lane, *Manners and Customs of the Modern Egyptians*, 5th ed., p. 35 (1860).

[4] *Qisas al-Anbiyā*, belonging to Mr. A. Chester Beatty.

classical predilection for depicting the nude, have for centuries been accustomed to representing Adam and Eve naked, having scriptural warrant for
thus disregarding ecclesiastical condemnation of such a breach of the conventional demands of modesty in the majority of cases, but respect for a
Prophet of Allāh would stand in the way of a Muslim painter in a similar
manner outraging orthodox sentiment, and the picture of Adam and Eve
merely semi-nude (in the MS. formerly in the Yates Thompson[1] collection
and now in the possession of Mr. Gulbekian) is an isolated example, which
may partly be explained by its occurrence in an anthology compiled for
a prince, and not in a religious work such as a history of the Prophets.

Muslim theologians have given various estimates of the number of the
Prophets, attaining so high a figure as 224,000, and as geographical knowledge grew, even that number was not held to satisfy the verses in the
Qur'ān (x. 48; xiii. 8; xxxv. 22) in which God declares that He has sent a
Prophet to every nation. But the Qur'ān mentions by name only twenty-
eight, and in regard to some of these no details whatsoever are given, and even
of so great a figure in Jewish and Christian literature as David it is merely
recorded that he was a maker of armour, that the birds joined with him in
singing the praises of God, and that he decided a dispute between two
shepherds (Qur'ān, xxi. 78–80; xxxiv. 10; xxxviii. 16–25). The compilers of
the popular Biographies of the Prophets, and the poets who introduced
stories of the Prophets into their narrative and didactic poems, naturally
followed the lead of the Word of God, and consequently the Prophets of
the Old Testament whose history the Muslim painter was most commonly
called upon to illustrate were Noah, Abraham, Joseph, Moses, and Solomon,
and among the Prophets sent to Arabia, Ṣāliḥ, who caused a she-camel to
come out of the mountain side, when his unbelieving fellow tribesmen called
upon him to perform a miracle in confirmation of his claim to be the bearer
of a divine message. Alexander the Great, whom the commentators identified
with Dhu'l-Qarnayn mentioned in the Qur'ān (xviii. 82–96) and regarded as
a pious Muslim, engaged in spreading the faith among unbelievers, and
warring against giants, monsters, and obstinate infidels, became the hero of
marvellous adventures, the recital of which, as elaborated by writers both
in prose and poetry, furnished abundant material for the painters to work
upon. Another favourite subject was the story of the Seven Sleepers of
Ephesus, who, as witnesses to the true faith in an unbelieving generation,
received special mention in the Qur'ān (chapter xviii).

[1] *Illustrations from One Hundred Manuscripts in the Library of Henry Yates Thompson*, Vol. III, Plate XLII
(London, 1912).

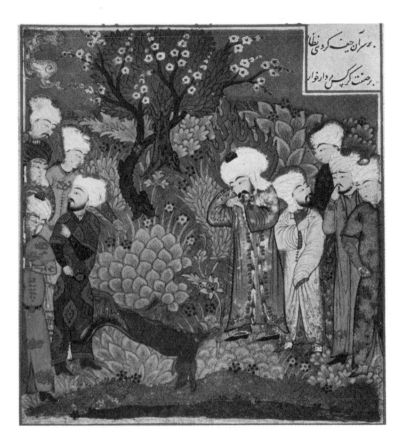

XXVIII. Jesus and the dead dog

XXIX. Jesus, as represented by a Turkish painter

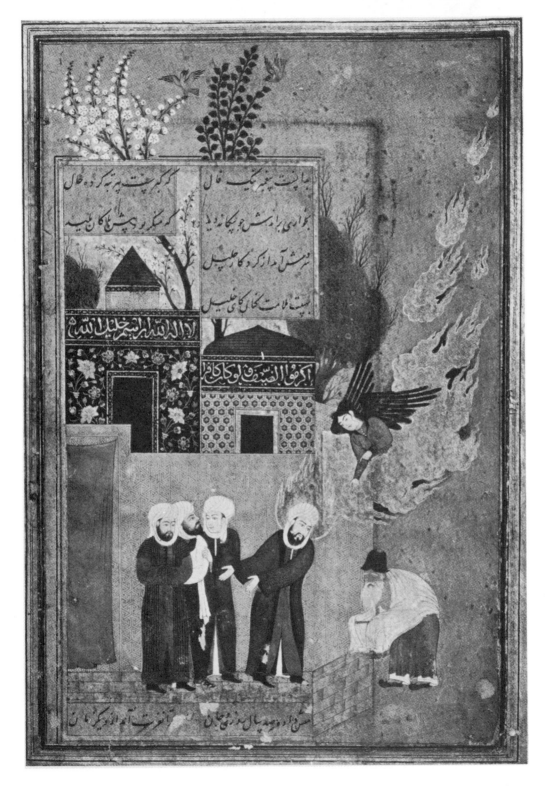

XXX. Abraham and the fire-worshipper

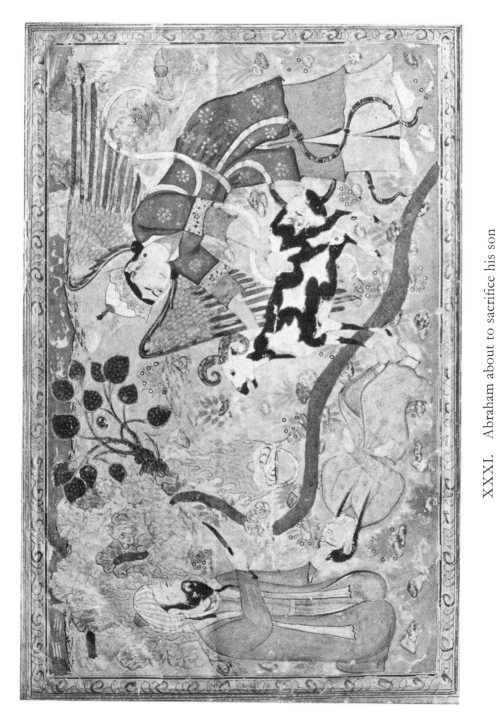

XXXI. Abraham about to sacrifice his son

XXXII. b. Zulaykhā, as an old woman, brought
before Joseph

XXXII. a. Joseph tempted by Zulaykhā

The story of Abraham is often illustrated; we see him destroying his father's idols and as a punishment for his blasphemy being cast into the flames of a huge fire by order of King Nimrod, and there comforted by an angel, and, later, about to sacrifice his son, who is generally given by Muhammadan writers the name of Ishmael, rather than Isaac. As the painters were most commonly employed to illustrate the poems of Sa'dī, Nizāmī, and other popular writers, such incidents in the life of Abraham as these poets recorded were those most frequently selected for pictorial treatment; thus, we often see Abraham and his son praying before the Ka'bah, which they built on the spot where it still stands in the city of Mecca (Qur'ān, ii. 121). Sa'dī in his *Būstān* (ed. Graf, pp. 142–3) tells the story of Abraham's entertainment of the fire-worshipper, which was introduced into English literature by Bishop Jeremy Taylor at the conclusion of his *Discourse of the Liberty of Prophesying*. It was the custom of the Prophet never to sit down to his morning meal until some traveller had come, with whom he could share it. One day an aged man made his way across the desert and was invited by Abraham to be his guest. When they sat down the Prophet said grace, but the old man did not utter a word, and when Abraham asked him, 'Is it not our bounden duty when we break bread, to do so in the name of the Giver of it?' he replied, 'I observe no rite that I have not learned from my spiritual guide, the fire-worshipper'. Abraham is so filled with horror at the thought that he has unawares been entertaining an idolater that indignantly he drives the old man away. Then God sends down an angel to rebuke the Prophet for his intolerance, and the message of the angel is this: 'If I have borne with this aged man and given him his daily bread for a hundred years, can you not bear with him for a single hour?' Filled with shame at this rebuke, Abraham hurries after the fire-worshipper and brings the old man back again into his house and treats him as an honoured guest. In a sixteenth-century MS. of this poem[1] the painter selects this last moment in the story as the subject of his picture; the Prophet, a tall dignified figure, is seen commending to the members of his household the white-bearded fire-worshipper, bent double with age, while a brilliantly coloured angel swoops down in a mass of flame that floats behind him like broken fragments of cloud (Plate XXX).

None of the great figures of Old Testament history have so profoundly stirred the imagination of Muhammadan writers as that of Joseph. The Qur'ān had given them a lead, in that it devoted a whole chapter, the *Sūrah* of Joseph (chapter xii), to the recital of his story, but this narrative was much amplified by succeeding generations. His adventures were taken as the

[1] Belonging to Mr. Gazdar, of Bombay.

subject of poems by some of the most famous of the Persian poets, and the *Yūsuf and Zulaykhā* by Firdawsī, written about 1010, and that by Jāmī in 1483, are counted among the greatest achievements of the Persian genius. But neither was Firdawsī the first nor Jāmī the last of Persian poets to put the tale of *Yūsuf and Zulaykhā* into verse, and the list of such poems is a long one.[1] Nine years after the completion of Jami's romance the Turkish poet, Ḥamdī, completed his own popular poem which was modelled on those of his famous predecessors, and it still remains the finest Turkish poem on the theme, though it was taken up by many others in succeeding generations.[2] This story not only made the same romantic appeal to Muhammadan readers as it has done to the Christian world for centuries, but, receiving at the hands of the Persian poets an allegorical interpretation, was made the vehicle for the inculcation of mystical doctrine. Joseph was taken as the type of the Celestial Beauty, i.e. God; and Zulaykhā, as the personification of over-mastering and all-compelling love, was made to represent the soul of the mystic, the love of the creature being regarded as the bridge leading to love of the Creator. This application of the story to the apprehension of divine knowledge was set forth in the following verses of Jāmī, as finely translated by Professor Browne:[3]

> Though in this world a hundred tasks thou tryest,
> 'Tis Love alone which from thyself will save thee.
> Even from earthly love thy face avert not,
> Since to the Real it may serve to raise thee.
> Ere A, B, C are rightly apprehended,
> How canst thou con the pages of the Qur'ān?
> A sage (so heard I) unto whom a scholar
> Came craving counsel on the course before him,
> Said, 'If thy steps be strangers to Love's pathways,
> Depart, learn love, and then return before me!
> For, should'st thou fear to drink wine from Form's flagon,
> Thou canst not drain the draughts of the Ideal.
> But yet beware! Be not by Form belated;
> Strive rather with all speed the bridge to traverse.
> If to the bourn thou fain would'st bear thy baggage
> Upon the bridge let not thy footsteps linger.

The most popular details of the story, selected by the painters as subjects for illustration, were the drawing of Joseph out of the well into which his brethren had thrown him[4]—his sale in Egypt—his temptation by Zulaykhā

[1] H. Ethé, *Neupersische Litteratur* (*Grundriss der iranischen Philologie*, Vol. II, pp. 231-2).
[2] E. J. W. Gibb, *History of Ottoman Poetry*, Vol. II, pp. 148-9.
[3] *A Literary History of Persia*, Vol. I, p. 442.
[4] The subject of the famous picture by al-Kutāmī in the house of a certain Nu'mān in Cairo, painted

(for this is the name by which Potiphar's wife is known to the whole Muhammadan world)—his imprisonment—his subsequent greatness. Though so far the Muslim version corresponds to that of the Bible, in no case does any Muslim painter appear to have taken any Christian picture as his model. In regard to other details of the story, no such borrowing would even have been possible, because both the original account in the Qur'ān and the additions made by poets and others find no place in the Christian Scriptures, but are peculiar to the Muslim version. Thus, Zulaykhā, in order that Joseph should entertain no doubt as to her feelings towards him, is said to have had pictures of herself and Joseph painted on the walls of her room, on the ceiling, and even on the floor, so that wherever he turned his eyes he saw himself and his mistress, embracing or seated side by side, or Zulaykhā kneeling at his feet. Such a picture, painted in 1470, is given on fol. 199 b of a copy of the *Haft Awrang* by Jāmī in the Bodleian Library (Elliot 149) (Plate XXXIIa); another is in a MS. (Cod. Pers. 6, fol. 105) in the Biblioeca Casanatense in Rome.

The Qur'ān (xii. 31-2) relates that the ladies of Egypt were so scandalized by the behaviour of Zulaykhā and took such good care that she should come to know of their disapproval, that she invited them to a feast, and having first set fruit before them, put into the hand of each a knife with which to skin it; just at this moment she called Joseph into the room, and as soon as they saw him, all the ladies cut their hands, crying out in amazement, 'O God! this is no mortal being! this is none other than an angel!' The implication appears to be that the ladies of Egypt were thus compelled to recognize that there was sufficient justification for Zulaykhā's passion for Joseph. This subject became a favourite one, especially among the later Persian illustrators, but nowhere received such attractive presentation as in the MS. of Jāmī's *Yūsuf and Zulaykhā* in the British Museum (Or. 4535, fol. 104).

The poets carried the story far beyond the point reached in the Book of Genesis or in the Qur'ān. Potiphar dies and Zulaykhā is reduced to a state of abject poverty, and with hair turned white through sorrow, and eyes blinded by continual weeping, she dwells in a hut of reeds by the roadside, and her only solace in her misery is listening to the sound of Joseph's cavalcade as from time to time it rides past. After fruitless prayer to her idol for relief, she turns in penitence to the true God, Allāh, and one day she prays in a loud voice for the blessing of God upon the head of Joseph. He hears

towards the end of the tenth century A.D., was Joseph in the well, and the manner in which the painter had made the white body of the young man stand out against the black background of the well was much admired (Maqrīzī, *Khiṭaṭ*, Vol. II, p. 318 (ll. 6-7 *a fin.*)).

her cry and orders her to be brought before him, and learns to his surprise that this wretched woman is his former mistress. He then prays to God on her behalf; her sight and her beauty are restored to her, and a divine message bids Joseph marry her. This happy sequel to the story seldom finds an illustrator, but in the MS. in the Bodleian Library (Elliot 149, fol. 190) there is a picture of the interview between Joseph and the decrepit, afflicted woman (Plate XXXII b).

Another Prophet of the Old Testament who fills a large place in Muslim literature is Solomon. Mention is made of him and his marvellous doings in four separate chapters of the Qur'ān (xxi, xxvii, xxxiv, and xxxviii)—how God subjected to him the wind, and the birds and the Jinns, and how he met Bilqīs, the Queen of Sheba, and put her wisdom to the test. The painters found ample scope for the exercise of their imagination in illustrating this story, as it was elaborated by the commentators and, after them, by the poets. Pictures showing the two wise monarchs seated together, surrounded by birds and beasts and strange monsters of various kinds, are common, especially in the opening pages of romantic poems. One obscure verse in the Qur'ān (xxvii. 44)—'It was said to her, "Enter the palace"; and when she saw it, she thought it a lake of water and bared her legs. He said, "Lo! it is a palace smoothly paved with glass" '—is explained by the commentators to have reference to a rumour that had reached to the ears of Solomon to the effect that the Queen of Sheba had hoofs and hairy legs like those of an ass; so he had a courtyard of the palace flooded and stocked with fish, and then covered with glass. Apparently the Queen of Sheba, for all her wisdom, was not acquainted with the transparency of glass; so when she saw the fishes swimming about, she lifted her skirts with the intention of wading through the water, and (according to the common account) Solomon recognized that her feet and her legs were beautifully formed, but that the rumour as to their being hairy was unfortunately true; so he refused to marry her until this blemish had been removed by means of a depilatory. The painter of a charming picture of this incident in a MS. of *Majālis al-ʿUshshāq*, by Sultan Ḥusayn Mīrzā, in the Bodleian Library (Ouseley Add. 24, fol. 127 b), obviously considered this story to be scandalous, and he has represented Bilqīs as entirely free from any such disfigurement; but at the same time he has so misunderstood the story as to depict the feet of the queen as actually covered by the water. The surprise of her attendant ladies and of Solomon and his Jinns is naïvely indicated by the conventional gesture of putting the finger to the lips (Plate XXXIII).

In connexion with Solomon, some of the earliest representations of the

Jinns, those strange beings intermediary between the angelic and the human creation, make their appearance in Muslim art. According to the theologians, some of the Jinns were true believers, while others were infidels; to the former class, of course, belonged those who did service to Solomon. But even these, as depicted by the painters, are terrific in appearance, being coloured either black or a corpse-like white, and wearing bristling horns on their heads. While these hideous, but virtuous, beings are not uncommon in Muslim painting, devils and demons as ministers of evil are comparatively rare until a later date. In Muslim art the devil has never played so prominent a part as in the art of the Christian world, and in the picture[1] which depicts his first historic appearance as a rebel against God, when God ordered the angels to bow down before the form of Adam before the breath of life had been breathed into the newly created man (Qur'ān, xv. 30 sqq.), the rebellious angel, Iblīs, appears as a dignified figure, in human form, seated on a prayer carpet. In Indian paintings, especially those of the eighteenth and nineteenth centuries, devils occur much more frequently, and their hideous appearance suggests the influence of Hindu demonology, which has been so prolific in the production of such monsters. Pictures of Hell are likewise rare—in striking contrast to the frequency with which such eschatological subjects found a place in Christian art. There are few Muhammadan manuscripts like the Uighur MS.[2] of the *Mi'rāj Nāmah*, full of pictures of the progress of Muḥammad through heaven and hell, painted in the fifteenth century at Harāt, probably for the great Timurid sovereign, Shāh Rukh. It is not impossible that the illustrators of this manuscript were influenced by the Buddhist representations of hell, of which their neighbours in Central Asia were so fond; but for some reason difficult to determine they did not find imitators in later Muslim painting.

Equally rare are pictures of Heaven. The most charming of these are found in the same *Mi'rāj Nāmah* in the Bibliothèque Nationale (foll. 49, 49 b, 51), where the blessed are seen in a beautiful garden, paying visits to one another on their camels and exchanging bouquets of flowers.[3] The vast literature, both in Arabic and Persian, describing the ascent of the Prophet to heaven and his passage through the various circles of the realms of the blessed might have provided abundant subject-matter for the activity of the painters, had not such books as a rule been regarded as belonging to the domain of theology and been thus protected from the sacrilegious touch of the painter's brush, in consequence of the hostile attitude of the students of such literature

[1] Bibliothèque Nationale (Supplément persan 1559, fol. 106 b). (Plate XXXIV.)
[2] Bibliothèque Nationale (Supplément turc 190). [3] Plate XXXV b.

towards his art. The Muhammadan world produced no poet like Dante who
brought the consideration of the Last Things out of the domain of profes-
sional theological studies and embodied them in a poem that the ordinary
man could read and would wish to have illustrated. On account of the great
rarity of pictorial representations of the Muslim Paradise, mention may be
made here of the painting reproduced by Professor M. Th. Houtsma, though
as a work of art it is poor, and serves the purpose rather of a presentation of
the members of the Holy Family than of the joys of Paradise. It represents
Muḥammad seated by the side of a tank of water, with his two grandsons,
Ḥasan and Ḥusayn, behind him, while their father ʿAlī stands on the other
side of the tank with a cup in his hand and a group of unnamed persons by
his side. In the upper corners of the picture are two buildings, from the
windows of which eight unattractive houris look out. In the centre of the
picture, on the bank of the tank, grows a tree with wide-spreading branches,
obviously intended for the lote-tree mentioned in the Qur'ān (liii. 14, 16);
on it are perched three enormous birds, one having a human head.[1]

The other Prophets of the Old Testament do not appear to have attracted
the painters to the same degree, but Jonah, who receives mention in as many
as five chapters of the Qur'ān, inspired a remarkable drawing in the Edin-
burgh MS. of Rashīd ad-Dīn's History.[2] The fine drawing of a Chinese carp,
as the fish that had swallowed Jonah, is evidence of the influence under which
the artist was working in Tabrīz; it seems to be gazing with a certain degree
of sympathetic interest at the unfortunate Prophet, lying exhausted under the
gourd-tree, after the trying experience of his three days' ordeal (Plate XXXVI).

In the eighteenth chapter of the Qur'ān there is an account given of Dhu'l-
Qarnayn ('He of the two horns') and of his wanderings to the West and to
the East. Most Muslim commentators look upon him as a prophet and
identify him with Alexander the Great, and in this they were followed by
the Persian poets. His most notable adventure, as given in the Qur'ān
(xviii. 92–6), is as follows: 'Then he followed a route until he came between
the two mountains, beneath which he found a people who scarce understood
a language. They said, "O Dhu'l-Qarnayn, verily Gog and Magog lay waste
this land; shall we then pay thee tribute on condition that thou build a
rampart between us and them?" He said, "The power wherein my Lord
hath established me is better; but if ye aid me strenuously, I will set a barrier
between you and them. Bring me blocks of iron"—until when he had filled
the space between the two mountain sides, he said, "Blow upon it"—until
when he had made it like fire, he said, "Bring me molten brass that I may pour

[1] *Internationales Archiv für Ethnographie*, III, Tafel XII (Leiden, 1890). (Plate XXXV a.) [2] fol. 25.

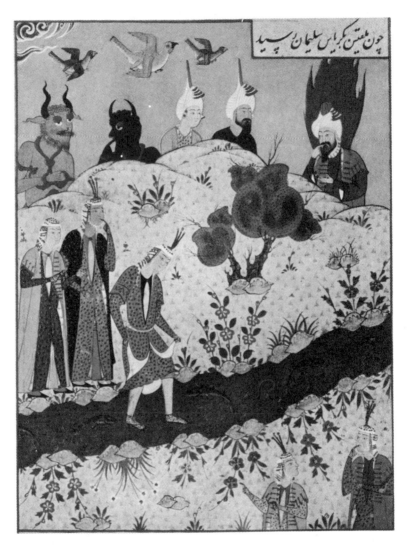

XXXIII. Solomon and the Queen of Sheba

upon it". So Gog and Magog were not able to scale it, nor could they make a hole through it.'

In a MS. in the Bodleian Library,[1] written in Bukhārā in A.H. 960 (= A.D. 1553), Alexander, in the dress of a Turki prince, is seen superintending the building of his wall between the two sides of a mountain pass; it is made of well-cut blocks of stone, between the interstices of which molten iron is being poured. In the foreground workmen are cutting up the ingots of iron, while another is working a huge bellows for supplying a blast of air to the furnace.

The Romance of Alexander had been well known in the East for centuries before the rise of Islam, and the Syriac and Pahlavi versions were among the sources from which the Muslim imitations were derived. The Persian poets, beginning with Nizāmī, added a large number of adventures to those recorded in the Qur'ān, and this poet says that he derived his information from Christian, Jewish, and Pahlavi sources; he had several imitators and they provided the painters with an abundance of subjects for illustration; but such elaboration of the story of Alexander belongs rather to the realm of romance than to that of religion.

With the biographies of the mystics, Muslim religious art enters on a new phase. The Acta Sanctorum of the Muslim Church constitute an enormous literature of their own, and the biographies of the members of the many different religious orders that have concerned themselves with the organization of the devout life in Islam form a considerable part of it. Except in the earliest generations, the majority of the mystics were affiliated to one or other of these religious orders, but apart from these there were also a number of isolated devotees, thaumaturgists, and innumerable martyrs. In the history of religious art the appearance of the *Majālis al-ʿUshshāq*, or Assemblies of the Lovers (i.e. the lovers of God), is especially significant. The reputed author of this work is Sultan Ḥusayn Mīrzā,[2] though his contemporaries doubted the truth of this claim. But for the present purpose the more important fact is that this prince had a number of painters in his employ, and their work influenced the artists of later generations. There are several illustrated MSS. of this book, one of the finest of which is in the Bodleian Library.[3] The saints in whom the author was interested were those of the Muslim period, and the dates of those he selected range from the second century of the Hijrah down to his own time, for the author concludes with an account of himself as one of the lovers of God.

[1] Elliot 340 (Ethé 2121), fol. 80. [2] See p. 75. [3] Ouseley Add. 24, fol. 55 b.

Two examples of pictures of these mystical saints are given in Plate XLVI: one who died early in the thirteenth century, Majd ad-Dīn al-Baghdādī, who is shown preaching to a mixed congregation of men and women;[1] the poet Farīd ad-Dīn 'Aṭṭar (*ob.* 1230), who himself wrote a great work on the biographies of the mystic saints.[2] A third, who died in the latter part of the same century, was Jalāl ad-Dīn Rūmī (*ob.* 1273),[3] the renowned author of the *Mathnawī-i-Ma'nawī*, which is now being made accessible to English readers in a complete translation by Professor A. R. Nicholson.

No reliance can, of course, be placed on these pictures as being actual portraits of the holy personages concerned, since they were painted at least two centuries after their death. But in the case of some of the Indian mystic saints it is not impossible that the constantly recurring types, revealing in several instances a distinct individuality, may really be portraits, for some of them, such as Mī'ān Mīr and his disciple, Mullā Shāh, who was the spiritual guide of Prince Dārā Shikoh (1615–1659), were historical personages who lived at a time when the art of portraiture was common in India and was cultivated with pre-eminent success. Groups of Indian mystics, the founders of various religious orders, or individual portraits, are also commonly depicted.

One of the most popular of these mystic saints with Indian painters was Ibrāhīm ibn Adham—well known to English readers through Leigh Hunt's sonnet, 'Abou Ben Adhem'. Though many legends have attached themselves to his name, he appears to have been an historical character and to have lived in the eighth century of the Christian era. One of the commonest representations of him is as an ascetic before whom the angels have spread a meal; such pictures used to be believed to portray Jesus after the temptation in the wilderness, when 'angels came and ministered to Him', and it is probable that some such picture served as the model for the numerous Indian representations of the Muslim saint (Plate XLIX).

Apart from the more famous mystics, whose disciples preserved the pious utterances of their teachers and collected the materials for their biographies, are the many nameless dervishes who wandered about the country, like the Franciscan friars in the Middle Ages, living on the alms of the faithful and winning the hearts of the common people by their songs of the love of God. A light-hearted merry company of such dervishes is presented in the picture[4] reproduced in Plate XLVII, which bears a striking resemblance to the signed pictures by Muḥammadī, who from a dated drawing in the Louvre we know

[1] Ouseley Add. 24, fol. 55 b. [2] Id., fol. 65 b. [3] Id., fol. 78 b. (Plate XLV a.)
[4] Belonging to Miss Jessie Beck.

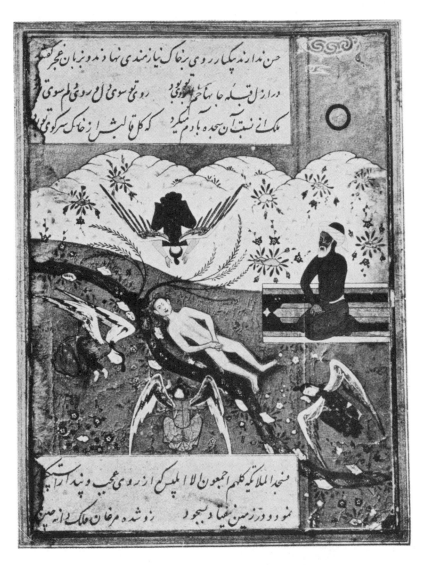

XXXIV. Satan refusing to worship Adam

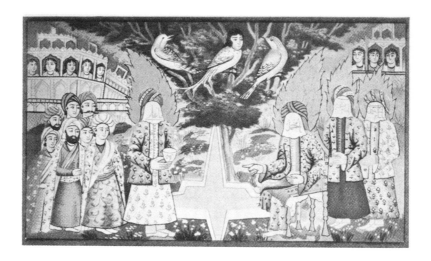

a

b

XXXV. Muhammadan representations of Paradise

XXXVI. Jonah and the fish

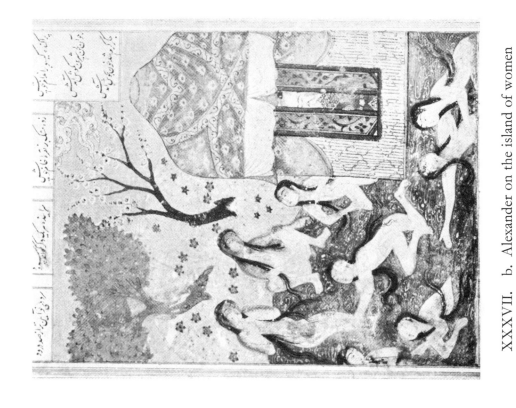

XXXVII. b. Alexander on the island of women

XXXVII. a. The queen of the island of
Wāqwāq

to have been working in 1578. Muḥammadī[1] was particularly fond of drawing such lively bands, making merry and capering about with antic gestures, and behaving rather like a troupe of buffoons than professed religious, and he has thus put on record an aspect of the devout life of Islam which is in striking contrast to the commonly prevailing sternness and austerity of its exterior manifestations. Such vagabond groups of dervishes did not as a rule attract the more serious minded and learned among the mystics of Islam, but a Persian poet of note in the thirteenth century, Fakhr ad-Dīn 'Irāqī, is said to have thrown in his lot with such a roving company of dervishes, attracted by the beauty of one of their number, and travelled with them from Persia to India; in the course of his wandering life he visited the holy cities of Arabia, Asia Minor, Syria, and Egypt; his poems gave offence to some of his brethren on account of their apparent antinomianism and the erotic character of their language; some of them have been translated by the late Professor E. G. Browne,[2] including the following ecstatic ode:

Save love of thee a soul in me I cannot see, I cannot see;
An object for my love save thee I cannot see, I cannot see.
Repose or patience in my mind I cannot find, I cannot find,
While gracious glance or friendship free I cannot see, I cannot see.
Show in thy face some sign of grace, since for the pain wherewith I'm slain
Except thy face a remedy I cannot see, I cannot see.

In the accompanying picture[3] 'Irāqī is seen walking with a wild band of dervishes, some of whom are half-naked, carrying sticks like the ḍaṇḍā of the Hindu mendicant; one holds up a long banner, another blows a horn, another hugs a huge begging-bowl, and the rest carry various other symbols of their profession.

The Muslim orders of dervishes are not in agreement with one another on the question of the lawfulness or illegality of dancing as an accompaniment of religious emotion; while some sternly condemn it, others make it a regular part of their religious exercises, like the Mawlawīs, founded by Jalāl ad-Dīn Rūmī. The dance was often followed by a state of religious ecstasy, in which the worshipper lost all consciousness of the external world. Of one of the saints of the Chistī order in India, Shaykh Adham (ob. 1562), it is recorded that 'he possessed to the highest degree perception of God, a keen longing after ecstatic songs and dances, and the faculty of being overcome by religious ecstasy. In spite of his bodily feebleness and constitutional weakness, and the languor which prevailed over all his limbs, which were

[1] E. Kühnel, *Miniaturmalerei im islamischen Orient*, Tafel 65, 66.
[2] *History of Persian Literature under Tartar Dominion*, pp. 124–38.
[3] Bodleian Library (Ouseley Add. 24, fol. 79 b). (Plate XLV b.)

such that he could hardly arise from his couch to perform the ceremonial ablutions, the prayers, and other necessary acts without the assistance of his attendants, yet whenever he heard the strains of holy song he would arise in ecstasy and would involuntarily join in the dance with such violence and strength that several persons could not, by their bodily power, restrain him.'[1] In Plate XLVIIIa, such a saint, Muḥammad Tabādkānī (*ob.* 1486), is seen dancing in ecstasy with some of his disciples.[2] An Indian picture represents a much larger group of venerable, white-bearded personages engaged in watching some aged mystics dancing; one has fallen to the ground in a state of ecstasy, another has to be supported by a friend, while another grey-beard seems to be just on the point of collapse.[3]

As several of the members of the imperial house of Dihlī, particularly Shāh Jahān and his family, were distinguished for their devotion to the saints, the painters often represented them as visiting a mystic or ascetic, and such honour was shown to Hindus as well as to Muslims. This tolerance of spirit is probably anticipated, when Bābur is depicted as being welcomed by Hindu sannyāsīs,[4] but it was true enough of a later generation, as shown by abundant historical evidence and frequent pictorial illustration.[5]

Some of the most striking pictures of dervishes are those by Riżā 'Abbāsī, who appears to have taken pleasure in turning from the frivolous subjects that generally occupied his attention in order to draw examples of some of the finer types of the Muslim dervish—serious, thoughtful men, grown old in pious meditation.[6]

Apart from such pictures which undoubtedly represent persons and scenes that were familiar to the painter's actual experience, there are many others which are prompted by a love for the strange and miraculous. The legends of the Muslim saints are full of strange stories bearing testimony to the wonder-working power of their sanctity, e. g. more than one is said to have ridden on the back of a lion, and several pictures of such an exploit are extant. Pīr Rāmdīn was once seated on a wall, meditating on some verses of the Qur'ān, and in his abstraction he began to kick the wall with his heels; whereupon the wall began to move forward until the saint became aware of what had happened and bade it stop. Such marvellous stories and many others could provide the painter with abundant material for the exercise of

[1] Al-Badāonī, *Muntakhabu' t-tawārīkh*, translated by Sir H. Wolseley Haig, Vol. III, p. 67 (Calcutta, 1899). [2] Bodleian Library (Ouseley Add. 24, fol. 119).
[3] Id. (Or. b. 2, fol. 47). [4] British Museum (Or. 3714, fol. 320 b).
[5] See F. R. Martin, *Miniature Painting of Persia, India, and Turkey* (Plates 201 e, 207); L. Binyon and T. W. Arnold, *Court Painters of the Grand Moguls* (Plates VI, XVII, XXII).
[6] India Office Library, Johnson Collection, Vol. XXII, p. 8 (Plate LXIV a); Bibliothèque Nationale, Suppl. pers. 1572, fol. 22.

his art, but the miracles most commonly depicted were naturally those described in the works of popular authors, which the painter was called upon to illustrate. Thus, Sa'dī tells a story, in his *Būstān*,[1] of the dervish who crossed a river on his praying-carpet because he could not pay the fee of the ferryman, which gives occasion for illustration in a book that was popular throughout the greater part of the Muhammadan world and has been more frequently illustrated than almost any other (Plate L).

But representations of such a miracle are not confined to copies of Sa'dī's *Būstān*, since similar accounts of holy men crossing a stream are found in various parts of the Muslim world. Busbecq in 1562 heard such a story in Constantinople from the lips of a Turkish dervish who told him that the head of his monastery, a man famous for his sanctity and miracles, used to spread his cloak on a lake adjoining the monastery, and, seated upon it, be carried wherever he liked.[2] A more detailed variant of the same kind of legend is presented in the story of two rival saints, one of whom was once crossing a river with his disciples in a boat (according to one account), or seated on his praying-carpet (according to another), when a fearful storm arose and the terrified disciples expected every moment to be drowned; but the saint remained undisturbed, because he knew that it was the envious spite of his rival that had brought about the storm, and scanning the bank of the river he saw this rival looking out of a window. Then by the exercise of his miraculous power the saint caused two horns to grow out of the head of this ill-disposed wretch, so that he could not draw back his head, and then, shouting across the river, he cried out: 'There shall you stay until you stop this storm.' The rival, thus outwitted, had perforce to allay the tempest, whereupon his horns dropped off, and the saint with his disciples came safely to shore.[3]

Any account of Muslim religious painting would be incomplete without reference to the copies of Christian pictures which became common in India in the sixteenth century. Akbar took a special interest in the Christian pictures which the Portuguese missionaries brought to his court, and there still remain on the wall of one of his palaces at Fathpūr-Sīkrī the faded traces of a fresco of the Annunciation.[4] During the reign of his son, Jahāngīr (1605–1628), the fashion of employing Indian painters to depict Christian subjects became more common, and various incidents in the life of the Virgin Mary frequently occur from this period onwards. In Persia also there are occasional examples of such pictures from the sixteenth century, while in

[1] India Office Library, Ethé 1142, fol. 27 b.
[2] Ogier Ghiselin de Busbecq, *Turkish Letters*, translated by E. S. Forster, p. 209 (Oxford, 1927).
[3] Bodleian Library (Or. 133, fol. 42). (Plate LI.)
[4] E. W. Smith, *The Moghul Architecture of Fathpur-Sikri*, Part I, Plate CIX, Fig. 1 (Allahabad, 1894).

the eighteenth century there grew up an active school of painters of sacred subjects, of which Agha Shāh Najaf, who flourished in the reign of Karīm Khān Zand (1750–1779) and lived on into the nineteenth century, was the most distinguished representative. They devoted themselves especially to the decoration of hand-mirrors and mirror cases, on which they not only painted portraits of Muḥammad but also subjects from Christian hagiology, one of the favourite subjects being the Holy Family, with attendant saints and angels; the type of face in such cases is obviously imitated from Italian pictures.[1]

The illustrators of the treatises on Muhammadan mysticism, referred to above, were interested merely in personality, so the incidents they present are taken from the biographies of individual saints and teachers. Even in the case of the *Dīwān* of Ḥāfiẓ, in which story-telling is almost entirely lacking, and personal interest in regard to the poet himself is hardly excited at all, the painters have treated this volume (in the few instances on which they have illustrated it) as though it contained merely a series of historical incidents, and have made no attempt to bring out the mystical or devotional character of the book in accordance with the commonly accepted interpretation of the work. Indeed, mystical art in the narrow sense of the term is unknown to the Muhammadan painters, and since the theologians gave no encouragement to pictorial art, Islam has worked out no distinctive religious symbolism of its own. The crescent, which is commonly regarded as the typical emblem of the Muhammadan world, just as the cross is of Christendom, has only recently come to be accepted by Muslims as a religious emblem ; it occurred sporadically only as a decoration on flags, &c., before its more general adoption by the Turks after their conquest of the Christian Byzantine empire.

The nearest approach to any painting of a symbolic character is found in some strange kneeling figures entwined in foliage, which occur in the earlier pages of a Persian MS. in the India Office Library.[2] No indication as to the special significance of these figures is given in the text of the work, which is a treatise on practical ethics, compiled in 1495 by a prolific writer named Ḥusayn al-Wā'iẓ al-Kāshifī. On almost every page of this MS. there is painted a little figure, which might have been made to represent the particular virtue described in the text, had the artist so cared, but they are too common-place to bear such an interpretation, and the only pictures that arrest attention are those in the first group, a specimen of which is given on Plate LII.

[1] S. G. W. Benjamin, *Persia and the Persians*, pp. 327–31 (London, 1887).
[2] No. 1097 (Ethé 2197), Akhlāq-i-Muhsinī.

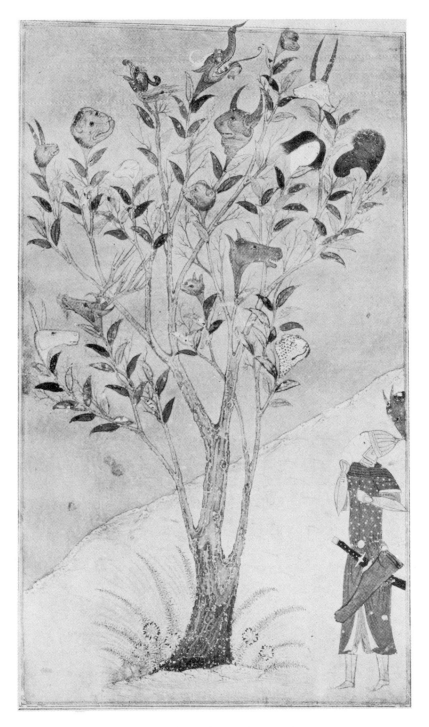

XXXVIII. Alexander and the talking tree

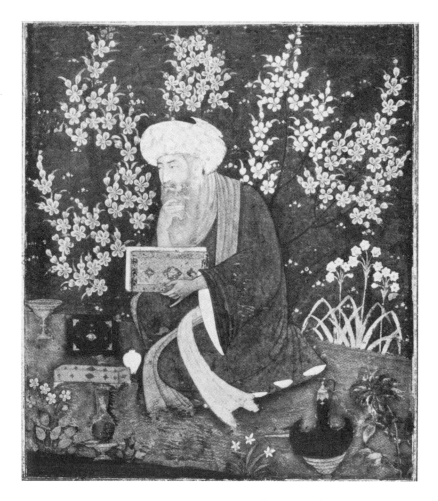

XXXIX. A mystic seated in a garden

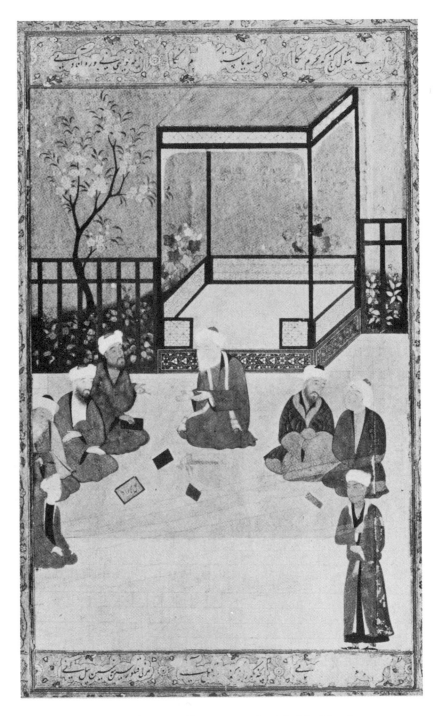

XI. The poet Jāmī, seated with his friends

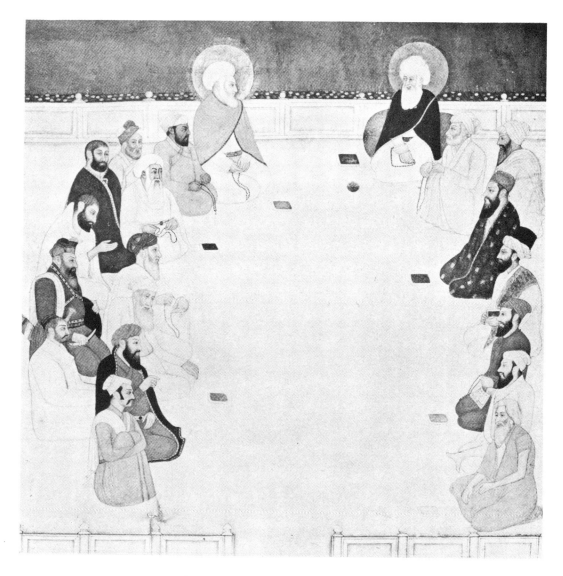

XLI. A group of Indian saints

VII

BURĀQ

ONE of the strangest phenomena in Muslim religious art is the representation of Burāq,[1] the beast on which the Prophet is said to have ridden when he made his ascension to heaven on the occasion of his famous night journey. The starting-point for the detailed accounts of this night journey, elaborated by later writers, is in the chapter of the Qur'ān bearing that title (xvii, 'The Night Journey'): 'Glory be to (God) who caused His servant to make a journey by night from the sacred place of worship to the remote place of worship which We have encircled with blessings, that We might show him of Our signs.'[2]

According to the common interpretation of Muhammadan theologians this journey was made, under the guidance of the angel Gabriel, from Mecca to Jerusalem, whence the Prophet ascended to heaven. The various accounts differ in several important particulars;[3] sometimes the ascension is made by means of a ladder, sometimes by means of a tree; in another account it is simply stated that the Prophet was 'taken up'. Again, in one account an interval of six months elapses between the journey to Jerusalem and the ascension to heaven; more commonly, the two events are continuous; sometimes Burāq is only brought in to convey Muhammad as far as Jerusalem, sometimes the same mount carries him to heaven also. Passing through the seven heavens, one after the other, he meets in each one of the Prophets who were his predecessors, generally in the following order: Adam, John and Jesus, Joseph, Idrīs, Aaron, Moses, and Abraham. Then he is brought into Paradise and finally into the presence of God Himself. This is not a suitable occasion for examining the question, much debated by Muslim theologians, as to whether this journey was actually performed in the flesh by the Prophet or was only a spiritual experience vouchsafed to him in a vision of the night, for by the Muslim painter this heavenward journey was regarded as an actual physical experience and no mere dream. The problem that demands consideration here, therefore, is the origin of the type of beast that the painters chose for the animal on which the Prophet rode on this great occasion. In

[1] There is some uncertainty as to the derivation of this word, but the most plausible explanation is that it means 'the little flash of lightning', and that the beast was so named either for its swift pace or bright colour (J. Horovitz, 'Muhammeds Himmelfahrt', *Der Islam*, Vol. IX, p. 183). (Appendix D.)

[2] Cf. Qur'ān, xvii. 62; liii. 1–18; lxxxi. 19–25.

[3] These are summarized in Professor Miguel Asin's *Islam and the Divine Comedy*, pp. 4–35 (London, 1926).

one tradition it is said to have been a horse, and in another 'a white riding beast, smaller than a mule and larger than an ass'. It was the same beast as earlier Prophets had ridden upon, notably Abraham, who, according to Genesis xxii. 3, rode upon an ass, and likewise Jesus (St. John xii. 14); the Muhammadan writers could not wholly ignore this early record that it was the ass which had served as a mount for the Prophets, but it has been suggested that they were sensitive to possible scornful disparagement of so humble a beast, and were unwilling to describe Burāq as merely an ass, though they had to admit that it was something like one;[1] hence the bifarious nature of this beast. Burāq was undoubtedly originally brought in to carry the Prophet to Jerusalem; when it had to make the further journey to heaven, wings were ascribed to it. So, in the oldest extant biography of Muḥammad, that by Ibn Isḥāq (*ob.* A.D. 768), which has only come down to us in the recension of Ibn Hishām (*ob.* A.D. 833), the description—put into the mouth of the Prophet himself—given of Burāq is that of a winged beast, white in colour, and in size intermediate between a mule and an ass.[2] In the earlier narratives there is no mention of the human head which is so characteristic a feature of the pictorial representation of Burāq, and the first writer who suggests that this strange beast possessed any human feature was Tha'labī (*ob.* A.D. 1036), the author of a well-known history of the Prophets, who quoted an untrustworthy tradition to the effect that Burāq had a cheek like the cheek of a human being.[3] Later writers describe this marvellous beast in fuller detail; e.g. Khwāndamīr says:[4]

'Burāq was a riding beast smaller than a mule and larger than an ass, having a face like that of a human being and ears like those of an elephant; its mane was like the mane of a horse; its neck and tail like those of a camel; its breast like the breast of a mule; its feet like the feet of an ox or, according to one tradition, like those of a camel; its hoofs were like the hoofs of an ox. Its breast looked just like a ruby and its hair resembled white armour, shining brightly by reason of its exceeding purity. On its flanks it had two wings which hid its legs. The swiftness of this riding beast was such that in a single stride it could reach as far as eye could see.'[5]

In the earlier versions of the story there is no agreement as to the sex of this animal; usually it is described as masculine, but Ibn Sa'd, whose biography of the Prophet was composed about seventy years later than that of Ibn Isḥāq, makes Gabriel address Burāq as a female.[6] Accordingly, the painters commonly represented this beast as having a woman's head, but wisely made

[1] J. Horovitz, *op. cit.*, pp. 180–2. [2] Ed. Wüstenfeld, p. 264 (l. 6).
[3] J. Horovitz, *op. cit.*, p. 180. [4] For an account of this writer see p. 34.
[5] Khwāndamīr, *Ḥabīb as-Siyar*, Vol. I, Part III, p. 21 (ll. 14–17) (Bombay, 1857).
[6] A. A. Bevan, 'Mohammed's Ascension to Heaven', p. 59 (*Studien zur semitischen Philologie und Religionsgeschichte*, Julius Wellhausen . . . gewidmet, Giessen, 1914).

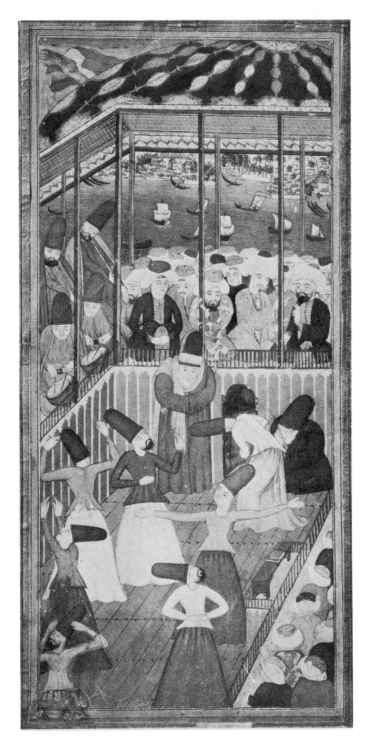

XLII. Dancing dervishes in Constantinople

no attempt to reproduce in detail so complex a zoological curiosity as that suggested by Khwāndamīr. They had not to devise a new type of beast on the basis of any literary record, since their predecessors had provided them with abundant examples of such a hybrid animal, to serve as models for their own representation, for such a combination of the body of an animal with a human head goes back to the earliest periods of art—in the form of the sphinx in Egypt, Syria, Greece, &c., the centaur in ancient Babylon and Greece, and the Assyrian man-headed bulls. Several variants of the particular type—with animal body, wings, and human head—which most clearly corresponds to the commonest representation of Burāq in Muhammadan painting, make their appearance in some of the earliest periods of oriental art, e. g. on objects of stone, ivory, and bronze from Nimrud,[1] and on a clay plaque from Eastern Crete (Plate LIV).[2] At what period in the history of Muslim art any pictorial representation of Burāq made its appearance it is impossible to say, owing to the lack of primitive examples, but even in the lifetime of the Prophet some similar artistic fabrication had made its way to Medina, for among the many traditions that record how 'Ā'ishah excited the anger of her husband by hanging up figured stuffs in her room is one in which she relates how she had hung over the door of her room a curtain in which were woven pictures of winged horses, but the Prophet tore it down.[3]

In the earliest picture of Burāq, however, that has hitherto been noted— namely, in the *Jāmi' at-Tawārīkh* of Rashīd ad-Dīn, which is dated A.H. 714 (=A.D. 1314)[4]—it is rather a centaur type that is followed, for the upper part of the body has two arms, as well as the usual four legs of an animal; in other respects also it presents features that are unusual, for Burāq holds in her hands a book, presumably a copy of the Qur'ān, and her tail is upturned and ends in the upper part of a human body—the breast, head, and two arms, carrying in the right hand a long sword and in the left a round shield; the long thick masses of hair, curled up at the end, which hang down below each cheek, are similar to those of Burāq herself, and the crown on the head of each is of the same kind, and exactly resembles in shape and ornamentation that worn by kings in several illustrations in Berūnī's *al-Āthār al-Bāqiyah* (Edinburgh University Library, no. 161); but the artistic origin of this strange caudal appendage is obscure. The incident represented in this picture forms part of Muhammad's adventures in heaven, where in the seventh heaven (according to some authorities) three vessels, containing severally water, wine, and milk, are offered to him; of these he chooses the

[1] British Museum, nos. 90954, 118103, 115504. [2] Ashmolean Museum, Oxford, no. G. 488.
[3] Ibn Ḥanbal, *Musnad*, Vol. VI, p. 208 *ad fin.* [4] Library of the Edinburgh University. (Plate LIII.)

milk, and his choice wins approval, as symbolizing that his community will be guided into the paths of righteousness.[1]

The type which commonly found acceptance with later Muhammadan painters was that of the sphinx, though in accordance with the accepted traditional descriptions of Burāq the body had to be approximated to that of a mule rather than to that of a lion. As already indicated, the representation of the sphinx has a long artistic history in Western Asia, but for the present purpose it is not necessary to go back to some very remote period, as there appears to be little doubt that the common representation of Burāq can be most closely linked on to the winged sphinxes that occur on the pottery of Rayy;[2] as this city was plundered and burnt by the Mongols in 1220 and never recovered its former prosperity, we thus have a date not far removed from the earlier pictures of Burāq that have survived to us. Just a little later are the sphinxes that in a stately procession march round the central medallion on the platter[3] made for the Zangid Atābeg of Mosul, Badr ad-Dīn Lu'lu' (1233-1259) (see Plate LV b).

There were abundant opportunities for the painters to draw pictures of Burāq when once this primeval beast had been taken into Muslim religious art. The literature on the subject of the Prophet's ascension to heaven was enormous;[4] every life of the Prophet had a chapter on the subject, and every commentary devoted special attention to so stupendous an event; there were also special treatises devoted to it, and the mystical writers gave it interpretations of their own. But it was particularly in illustrated copies of the works of the Persian poets that pictures of Burāq most commonly made their appearance. It was a frequent practice for the poets, especially Nizāmī, whose writings were such favourite subjects for pictorial representation, to include in the preface, in which they offered praises to God and to His Prophet, a lyrical outburst on the theme of Muhammad's ascension. There was no event in the Prophet's life that had so triumphantly indicated his claim to be 'the Apostle of God and the seal of the Prophets' (Qur'ān, xxxiii. 40), and despite his protestations to his followers that he was only a man such as they were themselves (Qur'ān, xviii. 110; xli. 5), his ascension had raised him to a level such as no ordinary mortal had attained; he had gazed upon the face of God Himself and had beheld secrets that had been revealed to none other. Since he had then interceded with God for his people, he could assuredly

[1] Ibn Hishām, *op. cit.*, p. 263 *ad fin.*

[2] See British Museum (Ceramics Dept. 13270-3). (Plate LV a.) A number of examples are shown in the sale catalogue, *Objets d'art anciens de la Perse, Collection de M. J. M. de Téhéran* (Paris, 5-6 Mai 1922).

[3] In the Museum für Völkerkunde, Munich.

[4] V. Chauvin, *Bibliographie des ouvrages arabes*, Vol. X, pp. 206-8.

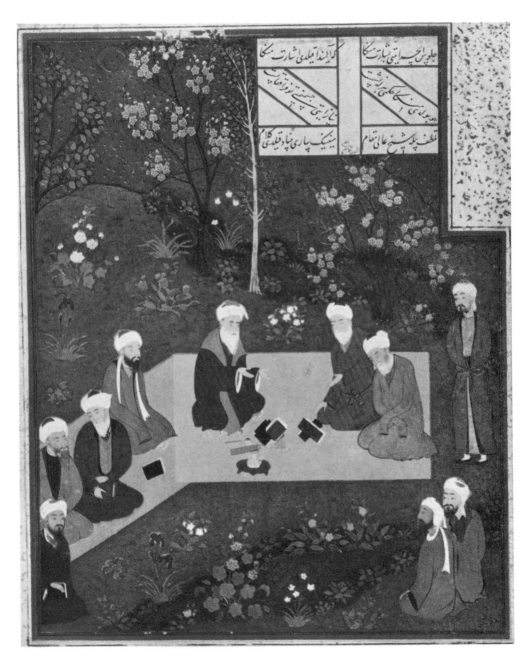

XLIII. Mystics discoursing in a garden

be their mediator in the future, and the advantages of being counted among the number of his faithful followers were thus obvious; consequently he became transfigured in their eyes, and the exalted position thereby attained goes far to explain the frequent occurrence of the pictures of Burāq; for no incident in the religious history of Islam is more commonly represented in Muslim art than this of the ascension of the Prophet.

Perhaps nowhere has this incident received nobler treatment than in the manuscript of Nizāmī's _Khamsah_, which is one of the treasures of the British Museum (Or. 2265, fol. 195).[1] Across the great space of the heaven densely covered with masses of white cloud, through the interstices of which a brilliant dark blue sky shines out, Muḥammad passes majestically on his way, seated at his ease on his human-headed steed and undeterred by the measureless depths that yawn beneath him. In the far distance the globe of the earth that he has left behind shines out surrounded by a white haze. In front of him goes Gabriel, a dignified winged figure, leading the way; between the archangel and the Prophet an angel bears, suspended from a long rod, a great censer sending out flames of gold. Another angel below the Prophet keeps along side by side with him, holding high a chafing dish full of burning perfume. Over the Prophet's head angels empty out dishes of pearls and rubies, which can be seen falling down in a glittering shower. A host of other angels swoop down towards him from the skies, bearing various gifts— one carries the Qur'ān, another the famous green robe (which is still said to be preserved among the relics of the Prophet in Constantinople), another brings a crown, others present dishes of fruit and various kinds of food. The conception of the whole picture is most impressive, filled with a great sense of movement, which is emphasized by the fluttering of so many brightly coloured wings in the great company of attendant angels.

As a rule the only personages in the picture are the angel Gabriel and Muḥammad; sometimes the Ka'bah and the sacred enclosure of the Ḥaram in Mecca are brought into the picture, and in such a work as the _Mi'rāj Nāmah_, in the Bibliothèque Nationale (Supplément turc 190), which is entirely devoted to the story of the heavenly journey of the Prophet, Muḥammad remains seated on Burāq in the presence of the various prophets and angels he visits.

During the decline in Muhammadan painting in the seventeenth and eighteenth centuries, the representation of Burāq tended to become vulgarized, and her appearance was certainly not improved by the addition of an

[1] This picture has now been made accessible to all by being included in the series of coloured reproductions published by the British Museum (B. 31). (Plate LVIII.)

ill-shaped, heavy crown, such as that worn by the later Shahs of Persia, or by the substitution of an upstanding peacock's tail for that of an ordinary mule.

The common occurrence of pictures of Muhammad upon Burāq affords a remarkable example of the persistence of an earlier artistic convention and of its intrusion into a religion of a later date. By theory, and in accordance with orthodox theological teaching, no such representation should have appeared in the art of Islam at all, but like many other survivals it refused to be killed, and insisted on finding for itself a place in the art of a religion which ought never to have admitted it, but was not strong enough to keep out an artistic tradition of such great antiquity. Even to the present day, crude pictures of Burāq, without her rider, are popular in Egyptian villages, and flimsy representations of this strange beast are often carried in the Muharram processions in India.

VIII

PORTRAITURE

PORTRAITURE, in any form whatsoever, naturally came under the ban of the theological condemnation of the pictorial representation of living beings discussed in Chapter I. It is strange therefore to find it exemplified in the very earliest expression of artistic activity that has come down to us from the beginning of the Muhammadan era.[1] On coins of the Caliph 'Abd al-Malik, between the years 685 and 695, we find a standing figure wearing a long robe reaching to the ankles, and carrying a broad sheathed sword slung across the body from right to left. There are several examples of coins bearing this device preserved in various museums in Europe,[2] and the standing figure has sometimes been supposed to represent Muhammad the Prophet himself.[3] But such an identification is untenable for many reasons, nor indeed is it likely that more than a symbolic representation of the reigning Caliph, 'Abd al-Malik (685–705), is here intended. The presence on these coins of any figure at all can easily be explained by a political necessity that has imposed itself on the fiscal system of more than one conqueror or founder of a dynasty. When the Arabs in the seventh century had become masters of the civilized and wealthy provinces of the Roman empire, Egypt, Palestine, and Syria, accustomed to an organized system of government and old-established methods of trade and commerce, the new rulers wisely continued, for some years at least, to permit the current use of the coinage to which the inhabitants of these provinces had been accustomed under the old régime, just as they at first kept in office the bureaucracy and the tax-collectors of the Roman empire. For the same reason, the first coins the Arabs struck in Syria imitated those of the former rulers, in bearing the effigy of the Byzantine emperor, holding a cross and having a cross upon his diadem. As the Arab government became more firmly established, the Muslim creed was gradually introduced into the new coinage, and in place of the figure of the Christian emperor bearing the symbols of his faith, we find the Muslim Caliph, bare-headed, gripping in his right hand the handle of his sheathed sword. But this was not so much an attempt at actual portraiture as a modification of the earlier design in accordance with the new creed; it represents such a transitional concession to the popular conception of current coinage as is exhibited by the coins struck by Christian sovereigns in northern Europe, with Arabic

[1] Mu'āwiyah (661–680) had a dīnār struck with a figure on it, girt with a sword (Maqrīzī, an-Nuqūd al-islāmiyyah, p. 5, Constantinople, 1298); but no example of this coin appears to be extant.
[2] J. G. Stickel, Handbuch zur morgenländischen Münzkunde, Vol. II, pp. 27–56 (Leipzig, 1870).
[3] J. G. C. Adler, Museum Cuficum Borgianum, Pars II, p. 171 (CIX. B) (Hafniae, 1792).

inscriptions, in some cases even the creed of Islam, 'There is no god save Allāh; Muḥammad is the apostle of Allāh'—not that such an inscription conveyed any meaning to the unlettered European, but it was familiar to him through the many Muhammadan coins that had become current in various parts of northern Europe through trade with the dominions of the Caliphate.[1] Similarly, the British in India continued to strike coins up to 1832 in the name of Shāh 'Ālam, though this emperor died in 1806. About 696 'Abd al-Malik purged the coinage of the impurity of such pictorial representation, and his coins henceforth bore Arabic inscriptions only, according to the fashion adopted by the majority of successive Muhammadan rulers in every age and country.

From an equally foreign source were derived the six well-known portraits at Quṣayr 'Amra; these are likewise of a purely imaginary type, representing the six great potentates of the world, whose power had shrunk before the victorious advance of the Arab armies. The identification of them is not altogether easy, but from the inscriptions and other indications it would appear that they are intended to represent the Emperor of Constantinople, clad in his imperial robes, with a tiara on his head—the King of Persia, in rich garments, with a purple cloak over his shoulders, purple shoes on his feet, and a costly crown of a Sasanian type on his head—the beardless figure next to him must have been intended for the last of the Sasanian house, Yazdagird III, who met his death as a fugitive in 652—Roderic, the last king of the Visigoths of Spain, who was slain in battle with the Arabs in 711; his figure once stood behind the Caesar and the Khusrau, as the Arabic and Greek inscriptions clearly show, though nothing now remains on the wall but the top of his helmet—the Negus of Abyssinia, robed like a priest of the Mono-physite Church, in a white garment and a purple stole, with a turban on his head; the two other figures are uncertain, but it has been suggested that one may stand for the Khaqan of the Turks of Transoxiana, against whom Qutay-bah was fighting in 712, and the other for one of the Indian Rājās defeated by Muḥammad ibn al-Qāsim about the same period.[2] Though none of these pictures on the west wall of the main hall of the building can be regarded as portraits, yet they were intended to represent actual personages, and were probably, in the first two instances at least, modelled on coins or similar representations of the monarchs of the Roman and Persian empires.

[1] G. Jacob, *Der nordisch-baltische Handel der Araber im Mittelalter*, pp. 62–7 (Leipzig, 1887); J. Allan, 'Offa's imitation of an Arab dinar' (*Numismatic Chronicle*, Fourth Series, Vol. XIV).
[2] Max van Berchem, 'Aux pays de Moab et d'Édom' (*Journal des Savants*, N.S. 7 (1909), pp. 365–9); C. H. Becker, 'Das Wiener Quṣair 'Amra-Werk' (*Zeitschrift für Assyriologie*, Vol. XX (1907), pp. 364–9). (Plate LVII a.)

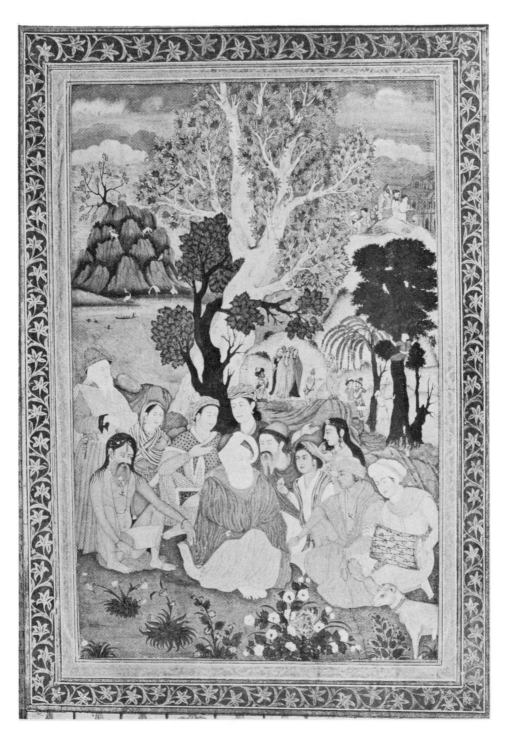

XLIV. A group of Indian ascetics

XLV.　b.　The poet Fakhr ad-Dīn ʻIrāqī

XLV.　a.　The poet Jalāl ad-Dīn Rūmī

XLVI. b. The poet Farīd ad-Dīn ʿAṭṭār

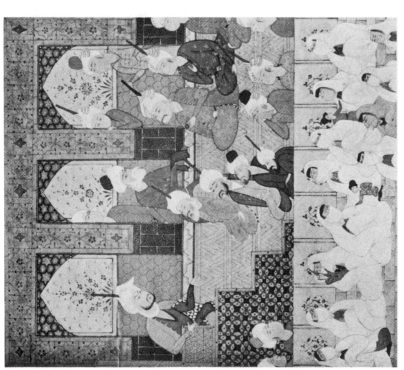

XLVI. a. The mystic Majd ad-Dīn al-Baghdādī

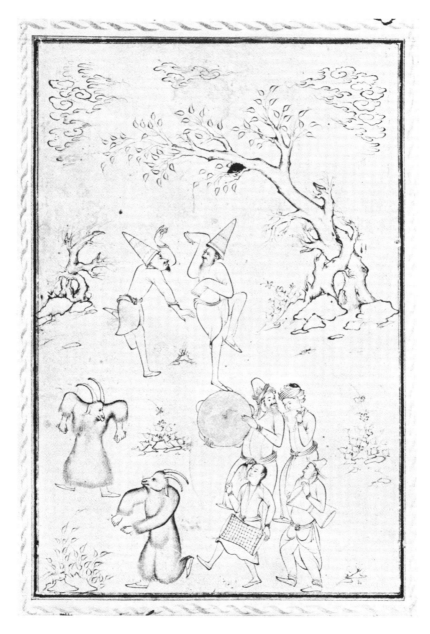

XLVII. Wandering dervishes, by Muḥammadī

But in the case of the figure seated in a niche of the wall opposite the entrance to the main hall of the building, we probably have what was really meant for a portrait of the ruler for whom this bath-house was erected—Walīd I (705–715). Unfortunately this picture is in a very damaged condition, but it presents a majestic figure, like that of God Almighty, in the apse of a Byzantine basilica, seated on a golden throne, flanked by two spiral pillars supporting a canopy; behind the head of the figure is a round halo, and in such a building, at such a date, it can only be taken to represent the reigning Caliph (Plate LVII b).

There is a long interval of time between the painting of the Quṣayr 'Amra frescoes and the striking of the coins which give us the next attempts at historic portraiture in the Muhammadan period. The first of these is a medal bearing on one side the effigy of the Caliph Mutawakkil (847–861), and on the other a man leading a camel. Mutawakkil is chiefly known to history as a persecutor, not only of Christians and Jews but of such of his co-religionists as he regarded as heretics, while he outraged the feelings of the Shiahs by destroying the tomb of the martyred Ḥusayn and forbidding pilgrimages to the site; but his religious zeal did not prevent him from being addicted to wine and keeping four thousand concubines, and he employed Greek painters to decorate his palace at Sāmarrā with pictures, among them one of a church with monks in it,[1] and some fragments of these decorations have been recovered from the ruins of this building by Professor Herzfeld.[2] This coin represents him with a long, two-pointed beard, wearing a richly decorated robe and a low cap, with two streamers, somewhat of a Sasanian type, hanging down on cither side of his face; on the obverse is a man leading a camel.[3]

The subserviency of the Caliphs to their Praetorian guard of Turks had already begun in the reign of Mutawakkil, and it was by some of these Turks that he was assassinated in 861. A similar fate befell his great-grandson Muqtadir (908–932), in whose reign the Caliphate sank to a low ebb; this indolent ruler wasted his time among slave-girls and musicians, and was entirely under the influence of the women of his palace and squandered on them the treasures that his predecessors had accumulated. On the medal which he had struck, the Caliph is represented wearing a tight-fitting robe of state, strewn with pearls and decorated with a lozenge pattern; he is sitting cross-legged, with a cup of wine in his right hand and some kind of a weapon

[1] Yāqūt, Mu'jam al-buldān, Vol. IV, p. 44.
[2] Die Malereien von Samarra, Tafeln I–LVI, LX–LXXXVIII.
[3] Numismatische Zeitschrift, Vol. I, pp. 445 sqq. (Wien, 1870). (Plate LIX.)

in his left. On the obverse is a musician, also sitting cross-legged, playing a lute, in a robe like that of the Caliph, but having broad pendent sleeves;[1] the pose of this figure and several details of the design, noticeably the broad sleeve, as well as the shape of the lute, correspond with those of the picture of the planet Venus in the MS. of Qazwīnī (Cod. Arab. 464, fol. 14) in the Staatsbibliothek, Munich.[2] There are similar examples of representations of the planets on some of the coins of the Urtuqids of Diyār Bakr, e.g. Mars[3] (id., fol. 16) on a coin of Yūluq Arslān, dated A.H. 596 (= A.D. 1199–1200),[4] and the Sun (id., fol. 14 b) on a coin of Masʿūd I, the Zangid Atābeg of Mosul (A.H. 585 = A.D. 1189).[5] In the reign of Muqtadir's son, Rādī (A.D. 934–940), there is a record of a medal having been struck, apparently in jest, by Bajkam, one of his Turkish mercenaries; this powerful soldier completely dominated the unfortunate Caliph, who complained that on this medal he was represented in an attitude of humiliation with his head hanging down, while on the obverse was the aggressive figure of Bajkam in full armour.[6]

The reign of Muṭīʿ (946–974) exhibits the lowest depth to which the Abbasid dynasty sank in Baghdad before its final extinction by the Mongols in 1258; during this Caliph's long reign of twenty-eight years, he was practically a pensioner on the grudging bounty of the Buwayhids, who had deprived him of all the characteristics of sovereignty except the empty title, and at last compelled him to abdicate. Like Mutawakkil and Muqtadir, he struck a medal bearing his portrait; the Caliph is seated cross-legged, holding a wine-cup in his right hand, with an attendant on either side of him, one holding a musical instrument, the other a cloth with which to drive away flies; on the obverse is a musician playing a five-stringed lute.[7]

To a later period, the reign of the Caliph Nāṣir (A.D. 1180–1225), who attempted with some slight measure of success to restore the fallen dignity of the Abbasid Caliphate, belongs that impressive monument, the so-called Talisman Gate, still standing in Baghdad, which he restored and embellished in 1221. Above the arch is the seated figure of a man grasping the tongues of two winged dragons, whose long involuted tails are coiled down the spandrels of the arch on either side. It has been suggested[8] that we have here

[1] *Zeitschrift für Numismatik*, Vol. XXII, pp. 259 sqq. (Berlin, 1901). (Plate LIX b.)

[2] Fritz Saxl, 'Beiträge zu einer Geschichte der Planetendarstellungen im Orient und im Okzident' (*Der Islam*, Vol. III (1912), Tafel 5, Abb. 6). (Plate LX c.)

[3] Id., Tafel 4, Abb. 3. [4] *British Museum Catalogue of Oriental Coins*, Vol. III, no. 421.

[5] Id., Vol. III, no. 529. [6] Masʿūdī, *Murūj adh-Dhahab*, Vol. VIII, p. 341.

[7] This coin is unique, and is reproduced here from a cast made in the Coins Department of the British Museum; there is no record of its present ownership. (Plate LIX a.)

[8] F. Sarre, 'Islamische Tongefässe aus Mesopotamien' (*Jahrbuch der Kön. Preussischen Kunstsammlungen*, Vol. XXVI (1905), p. 81).

a portrait of the Caliph himself, represented as triumphing over his enemies; but such an identification would imply so violent and public a breach with the accepted attitude of Muslim orthodoxy towards the art of sculpture, that the popular appellation of the gate seems to indicate a more likely interpretation, viz. that it was intended merely to serve as a talisman and protect the city.[1]

In less cultured times, when the rise of younger nationalities had broken up the great Arab empire, and various Turkish dynasties had established themselves in territories that had previously recognized the sway of the Caliph of Baghdad, we find on the coinage of the Urtuqids of Diyār-Bakr a curious succession of designs. These barbarians, apparently wishing to make their coins intelligible to the Christians with whom they traded, copied the devices they found on any coins that came in their way, and while they put their titles on one side, on the other we find rough imitations of the heads of Roman emperors and Seleucid or Sasanian monarchs, and even the figure of Christ enthroned, copied from the coin of a Byzantine emperor.[2] The Saljūqs of Asia Minor also struck coins with human figures on them, but in no case do they appear to be portraits of the monarchs whose names and titles they bear.

It is not impossible that those princes of the Abbasid house who had their effigies put upon their coins also employed painters to paint their portraits; but no evidence can be quoted in support of such a supposition. The art of portraiture, however, must have received some encouragement even in the Abbasid period, since in the reign of Maḥmūd of Ghaznī (998–1030) it appears to have attained such proficiency that it could be used for detective purposes, according to the story of the means which this inexorable monarch adopted in order to discover the whereabouts of Avicenna. This famous philosopher and physician was unwilling to accept the invitation of Maḥmūd to enter his service and fled into Gurgān; so Maḥmūd ordered Abū Naṣr ibn ‘Arrāq, who was a painter as well as a celebrated mathematician and astronomer, to draw the portrait of Avicenna on paper, and then ordered other artists to make forty copies of it, and dispatched these to the courts of neighbouring rulers, bidding them send him the man, whom they would recognize by this portrait.[3] According to this story Maḥmūd must have had a number of expert painters at his court.

In Egypt also such scanty notices as have been preserved suggest that the

[1] *Orientalische Litteratur-Zeitung*, Bd. IX (1906), coll. 181–5.
[2] S. Lane-Poole, *Catalogue of Oriental Coins in the British Museum*, Vol. III, p. ix.
[3] E. G. Browne, *Revised Translation of the Chahár Maqála*, p. 87 (London, 1921).

art of portraiture was practised, for among the treasures of the unfortunate
Fatimid Caliph, Mustanṣir (1035–1094), who was plundered by his unruly
Turkish soldiery, were curtains of silk brocade, worked with gold, having on
them pictures of the kings and famous personages of various dynasties, with
the name of each written above his portrait, together with an account of his
achievements.[1] The grandson of this Caliph, Āmir (1101–1130), had the
portraits of contemporary poets painted in a turret-room which he had caused
to be erected for his own use; each poet was invited to contribute some verses
of his own composition; these were inscribed by the side of his portrait,
together with the name and birthplace of the poet, and by each picture was
an elegant cornice. When the Caliph came to inspect the room and had read
the poems, he was so pleased that he ordered a sealed purse containing fifty
pieces of gold to be put on each one of the cornices, and the poets were then
admitted and each took the reward assigned to him.[2]

A similar form of appreciation of poetic talent is recorded of the last
Saljūq Sultan of 'Irāq and Kurdistān, Ṭughril ibn Arslān, who in the year
1184 had a collection of poems copied out by a celebrated calligraphist named
Zayn ad-Dīn, and the portrait of each one of the poets whose compositions
were included in the volume was painted by Jamāl Naqqāsh Isfahānī.[3] Of
this painter nothing whatever is known beyond this casual reference.

The Mongol conquerors, in spite of their acceptance of the religion of
their Muhammadan subjects, similarly refused to submit to the restrictions
imposed by the theologians in the matter of portraits, and they continued to
follow the practice of their heathen ancestors, who used to have their por-
traits painted by their court painters, probably Chinese or artists of some one
of the nationalities that went to make up the varied population of the country
between the ancestral home of the Mongols and the eastern border of Persia.
The MS. of Rashīd ad-Dīn's History in the Bibliothèque Nationale (Supplé-
ment persan, 1113) contains grim paintings of Chingiz Khān and his
descendants, executed towards the end of the fourteenth century, but copied
from others of an earlier date.

After the Mongol conquest of Persia, portrait painting became increasingly
common. There are several portraits of Tīmūr (1369–1404), though most
of those that have survived were painted by artists of later generations.[4]
Jahāngīr, in his *Memoirs*,[5] describes a picture by a painter named Khalīl

[1] Makkarī, *op. cit.*, Vol. I, p. 417 (ll. 10–11).
[2] Id., Vol. I, pp. 486–7.
[3] Rāwandī, *Rāḥat uṣ-Ṣudūr*, edited by Muḥammad Iqbāl, p. 57 (London, 1921).
[4] F. R. Martin, *op. cit.*, Vol. I, p. 26.
[5] *Memoirs of Jahāngīr*, translated by A. Rogers, Vol. II, p. 116.

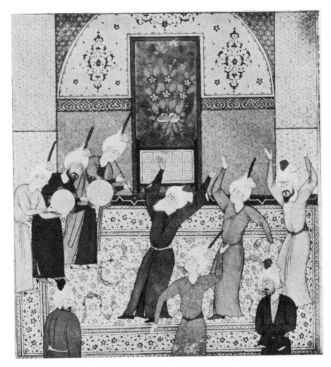

XLVIII. a. Muḥammad Tabādkānī in ecstasy

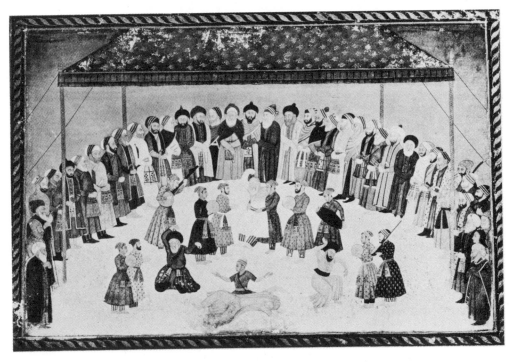

XLVIII. b. A group of mystics dancing

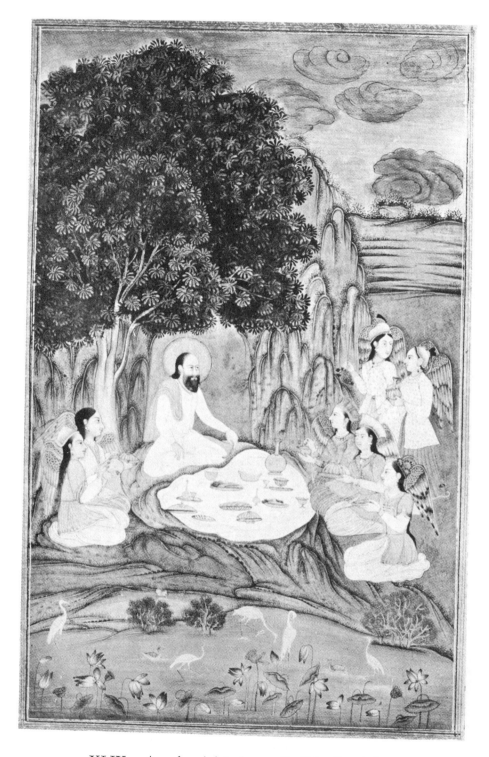

XLIX. Angels ministering to Ibrāhīm ibn Adham

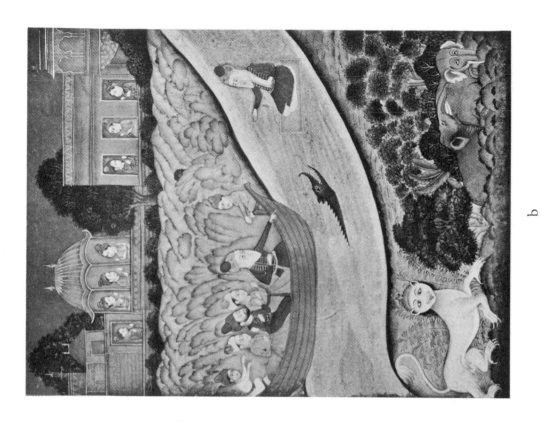

b

a

L. A saint crossing a river on his prayer-mat

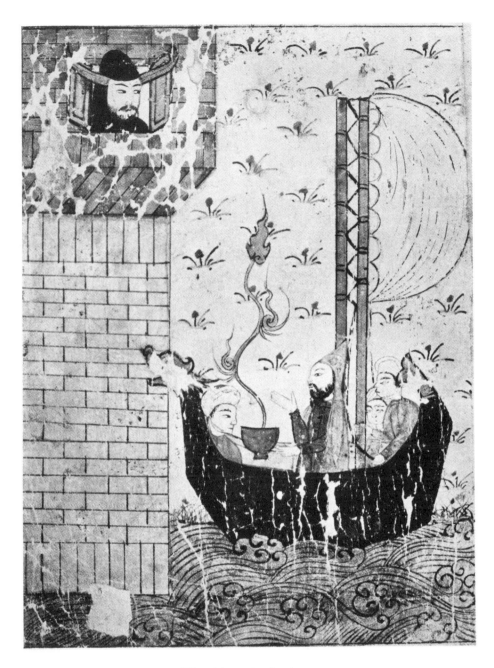

LI. Two rival saints

Mīrzā, which had once been in the library of the founder of the Safavid dynasty, Shāh Ismā'īl (1502–1524); it represented one of the battles of Tīmūr, in which this ruthless conqueror was depicted with his children and the chief officers of his army, and contained as many as 240 figures, each with his name written so that the personages concerned could be identified.

In the fifteenth century portraiture appears to have been considered by more than one Muhammadan potentate as a legitimate means of perpetuating his memory and greatness. Dr. Martin has pointed out how Sultan Husayn Mīrzā (1473–1506) had his own features portrayed in the illustrations of his manuscripts when his court painters depicted the exploits of Alexander, whom (it must be remembered) the orthodox opinion of that age regarded as an inspired Prophet of God and as a devout Muslim, leading his armies against the enemies of the Lord and carrying the true faith into the lands of the unbelievers. Thus, in the MS. of Nizāmī's Epic of Sikandar in the British Museum (Or. 6810), where Bihzād represents (fol. 273) Alexander visiting a hermit dwelling in a cave, the painter's patron, Sultan Husayn Mīrzā, is the real hero of the scene, and has lent his features for the occasion. An early portrait of this enlightened patron of art, and another taken later in life, are both ascribed to Bihzād.[1]

Similarly, portraits of Shāh Tahmāsp (1524–1576), the Safavid prince who himself dabbled in painting and patronized such great artists as Sultān Muhammad and Mīrak, are common. He appears, too, in the pictures which adorn the pages of his superb manuscripts, e.g. in the _Khamsah_ of Nizāmī (British Museum, Or. 2265) it is Tahmāsp who gallops across the field, under the guise of Bahrām Gūr hunting the wild ass.[2]

Later Shāhs of the Safavid dynasty also encouraged the art of portraiture, and the features of Shāh 'Abbās (1587–1629) appear in more than one picture. His grandson and successor, Shāh Safī (1629–1642), is seen surrounded by the generals and nobles of his court, in a diptych described by the present writer in the _Journal of Indian Art_ (Vol. XVII, No. 135). Twenty-one out of the thirty-four figures in this picture bear the name or title of the person indicated—a practice which was common also in contemporary Indian art, and indicates the deliberate intention of representing personality, in consequence of which the art of portraiture from this period onwards constitutes one of the most prominent forms of artistic activity both in Persia and India, as later in Turkey also.

It is not only the sovereign who has himself so immortalized, but the

[1] Marteau et Vever, _Miniatures persanes_, Plate 137 (Paris, 1913); F. R. Martin, _Miniature Painting and Painters of Persia_, Vol. II, Plate 81. [2] F. R. Martin, _op. cit._, Plate 138.

fashion spread also to his subjects. In Persia this popularizing of the art of portraiture may in some degree have been a result of the break-up of the royal atelier, when the increasing cost of Shāh 'Abbās's campaigns forced him to cut down expenses, and accordingly he withdrew his allowance to the court painters, and thus compelled them to seek the patronage of commoners. To this circumstance is probably due the increase in the number of the separate portraits of Persians other than those of members of the royal family—such as nobles, military officers, physicians, scholars, &c.—and the facile brush of Rizā 'Abbāsī[1] was fortunately ready to supply the demand.

The Timurids in India were even more enthusiastic patrons of the portrait painter than the Safavids of Persia. Akbar often sat for his portrait and also ordered the portraits of the grandees of his court to be taken. Apart from separate pictures, the illustrators of the MSS. especially prepared for this emperor's library provide a whole picture-gallery of portraits of the great personages of his court, e.g. in such a work as the *Akbar Nāmah*[2]—the annals of his reign compiled by his prime minister and devoted personal friend Abu'l-Fazl. Here we find them playing their part in the various incidents of their master's career, his campaigns, the sieges of hostile fortresses, his hunting expeditions and convivial gatherings. Though such importance is not attached to individual characterization as is implied in separate portraiture, still the distinctive features of each make the various members of the court of whom there is any historic record easily recognizable, and they do not form indistinguishable members of a crowd, as in some earlier representations of the courts of Muhammadan monarchs, or in such a picture as hangs in the palace of the Nawāb of Rāmpūr, in which one of his ancestors is seen seated among the ladies of his harem, each one of which is an exact facsimile of her neighbour—the painter probably never having set eyes on any one of them. Such colourless presentations of individuals are, of course, common also in Western art, e.g. in Giotto's picture in the Upper Church at Assisi of St. Francis before Pope Innocent III, where the attendant cardinals have features wholly indistinguishable from one another.

Akbar's successor, Jahāngīr (1605–1628), seems to have been even more fond of portraits than his father. Not only did he have himself and his nobles frequently painted, but he even sent a painter named Bishan Dās, who was said to be unrivalled as a portrait painter, to accompany the Indian ambassador to the court of Persia, and there take the portraits of the Shāh and the chief personages of his court.[3]

[1] See pp. 143–4, 145–7. [2] The finest example is the MS. in the possession of Mr. A. Chester Beatty.
[3] *Memoirs of Jahāngīr*, Vol. II, p. 116.

LII. Two figures, from a treatise on ethics

Jahāngīr was the only one of the rulers of the Mughal dynasty who struck coins engraved with his own portrait; sometimes even holding a wine-cup in his hand [1] (Plate LIX c).

Further notice of this vast picture-gallery of portraits is unnecessary here, as so many recent publications have provided abundant materials for the study of it.

As court patronage declined in India, and in the reign of Aurangzīb (1659–1707) ceased for a time altogether, the Indian painters, like their contemporaries in Persia, had to look elsewhere for patrons, and the number of portraits of private individuals increases and the degree of artistic attainment tends proportionately to decline.

Among the descendants of Aurangzīb there appears to have been a revival of court patronage, for portraits of Farrukhsiyar (1713–1719) and of Muhammad Shāh (1719–1748) are common. About the same period in Persia also, later Shāhs extended their patronage to painters, e.g. there are several portraits of Nādir Shāh (1732–1747), the most noteworthy of which is that in the India Office.[2] Fath 'Alī Shāh (1797–1834) kept his court painters particularly busy; he was inordinately proud of his long black beard and had his portrait taken on innumerable occasions, either by himself or surrounded by his court or attended by his ladies. In 1822 he presented to the Court of Directors of the East India Company an oil painting of himself in a scarlet coat, richly decorated with jewels, and a turban covered with pearls. This portrait, together with another by his court painter, Mīrzā Bābā, now hangs in the India Office. In another oil painting of vast size (139 in. × 205 in.) the Shāh is seen hunting with the royal princes and his courtiers, the names of the chief personages being painted in Persian on the canvas.[3] Another of his presents to the Directors of the East India Company is a copy of an epic poem by his poet laureate, Sabā, in which an account is given of the various exploits of his master; in this copy the picture of the Shāh appears as many as nine times.[4]

In Turkey portraiture appears to have enjoyed the patronage of the Ottoman Sultans from the fifteenth century onwards, and a whole series of the monarchs of this dynasty adorned one of their palaces in Constantinople and has frequently been copied and in modern times been reproduced in various publications.[5]

[1] S. Lane Poole, *Coins of the Moghul Emperors of Hindustan in the British Museum*, p. lxxx.
[2] In the Military Committee Room.
[3] Sir William Foster, *Descriptive Catalogue of the Paintings, Statues, &c., in the India Office*, nos. 21, 39, 51.
[4] Ethé, *Catalogue of Persian Manuscripts in the Library of the India Office*, no. 901.
[5] See pp. 38–9.

It is thus clear that the art of portraiture has had a long history in the Muhammadan world, and it is probable that the memorials which have survived, abundant as they are, form only a comparatively small part of those that once existed, as is obviously the case with the other artistic products of the activity of Muhammadan painters.

It is, however, important to notice that this love of portraiture, in spite of the abundant artistic activity which it prompted and encouraged, was mainly confined to the court, since the theologians and the general body of the orthodox in no way relaxed their hostile attitude towards such infringements of the sacred law. Even up to the nineteenth century this condemnation of the painter's art was extended to photography, and in spite of the sophism that attempted to attribute the production of such a method of taking a likeness to divine agency, since it was the sunlight and no human paint-brush that made the picture, the orthodox refused to abate a jot of the severity with which earlier theologians had viewed any representation of living beings.[1]

[1] C. Snouck Hurgronje, *Mekka*, Vol. II, p. 219.

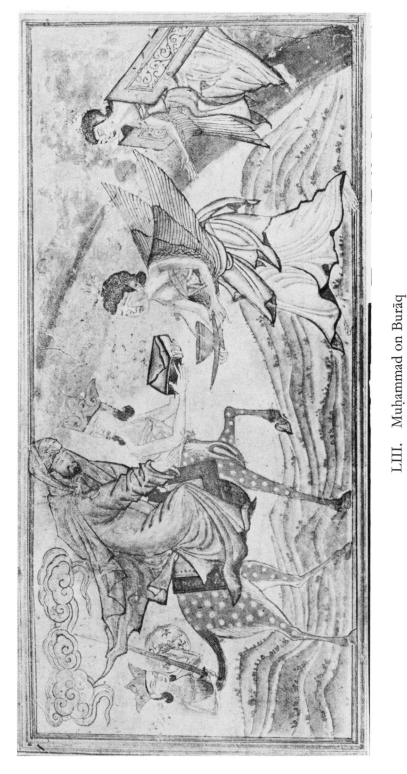

LIII. Muḥammad on Burāq

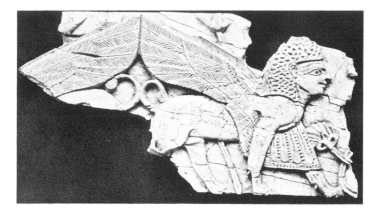

a

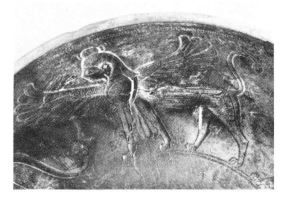

b

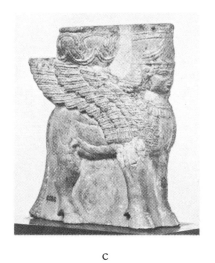

c

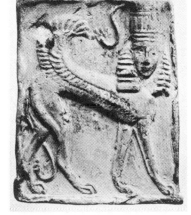

d

LIV. Prototypes of Burāq

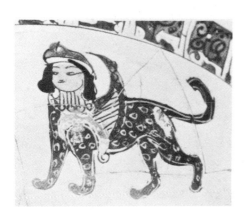

a

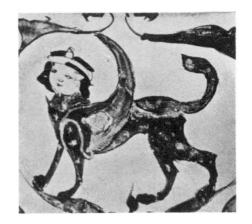

b

c

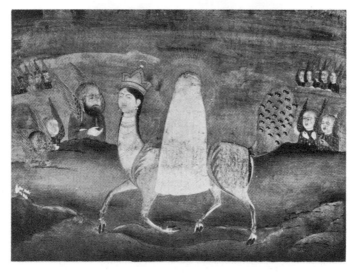

d

LV. Representations of Burāq

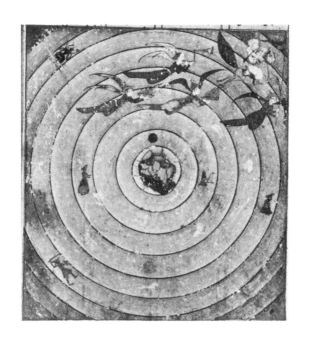

a

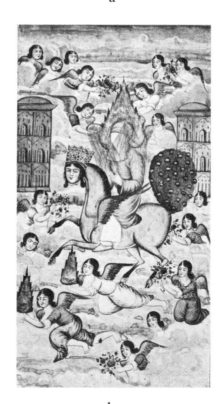

b

LVI. Burāq

IX

THE EXPRESSION OF EMOTION

THERE is one characteristic of the figure painting of the Muhammadan period which is deserving of special attention, viz. the infrequency of any attempt to give emotive expression to the faces of the living persons represented in these pictures. Such a deficiency can hardly be ascribed to lack of ability, in view of the noteworthy achievements of the Muhammadan artists in other varieties of their creative activity, especially in the delineation of character. Several circumstances belonging to divers categories may have contributed to this result. Since these paintings appertain to a courtly art, the demeanour of the persons depicted is made to correspond with that serenity and dignity of bearing which are so characteristic of the ideal of outward behaviour, cultivated in polite society throughout the greater part of Muhammadan history. This avoidance of any violent manifestation of feeling is not unconnected with the discipline imposed on the believer by the faith of Islam, as manifested in the decorum and solemnity of the ritual of public worship at the five canonical hours, and with the calm, imperturbable acceptance of the vicissitudes of fortune, however unexpected and disastrous, as expressions of the will of Allāh, the Merciful, the Compassionate.

From the artistic point of view, the fact that much of the illustration of Persian MSS. had its origin in the paintings covering the walls of royal palaces made the expression of emotion subordinate to the demands of mere decoration. Further, as Dr. Laurence Binyon has finely pointed out, 'in the later Persian art, beauty of line for its own sake was pursued to the suppression of interest in character and expression'.[1]

Whatever the reasons may have been,—and they were certainly multifarious—the fact remains that, charming as these pictures are in colour, graceful in outline, and successful in their presentation of the story or incident that has to be illustrated, they are for the most part lacking in any attempt at the expression of emotion. The painter seems, in the majority of cases, to have contented himself with the creation of sheer beauty; he exhausts the resources of his palette in a riot of colour, and with that feeling for fine calligraphy which to his contemporaries often stood for the highest expression of beauty of form, draws his graceful undulating lines with an unmixed delight in the creation of pleasing contours. Having set his figures

[1] *The Court Painters of the Grand Moguls*, p. 43.

in their due relation one to another, having decorated them with magnificent raiment and fantastic head-dresses, enriched the saddle-cloths with gold-work and embroidery, and exercised his ingenuity in the patterns upon their robes, the painter appears to have been satisfied with the beautiful decorative effect thus achieved. He was apparently willing to spend hours of work upon the delicate veining of the leaves of a plane-tree or the shades of colour on the petals of an iris, but it does not seem to have occurred to him to devote the same pains and effort upon the countenances of his human figures and make them show by their expressions their mental attitude towards the scene in which they were playing a part. As a rule the actors in these pictures look out upon the scene with unconcerned, emotionless faces, whether they be kings or attendants, soldiers or peasants. Warriors in the frenzy of battle deal blows and receive mortal wounds with apparent unconcern; a head just about to fly from the shoulders at the vigorous blow of a stalwart foe seems to regard the unwonted separation with entire indifference, and a knight from whose body the blood is pouring with an abundance that bears evidence more to the possession of plenty of crimson paint than to any knowledge possessed by the painter as to what happens in such circumstances, stolidly refrains from exhibiting any outward sign of the agony that must accompany such a painful experience. Even moments of ecstatic delight leave the actors in the scene with unimpassioned faces, as though they did not know that they were attaining the zenith of delight in the sphere of human experience.

In consideration of this lack of varieties of emotive expression on the countenance the painters had to devise conventional modes of indicating emotion. One of the commonest of these is the putting of a finger to the lips as a sign of astonishment, and it constantly occurs in cases where, without this characteristic gesture, there would be no indication that the persons concerned were under the influence of any feeling whatsoever. Another conventional sign was the gnawing of the back of the hand to indicate the emotion of despair. Even violent grief makes no change in the features of the mourner, but is shown by the veiling of the face or tossing of the arms.

In this matter of emotional quality the MS. of Rashīd ad-Dīn's *Universal History*, so often referred to, stands apart from all others, and this deviation from the imperturbability that ordinarily characterizes Muhammadan painting probably finds its explanation in foreign influence, viz. the prevailing Chinese character of the pictures in this manuscript. The predominant horror of the incidents that the artist was called upon to depict seems to have frozen his blood; executions and mutilations, battles and massacres, are repeated on one page after another till the painter must have grown sick of them; at any rate

over most of his pictures there seems to hang a heavy pall of melancholy, which expresses itself as much on the faces of the unharmed spectators as on that of the victim who is having his throat cut or his arms and legs slowly hacked off.

Chinese influence of an entirely different character exhibits itself in the work of a particularly attractive artist of a much later period—Muḥammadī. His name (meaning 'Muhammadan') occurs very rarely as a personal name, and suggests that he was a convert to Islam. Of his history nothing whatever is known, and the character of his drawing suggests affinities with Chinese art, and he himself may have been a Chinese convert or a native of some region of Eastern Asia. Dr. Martin[1] has described one of his works as a copy of a drawing by the Chinese master, Li Lung-mien, but the subject is in every respect Muhammadan and the scene presented may well have occurred in Turkestan or even in Persia. A picture by him in the Louvre, dated A. H. 986 (= A.D. 1578),[2] enables us to place his *floruit* in the latter part of the sixteenth century, and an inscription on Riẓā ʿAbbāsī's copy[3] of a portrait by him refers to Muḥammadī as already dead, and describes him as having belonged to the city of Harāt, but whether this epithet is to be interpreted as indicating his birthplace or merely as his place of residence, it is impossible without further evidence to determine. In 1578 Harāt was under Safavid rule, though the capital was Tabrīz, but the kingdom was racked by civil war, and a few years later Tabrīz was captured and sacked by the Turks. It was no season for painters to hope for the patronage of the Persian Shāh, or to find much encouragement for a cheerful outlook upon life; but Muḥammadī's drawings show that he was endowed with a sense of fun and was fond of depicting comic figures dancing and capering about as though they really enjoyed their merry-making; there is no pretence about their frame of mind and no conventional gesture has to be employed in order to serve as a label.

Few other painters who worked in Persia made any attempt to express emotion. A notable exception occurs in the well-known picture[4] of the rival physicians, which illustrates a story told by Niẓāmī in his *Khamsah* to emphasize the power of suggestion. These two court physicians had challenged one another to an ordeal by poison, and the first gave to his rival a poisonous draught, which the second swallowed but rendered harmless

[1] *Op. cit.*, Vol. II, Plate 102 a. See also E. Kühnel, *Miniaturmalerei im islamischen Orient*, p. 60 (Abb. 66).

[2] G. Migeon, *Musée du Louvre. L'Orient Musulman*, Plate 50; E. Kühnel, *Miniaturmalerei im islamischen Orient*, Abb. 65. [3] L. Binyon, *Asiatic Art in the British Museum*, Plate LIV, 4.

[4] British Museum, Or. 2265, fol. 26 b. Reproduced by Dr. F. R. Martin, *op. cit.*, Vol. II, Plate 131, and by E. G. Browne, *Arabian Medicine* (frontispiece).

by taking the appropriate antidote immediately afterwards. The latter, in his turn, contented himself with plucking a rose, and after muttering an incantation over it gave it to his rival to smell, whereupon through excess of fear he at once fell down dead. The savage grin of delight with which the tricky victor looks down on the dead body of his weak-minded antagonist is an attempt at emotive expression rare in Persian painting (Plate LXI).

When so many legitimate opportunities for humorous art were neglected, it is strange to find caricature obtruding itself into an otherwise serious and dignified picture. In Shāh Ṭahmāsp's copy of the _Khamsah_ of Nizāmī (B. M. Or. 2265, fol. 18) there is a finely conceived representation of the interview between Sultan Sanjar and the old woman who complains that she has been robbed by one of his soldiers; it is one of the finest examples in Persian painting of the illustration of this incident, which the painters were fond of selecting; it is rich in colouring, and full of exquisite detail, especially in the delicate delineation of forms of flowers and trees; but a close examination of the somewhat strange structure of the rocky masses in the background reveals the presence of a number of grotesque human faces, so arranged as to suggest at first merely geological convolutions of the strata.

In Indian art—possibly because so many of the painters were Hindus and had a livelier interest in human character—there are more frequent examples of attempts to give animation and appropriate expression to the features of the persons represented. There are also more instances of the introduction of a comic element; one of the earliest examples is the humorous representation of the strange figure of Mullā Dū-piyāza[1] (i.e. the Rev. Two-onions), a wit and buffoon who enjoyed the favour of the Emperor Akbar; he wears an enormous turban, as an indication of his pretensions to ecclesiastical dignity, and is wrapped in a voluminous garment; he rides a lean and sorry nag whose ribs seem just about to burst through his fleshless hide, while bending under his bulky load the poor beast seems just about to collapse.

Perhaps the most successful examples of the expression of emotion are given in the pictures of animals, in the delineation of which both Persian and Indian painters were remarkably successful. They devoted to them the same patient and loving care as they gave to their drawings of trees and flowers. As pointed out in Chapter V, one of the earliest books they were called upon to illustrate was _Kalīlah wa Dimnah_, that Buddhist collection of

[1] His real name is not known, and he is said to have received this nickname from a dish of which he was particularly fond, the most important ingredient of which was onions. The _Ā'īn-i-Akbarī_ gives the recipe as follows: 7 lb. of meat, middling fat; $1\frac{1}{3}$ lb. of clarified butter; $1\frac{1}{3}$ lb. of onions; $\frac{1}{6}$ lb. salt; $\frac{1}{8}$ lb. fresh pepper; cumin seed, coriander seed, cardamoms, cloves, 1 oz. of each; 2 oz. of pepper (trans. Blochmann, Vol. I, p. 60).

b

a

LVII. Frescoes from Quṣayr ʿAmra

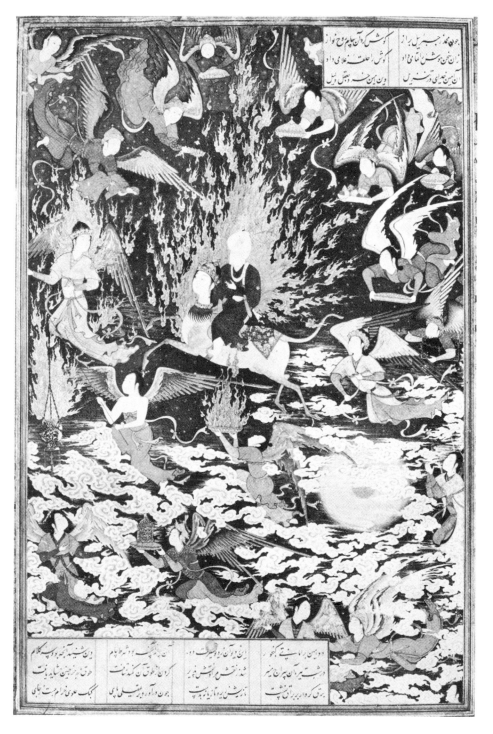

LVIII. Muḥammad's Ascension to Paradise

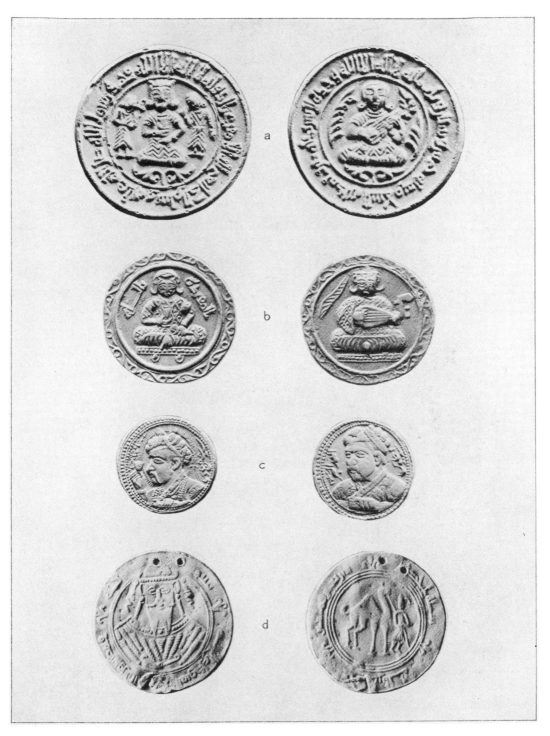

LIX. Coins with effigies

a

b

c

LX. Representations of the planets

stories in which animals discourse and behave like human beings; from the outset the painters seem to have entered into the original spirit of this ancient work, and were often more successful in imparting expression to the features of these animals than they were in the case of men.[1] The jackals who watch the unwary bull enticed to his doom grin sardonically in enjoyment over the success of their cunning; the crow watches sympathetically over the fate of his friends and wisely devises plans for their rescue; the owls show their spiteful humour and their savage rage as ruin overwhelms them. Similarly, throughout the many works in which animals appear, they receive a sympathetic treatment at the hands of the painters of one generation after another, until this attractive series of animal art attains its finest expression in India.

[1] Plate LXIII.

X

A CHAPTER OF BIOGRAPHY

THE biographical literature of the Muhammadan world—in Arabic, Persian, Turkish, and Urdu—is vast beyond all counting. There are many biographies of the Prophets—with many more, of course, specially devoted to Muhammad, the last of the series—of persons who were personally acquainted with Muhammad; Ibn al-Athīr (*ob*. 1234) included more than 7,500 biographies and Ibn Ḥajar (*ob*. 1449) as many as 8,986, in the respective works which they compiled on the Companions of the Prophet. There are separate biographical dictionaries devoted to saints, to the members of the various religious orders, even to persons who knew the Qur'ān by heart (Dhahabī (*ob*. 1348) could so early as this date write the lives of as many as 1,168 of them)—to philosophers, scholars, and physicians, to poets, to calligraphers.

But no Muhammadan writer appears to have cared to pay any attention to the painters before Maqrīzī (*ob*. 1442), who tells us that he wrote a history of painters,[1] but we know nothing of the contents of this work; no MS. of it is known to exist, though many of the much more voluminous writings of this prolific author have been preserved, nor does any subsequent writer appear to have quoted it. Such neglect is characteristic of the contemptuous attitude with which the painter was commonly regarded in the Muhammadan world.

The mere names of individual painters are occasionally mentioned, as has already been noticed,[2] but no further details are provided.

It is not until the sixteenth century that mention is occasionally made of painters who happened at the same time to have dabbled in verse or have practised the art of fine writing, so they succeed in finding a place in the biographies of poets or calligraphers. Moreover, from this period also, in consequence of the altered evaluation of pictorial art to which reference has been made,[3] painters might receive some notice among the distinguished persons of the reign of the monarch whose annals were being written.

In order to illustrate how meagre such information is, some extracts will be given from the writings of the historians who have made mention of contemporary painters.

The first is Khwāndamīr, to whose sympathetic attitude towards art reference has already been made.[4] He made an abridgement of his grandfather's

[1] See p. 22. [2] pp. 22, 71, 127–8. [3] p. 37. [4] p. 34.

great work the *Rawḍat uṣ-Ṣafà*, adding to it some supplementary matter of his own about 1498, and called it *Khulāsat al-Akhbār*, or Compendium of History; at the end of this work he finds room for a brief account of four painters whom he brings in along with the engineers or artificers. Thirty years later he expanded these brief notices in a much more ambitious work, a Universal History entitled *Ḥabīb as-Siyar*, as follows:

'Mawlānā Ḥājī Muḥammad Naqqāsh. He was a master of the arts of his time, and with the brush of imagination he depicted marvellous things and wonderful forms upon the pages of the age. He attained a high degree of skill in the art of painting and working in gold. Several times he made an attempt to bake Chinese vessels, and after much trial and unremitting effort the form of the vessels he made closely resembled those of China; but the colour and purity of them was not as it ought to have been. Among the inventions of Mawlānā Ḥājī Muḥammad was the case of a clock which he fixed in the library of Niẓām ad-Dīn 'Alī Shīr. In this case he put a statue with a stick in its hand, and one hour after sunrise the statue beat its stick once on the drum in front of it, and after the lapse of two hours it did so twice, and so on. Mawlānā was for a long time director of the library of Amīr 'Alī Shīr, but at last, having fallen out with him, in one of the months of 904 (= A.D. 1498-9) when Mīrzā Badī' az-Zamān was engaged in besieging the city of Harāt, he ran away and attached himself to that prince, and was appointed to the same post. He died in the beginning of the conquest of Abu'l-Fatḥ Muḥammad Khān Shaybānī.'[1]

'Mīrak Naqqāsh. He had no equal in the art of painting and gilding, and uplifted the banner of unsurpassedness in the art of calligraphy. The greater part of the inscriptions on the buildings of Harāt were written by him. He died when Muḥammad Khān Shaybānī obtained sovereignty over Khurāsān'[2] (April 1507).

'Mawlānā Qāsim 'Alī. He is one of the honoured men of learning and is distinguished for his generosity and innate liberality. From his early childhood he has devoted himself to the attainment of various branches of knowledge by observation and intellectual effort, and he is thoroughly acquainted with the art of drawing gold-thread and of gilding. He is well known for his self-denial and his righteousness, for his virtue and integrity. He has had the good fortune to make the pilgrimage of Islam and to perambulate the holy shrine of the Prophet. In the perfect integrity of his soul he has written nothing but loyalty on the tablet of his heart with the pen of reflection. At the time when Amīr Khān Mawṣlū was governor of Harāt, on the invitation of Sultan Maḥmūd he left his home for Sīstān and is living there up to the present day, and enjoys all honour and respect in the chair of teaching and instruction.'[3]

As Khwāndamīr selects only four painters in the accounts he gives of artists in the two histories mentioned above, he probably refers to the same person under the names Mawlānā Qāsim 'Alī and Master Qāsim 'Alī; of the latter, in the *Khulāṣat al-Akhbār*, he wrote:

'Master Qāsim 'Alī, a painter of faces, is the cream of the artists of the age and the leader of the painters of lovely pictures; he acquired this art in the library of Sultan

[1] *Ḥabīb as-Siyar*, Vol. III, p. 342 (Bombay, 1857). [2] Id., p. 343. [3] Id., p. 348.

Ḥusayn Bayqarā, and through the instruction he received from this prince he came to surpass all his contemporaries and remained continuously in his service.'[1]

In the *Ḥabīb as-Siyar* nothing is said of Qāsim ʿAlī's abilities as a painter, and emphasis is laid only on his intellectual and theological attainments; it would appear likely that this Qāsim ʿAlī had abandoned the practice of the art of painting during the course of the thirty years that had elapsed between Khwāndamīr's writing of his two histories, for otherwise it seems hardly possible that a writer with Khwāndamīr's interest in painting should have given no intimation at all in this latter account that Qāsim ʿAlī had ever been a painter. It is thus rash to identify him with the much-discussed miniatures which bear his name in the British Museum MS. (Or. 6810). This instance is typical of the difficulties in the way of identifying the few painters of whom there is any historical record with those of the same name to whom the authorship of individual miniatures is ascribed. The name Qāsim ʿAlī is itself so common that there may well have been more than one artist at the same time who was so styled.

This difficulty does not occur in the case of the last of the painters mentioned by Khwāndamīr—Bihzād—whose name has occurred so frequently in the preceding pages, though the information forthcoming is scanty enough and does not go beyond the limits of extravagant eulogy.

'Ustād Kamāl ad-Dīn Bihzād. He sets before us marvellous forms and rarities of art; his draughtsmanship, which is like the brush of Mānī, has caused the memorials of all the painters of the world to be obliterated, and his fingers endowed with miraculous qualities have wiped out the pictures of all the artists among the sons of Adam. A hair of his brush, through its mastery, has given life to the lifeless form. My revered master attained to his present eminence through the blessing of the patronage and of the kind favour of the Amīr Nizām ad-Dīn ʿAlī Shīr, and His Majesty the Khāqān (i.e. Sultan Ḥusayn Bayqarā) showed him much favour and kindness. At the present time too this marvel of the age, whose belief is pure, is regarded with benevolence by the kings of the world and is encompassed with the boundless consideration of the rulers of Islam. Without doubt thus will it be for ever.'[2]

An annalist of the early Safavid Shāhs, Iskandar Munshī, deals more fully with the painters of his period. The author lived in the reign of Shāh ʿAbbās (1587–1629) and originally brought his narrative only up to the year 1616, but later he continued it up to the death of ʿAbbās and the accession of his grandson, Shāh Ṣafī, in 1629. He devotes separate sections to the nobles, the ʿulamā, the physicians, calligraphers, poets, singers, and musicians, and gives four or five pages to painters. His account is here translated in full, as being the most extensive account of painters before the decline of the art

[1] India Office MS. (Ethé 77), fol. 309. [2] *Ḥabīb as-Siyar*, Vol. III, p. 350.

of painting in Islam, and as illustrating the meagre and jejune character of such information as is available.

'An account of eminent artists and gilders with magic-working pen, who were the artists of the day; in those times the pages of the age were gilded and decorated on account of their existence. *Verse.* The scribe, an artist with a hand like Bihzād's, has thus painted the garment of speech, that his late Majesty (Shāh Ṭahmāsp) was an incomparable artist, a painter with a fine brush whose work was like magic—though it is almost a piece of insolence to count his Majesty among the artists of the time—yet as his life's page was adorned with such marvellous painting, it is not overboldness to give an account of it.

His Majesty was a pupil of the celebrated painter, Master Sulṭān Muḥammad; he attained perfection in designing and the delicate use of the brush; in his early youth he had a great enthusiasm and love for this art, and established in his well-equipped library the incomparable masters of this art, such as Master Bihzād and Sulṭān Muḥammad, who had reached the greatest height in this noble art and had attained world-wide fame for the delicacy of their brush; and Āqā Mīrak, the artist from Iṣfahān, was his special friend and intimate boon companion.

His Majesty was very friendly with this group; whenever he was at leisure from the business of government and the cares of state, he would devote his attention to practising painting, but in the latter part of his reign the multitude of his occupations left him no leisure for such work, and he paid less attention to the work of those masters, who bestowed life on the beautiful forms produced by their mixing of colours. Some of the officers of the library who were still alive were permitted to practise their art by themselves. Towards the end of his life he appointed as librarian Mawlānā Yūsuf Ghulām-khāṣṣah, who was a fine writer of <u>Thulth</u> and had received instruction from his Majesty, so that he had charge of the royal private collection of books.

Of all the masters of this art who after the death of his late Majesty adorned the pages of the age, the first one, incomparable in his time and unique in his period, was Mawlānā Muzaffar 'Alī, who with a hair-splitting brush painted the portraits of models of justice and was a pupil of Master Bihzād and had learned his craft in his service and made progress to the height of perfection; all the incomparable masters, eminent portrait painters, acknowledged him (Muzaffar 'Alī) to be unrivalled in that art; he was a fine painter and a matchless draughtsman. The pictures in the royal palace and the assembly hall of the Chahil Sutūn were designed by him and for the most part were the work of his golden painting. After the grievous death of his late Majesty, he himself passed away.

Mīr Zayn al-'Abidīn was a son of a daughter of Master Sulṭān Muḥammad, the painter and teacher of his late Majesty, and was sober in character, pure and upright; he was invariably prudent and courteous; he was honoured both by high and low; he was a good artist and an agreeable companion and his nobility was without compare, and he was a virtuous painter; his pupils carried on the work of the atelier, but he himself always enjoyed the patronage of the princes and nobles and grandees, and the light of the consideration and the favour of the great shone upon him; in the reign of Ismā'īl Mīrzā,[1] who re-established the library, he became a member of the library staff.

[1] i.e. Shāh Ismā'īl (1502–1524), the founder of the Safavid dynasty.

Ṣādiqī Beg was a Turk of the Afshār tribe, a man of the world and a man of parts. Ṣādiqī was his pen-name. He conceived a liking for painting when he was quite young; he attached himself day and night to the paragon of the age, Master Muzaffar ʿAlī, who observing in him signs of ability and progress, devoted himself to training him, and (Ṣādiqī Beg) while he was his pupil attained the highest possible perfection. At one time when, out of pride and obstinacy, he lost interest in painting because the market for it was dull and things were not going as he wished, he abandoned it and, stripping himself of all superficialities, took to the life of a wandering dervish and travelled about from place to place. Amīr Khān Mawṣlū, while he was Governor of Hamadān, heard about him, induced him to abandon the garb of a dervish, and took him into his own service and treated him in a humane manner. In accordance with the natural disposition of a Turk and the habits of the Qizilbāsh, he made pretensions to hardihood and bravery and gave himself airs over the heroes of his period. In the reign of the Sultan Muḥammad Nawwāb Sikardarshān he took service under Iskandar Khān Afshār and Badr Khān his brother; in the battle with the Turkmans at Astarābād he displayed foolhardy deeds of daring, but at no time did he neglect the practice of painting, so that in the end he made excellent progress and became an unsurpassed painter, a fine artist and an unequalled designer, and with a brush as fine as a hair he painted thousands of marvellous portraits. He was endowed with ability and talent and had the gift of poetry and eloquence; he composed excellent qaṣīdas, ghazals, and mathnawīs; the following fine verse occurs in his mathnawī "Jang nāmah"

> The arrows like locusts in their flight
> Proved disastrous to the corn-land of life.

Since some of his verses will be quoted in the section on Poets, it is unnecessary to quote more here. In the reign of Ismāʿīl Mīrzā he was on the staff of the library. In the reign of his present Majesty, the Shadow of God, (Shāh ʿAbbās) the high office of librarian was conferred upon him and he enjoyed the royal clemency and favour. But he was of a disagreeable, jealous, and suspicious disposition, and his surly unpleasant character never left him free from self-seeking, and, in accordance with his disposition, he always behaved towards his friends and associates with a discourtesy which went beyond bounds, but they willingly purchased from him those worthless goods which are unsaleable in the market of merit. But he passed the limit of moderation and went to excess in his bad behaviour towards everybody, and for this reason he fell out of favour and was dismissed from the office which had been entrusted to him. But to the end of his life his official designation remained unchanged and he continued to draw his salary from the treasury.

Mawlānā ʿAbd al-Jabbār, son of Ḥājī ʿAlī Munshī of Astarābād, was a writer of Taʿlīq; at first he devoted himself to acquiring the art of painting and reached a high degree of attainment and perfect skill in it, and also practised writing till he became a fine writer; he was a pleasant and agreeable companion, witty and sweet-tongued, so that the grandees and the nobles sought his company and left him no leisure for the pursuit of his art. He went for a time to Gīlān and attached himself to the officials and courtiers of Khān Aḥmad of Gīlān; after the rebellion in that province and the arrest of Khān Aḥmad, he went to the capital, Qazwīn, and stopped there for a time, but though he had established there an atelier for painters, he wasted the greater

part of his time in the company of amīrs and nobles and consequently accomplished little.

Khwājah Naṣīr, his son, acquired some skill like his father, and even more, and used to work with his pupils; but he was especially associated and connected with Ḥusayn Beg Yūzbāshī, who was an officer of Sultan Haydar.[1] In the reign of Ismāʿīl Mīrzā he became attached to the service of the library. In the time of Sultan Muḥammad, when Khān Aḥmad was appointed to the government of Gīlān, he again took service with him and went to Gīlān and followed his flag.

Siyāwush Beg the Georgian had been a page of his late Majesty, who having observed in him signs of ability gave him opportunities for the study of painting and he became a pupil of Master Ḥasan ʿAlī the painter; when he had acquired some ability in that art, the fine work of his brush made an impression on his Majesty, so that he himself looked after his being instructed. While he was a pupil of his Majesty he made excellent progress. He painted some very delicate and fine work, and was an incomparable painter. In the reign of Ismāʿīl Mīrzā he was put on the staff of the library, and in the time of the Nawwāb he and his brother, Farrukh Beg, were admitted to the confidential circle of the fortunate prince, Sultan Ḥamza Mīrzā. In the reign of his present Majesty, the Shadow of God, they both died after having been in his service for a long time.

Mawlānā Shaykh Muḥammad Shīrāzī, a man of wit, of charming appearance and an agreeable companion, claimed to be unique as a painter and a colourist, and he was in fact justified in his claim, and all the masters of painting agreed with him in this matter. He wrote Naskh and Taʿlīq extraordinarily well, and copied verses written by masters of the calligraphic art so marvellously that even keen-sighted calligraphists could hardly distinguish them from the originals. In Persia he was the man who imitated European models and made this style of painting fashionable. He was unsurpassed in the making of colours and drawing portraits. He went to Sabzavar in the service of Sultan Ibrāhīm Mīrzā,[2] and while in his company visited ʿIrāq. In the reign of Ismāʿīl Mīrzā he joined the staff of the library, and afterwards went to Khurāsān, and during the reign of his present Majesty, the Shadow of God, he was in his service and took part in the building of the new palace of Qazwīn, and died while in his service.

Mawlānā ʿAli Aṣghar of Kāshān, an incomparable master and an accomplished painter; as an artist and as a colourist he was unique, and surpassed his contemporaries in drawings of streets and trees; he also took service with Sultan Ibrāhīm Mīrzā and in the time of Ismāʿīl Mīrzā was on the staff of the library.

His son, Āqā Riżā, became the marvel of the age in the art of painting and unequalled in portraying single figures, and his reputation has become firmly established in these days. In spite of the delicacy of his touch, he was so uncultured that he constantly engaged in athletic practices and wrestling, and became infatuated with such habits. He avoided the society of men of talent and gave himself up to association with such low persons. At the present time he has a little repented of such idle frivolity, but pays very little attention to his art, and like Ṣādiq Beg he has become ill-tempered, peevish, and unsociable. But the truth is there is a certain strain of independence in his character. In the service of his present Majesty, the Shadow of God, he has been the recipient of favours and kindnesses and consideration, but on account of his evil

[1] The father of Shāh Ismāʿīl. [2] A younger brother of Shāh Ismāʿīl.

ways he has not taken warning and consequently he is always poor and in distress. The following verse is applicable to his condition:

> All the kings of the world are seeking after me,
> While in Iṣfahān my heart has turned to blood in my search for a livelihood.

Mīrzā Muḥammad Iṣfahānī, a painter with a delicate touch, was a pupil of Khwajah 'Abd al-'Azīz Kākā; he was incomparable in decorating assembly halls, and in minute work no one could equal him; in the time of Ismā'īl Mīrzā he joined the staff of the library.

Mawlānā Ḥasan Baghdādī was incomparable and was unsurpassed and unique in his time in the art of gilding; in short he brought the art of gilding almost to a miracle, and all the masters of this art recognized his high attainment in it, and the gilding of Mawlānā Bārī, who had reached the greatest height in this art, cannot bear comparison with his minute and fine work. In the last years of the reign of his late Majesty he was accused of having forged the royal signet. In fact his success was almost miraculous. His late Majesty put pressure upon him and constantly threatened to have his hand cut off; but in the end, on account of the fact that he worked on the dome of Ḥaẓrat Abū 'Abd Allāh Ḥusayn and decorated that sacred tomb, his Majesty overlooked his punishment and accepted his repentance on this condition, that he would not do such a thing again. In the time of Ismā'īl Mīrzā he joined the staff of the library, and his son too derived some profit from the artistic skill of his father; they used to do gilding and painting together.

Mawlānā 'Abd Allāh Shīrāzī was also an accomplished worker in gold; after the murder of Sultan Ibrāhīm Mīrzā (in 1574) Ismā'īl Mīrzā gave him an appointment in the library. At the same period there were other excellent artists and painters, such as Muḥammadī of Harāt and Naqdī Beg, &c.

A selection has merely been made of a few of the more famous masters of this art.' [1]

For the history of the court painters of a powerful and wealthy monarch like Shāh 'Abbās, who appears to have been as generous a patron of art as his grandfather Ṭahmāsp, these materials are lamentably meagre and insufficient, and they disappoint us most in respect of that part of a painter's life which is naturally of the greatest interest, namely, the actual works of art which he produced. Iskandar Munshī might well have mentioned the fact that five of these painters (viz. Zayn al-'Ābidīn, Ṣādiqī Beg, Siyāwush Beg, 'Alī Asghar, and Naqdī Beg) co-operated in illustrating a copy of the *Shāh Nāmah*.[2] This MS. was exhibited in the Musée des Arts Décoratifs in 1912, and contains the only examples of the work of these painters known, unless the painter who signed his pictures with the name Ṣādiq can be identified with Ṣādiqī Beg.[3] A few examples of the work of Mawlānā Muḥammad Shīrāzī,[4] of Mīrzā Muḥammad Iṣfahānī,[5] and of Muḥammadī of Harāt[6]

[1] Iskandar Munshī, *Ta'rīkh-i-'Ālamārā-yi-'Abbāsī* (India Office MS., Ethé 540, foll. 74 b–77).

[2] *Miniatures persanes exposées au Musée des Arts Décoratifs, Juin–Octobre 1912*, Préface et commentaire par Georges Marteau et Henri Vever.

[3] W. Schulz, *Die persisch-islamische Miniaturmalerei*, p. 182.

[4] Id., p. 183. [5] Id., p. 182. [6] Id., p. 181.

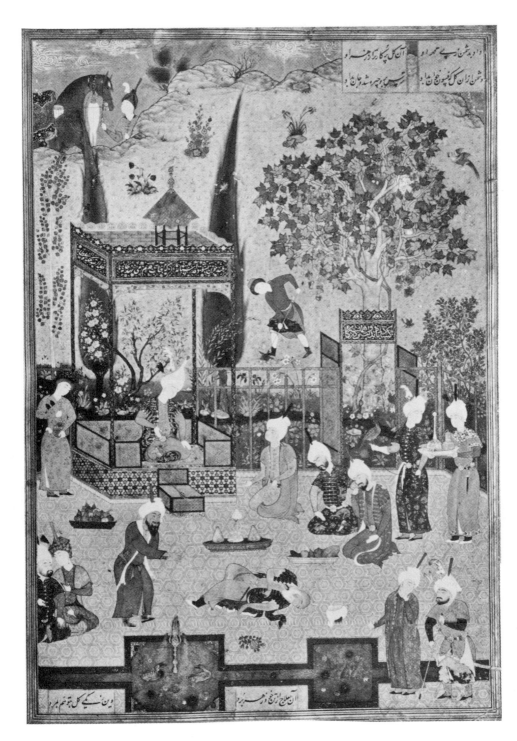

LXI. The rival physicians

a b

LXII. Dervishes, by Muḥammadī

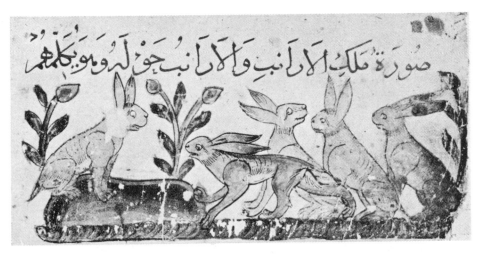

a

b

LXIII. The animals in council

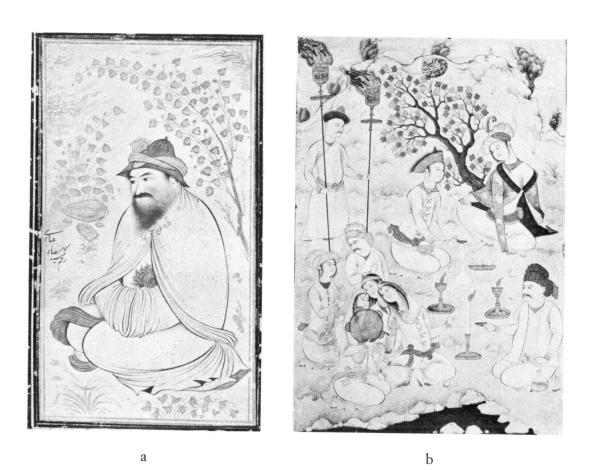

a b

LXIV. A dervish and a picnic party, by Rizā ʿAbbāsī

have been noted, but of 'Abd al-Jabbār and Khwājah Naṣīr we know nothing except what Iskandar Munshī has told us. But the fame of all these pales before that of Muẓaffar 'Alī (who painted fol. 211 in the famous copy of the *Khamsah* of Nizāmī in the British Museum (Or. 2265) and two miniatures in the Imperial Library, St. Petersburg[1]) and that of Āqā Riẓā. The latter of these two has received more attention from critics of Muhammadan art than any other Persian painter, and a considerable mass of literature has accumulated round his name. This Riẓā is undoubtedly the same as the artist who so frequently signed his drawings 'Riẓā 'Abbāsī', in a neat and characteristic handwriting; from the dates he also added, it is clear that he was actively at work between the years 1593 and 1629, when Iskandar Munshī finished his history. It is impossible that in an account of the court painters of the reign of Shāh 'Abbās the historian should have omitted to mention the name of an artist of such remarkable talent and such striking individuality, a truly great master in drawing and characterization, whose popularity is evidenced by the large number of the examples of his work in existence even up to the present day. The impression he made upon his contemporaries is shown by the fact that he founded a school of his own and gave to portraiture and figure-drawing a new direction, in which he had many imitators. Brief as the notice given of him by Iskandar Munshī is, it emphasizes certain characteristics which lend distinction to the work of Riẓā 'Abbāsī—his skill in making portraits of single figures and his delicacy of touch. The stress laid upon his independence of character fits in well with the self-assertiveness of Riẓā 'Abbāsī in almost always signing his pictures, and in many cases also writing out long inscriptions giving the exact date and the circumstances under which the pictures were made; this is a new phenomenon in the history of Persian painting, and it needed a man of a certain roughness of temperament to break with the modest habit of his predecessors, who rarely signed their pictures, and when they did so, generally sought out some unobtrusive part of the surface for the purpose. His wild life is reflected in the kind of subjects that Riẓā 'Abbāsī so frequently chooses. The comparison with Ṣādiqī Beg is also significant, as this contemporary painter at one time took to the life of a wandering dervish, and it is just this class of itinerant devotees that appears to have excited the interest of Riẓā 'Abbāsī, and some of his finest and most impressive drawings are devoted to representations of them. The cap fits so well that it is not easy to understand why most writers on Riẓā 'Abbāsī have failed to identify him with the Āqā Riẓā of Iskandar Munshī.

Some consideration may therefore be given to the difficulties that have been

[1] F. R. Martin, *op. cit.*, Vol. I, p. 118.

felt to stand in the way of such an identification; the weightiest of these is based on the erroneous supposition that the famous painter's full name was Riḍā 'Alī,[1] and this supposition was believed to find confirmation in an inscription on a portrait[2] of Riḍā 'Abbāsī by an ardent admirer, Mu'īn Muṣavvir; but the word which Professor Mittwoch read as ' 'Alī' is clearly ' 'Abbāsī'.[3] All necessity to search Persian literature for a Riḍā 'Alī, who might be identified with the painter, is accordingly entirely unnecessary; and the selection that had been made of a certain Mawlānā 'Alī Riḍā 'Abbāsī was singularly inappropriate; this latter was a famous calligraphist in the reign of Shāh 'Abbās, and wrote out inscriptions for some of the great mosques of Iṣfahān; he was also appreciated as a copyist of manuscripts, several of which in his handwriting are still preserved in libraries in Europe. But there is no evidence whatsoever that Mawlānā 'Alī Riḍā 'Abbāsī ever painted a picture in his life, and the calligrapher who owed his fame to the verses from the Word of God which he inscribed on the mosques of Iṣfahān would probably have viewed with horror the scandalous accusation that he should have so demeaned himself as to create such pictures as Riḍā 'Abbāsī delighted in— drinking-parties, love-scenes, catamites, and dancing-girls. Moreover, the only signatures in the characteristic handwriting of the artist are Riḍā (simply) or Riḍā 'Abbāsī; there is no evidence that he ever added 'Ali to his name.

Another difficulty has been felt in the fact that while Iskandar Munshī writes about Āqā Riḍā, the painter always signs himself Riḍā or Riḍā 'Abbāsī. But Āqā is merely an honorific, and would not be applied by a man to himself, though it would be polite for others to use it when speaking of him. Similarly, the painter who is referred to by the historian as Āqā Mīrak signs himself simply Mīrak (British Museum, Or. 6810, fol. 15 b), just as Corot signed his pictures with the single name Corot, rather than Monsieur Corot. In cases where the words 'Āqā Riḍā' are written on any one of the pictures by Riḍā 'Abbāsī, they have been added by some owner or cataloguer, and there are several instances of these words 'Āqā Riḍā' having been so added, in a hand-writing that is clearly not that of the artist himself, on drawings to which Riḍā 'Abbāsī had not himself attached his signature. It was therefore considered necessary to invent another painter, Āqā Riḍā—distinct from Riḍā

[1] This was the opinion of Karabacek (*Riẓa-i Abbasi*, p. 30), of Professor Mittwoch (*Zeichnungen von Riẓa Abbasi*, bearbeitet von Friedrich Sarre und Eugen Mittwoch), and of Dr. Martin (*op. cit.*, Vol. I, p. 122).

[2] Reproduced by F. R. Martin (*op. cit.*, Vol. I, p. 68) and (in colour) in *The Journal of Indian Art*, Vol. XVII, No. 135, Plate I.

[3] E. Littmann and A. Siddiqi, in *Göttingische Gelehrte Anzeigen*, 1917, p. 612 (in a review on Sarre and Mittwoch's *Zeichnungen von Riẓa Abbasi*).

'Abbāsī—to explain this variation in ascription, as Dr. Martin[1] has done in the case of a portrait in the British Museum, though Riza 'Abbāsī had added in his characteristic handwriting an inscription on this portrait setting forth the circumstances under which he painted it. There may quite possibly have been other painters of the name Rizā working at the same period, and an owner of one of their pictures might quite suitably have written the name Āqā Rizā on it, as an indication of authorship; but no painter of the period of Shāh 'Abbās has yet been discovered, to whom Iskandar Munshī's account of Āqā Rizā better applies, than the artist who signed himself Rizā 'Abbāsī.

This last appellation, 'Abbāsī, is no part of the name his mother gave him, but was probably adopted by the painter in token of the service he owed to his sovereign Shāh 'Abbās, who had shown him such kindness, just as the poet Muṣliḥ ad-Dīn styled himself Sa'dī after his patron Sa'd ibn Zangī, the Atābeg of Fars. The calligrapher Mawlānā 'Alī Rizā must also have added 'Abbāsī to his name for precisely similar reasons.

For the Indian painters in the latter part of the fifteenth and the early decades of the sixteenth century, there are some materials available in the *Ā'īn-i-Akbarī*[2] of Abu'l-Fazl and in the *Memoirs* of Jahāngīr;[3] but as both of these works are available in English translations and have served as the basis for more than one careful study of Mughal art,[4] a mere reference to them is sufficient here.

Enough has been said to show how scanty is the contribution that historical sources can make to the study of Muhammadan painting, and how perplexing are the problems which the historical material often presents. The most fruitful direction for future investigations will probably be in the way of the grouping of several schools of painters—an exact determination of the style of each individual painter, so far as that may be possible—such patient study of details and individual characteristics as Giovanni Morelli pursued about the middle of the nineteenth century in Italian picture galleries—the enumeration of the works of the greatest masters, based on principles of sound criticism and on enlightened artistic judgement—and then the co-ordination of these aesthetic researches with such literary sources as are available. Fortunately, the workers in this little-explored field are on the increase, and the publications of Dr. Hermann Goetz have shown what

[1] *Op. cit.*, Vol. II, Plate 110.
[2] Translated by H. Blochmann (Calcutta, 1873).
[3] Translated by Alexander Rogers (London, 1909, 1914).
[4] Percy Brown, *Indian Painting under the Mughals* (Oxford, 1924); L. Binyon and T. W. Arnold, *The Court Painters of the Grand Moguls* (Oxford, 1921).

illuminating results may be obtained from such patient and detailed investigations.[1]

How some connected account may be built up out of scattered information collected from several widely separated continents may be illustrated from the instance of that interesting Persian painter, Muḥammad Zamān. That gossipy traveller, Niccolao Manucci,[2] records how he met this painter in India about the year 1660; he describes him as being a man of great intelligence who had been sent by Shāh 'Abbās, King of Persia, early in his reign, to study in Rome. Manucci does not say which of the two possible sovereigns of this name showed such interest in Italian art as to wish one of his subjects to acquire the methods and technique of European painting, but from the evidence of other dates in Muḥammad Zamān's career it would appear to be 'Abbas II (1642–1667). In Italy he became a Christian and took the name of Paolo Zamān. On his return to Persia, he concealed the fact of his change of faith, but his conversation revealed his predilection for Christianity over Islam, and on account of the suspicions he excited thereby he fled from Persia and took refuge in India; here Shāh Jahān (1628–1659) extended to him his protection and assigned to him the salary of an official of the state, and sent him to Kashmir, which appears to have been commonly assigned to such Persian refugees as a place of residence. It was because these Persians, in receipt of allowances from the state, were suspected of concealing the death of one or more of their number and of appropriating the dead man's allowance, that Manucci had an opportunity of meeting Muḥammad Zamān, for the Emperor Aurangzīb determined to remedy this abuse and ordered all these Persians in Kashmir to present themselves at court, in order that the register of their names might be verified. While in Dihlī, Muḥammad Zamān consorted with the Christians, especially with Father Busée, S.J., a Fleming who had come to Agra in 1648 and died at Dihlī in 1667. In the library of this Jesuit he saw a copy of Matteo Ricci's book, *De Christiana Expedicione apud Sinas*, and translated into Persian Chapters II to X, under the title *Ta'rīkh-i-Chīn*, or History of China.[3] At this period of his career Muḥammad Zamān still declared himself to be a Christian, though his

[1] Ernst Kühnel und Hermann Goetz, *Indische Buchmalereien aus dem Jahângîr-Album der Staatsbibliothek zu Berlin* (Berlin, 1924) (English translation, London, 1926); Hermann Goetz, 'Kostüm und Mode an den indischen Fürstenhöfen in der Grossmoghulzeit' (*Jahrbuch der Asiatischen Kunst*, 1924); 'Die Malschulen des Mittelalters und die Anfänge der Moghul-Malerei in Indien' (*Ostasiatische Zeitschrift*, N.F. III), &c.

[2] *Storia do Mogor*, translated by William Irvine, Vol. II, pp. 17–18.

[3] A MS. of this translation is to be found in the Library of the Asiatic Society of Bengal (Wladimir Ivanow, *Descriptive Catalogue of the Persian Manuscripts in the Curzon Collection*, Asiatic Society of Bengal, pp. 96–8, Calcutta, 1926).

manner of life differed in no respect from that of the Muhammadans around him.

As to the date of his return to Persia we have no information, but in 1086 (= A.D. 1675-6) he was employed to fill up the three blank spaces on foll. 203b, 213, and 221 b,[1] which had remained unfilled for over a century in the copy of the _Khamsah_ of Nizāmī (British Museum, Or. 2265) made for Shāh Ṭahmāsp between the years 1539 and 1543. He was permitted to insert specimens of the new style of painting—so different from that of the court painters of Shāh Ṭahmāsp—which he had acquired in Italy; the costumes of his figures are in several instances of a European type and the landscapes are copied from late Italian paintings. In the same year (1086) and the two following years he was engaged in illustrating another MS. of the _Khamsah_ of Nizāmī, now in the Morgan Library, New York, and in the last of these years (1088) an inscription states that he was then working in Iṣfahān.[2] As in this manuscript, and on the pictures reproduced by Dr. Martin,[3] he describes himself as 'Muḥammad Zamān, son of Ḥājī Yūsuf', it seems probable that by this date he had returned to the religion of his birth, as otherwise he would have been unlikely to emphasize in such a manner his Muslim origin. He is said to have remained alive up to the close of the century.[4] To complete his history what is most needed is some contemporary evidence from Italian sources as to his life and studies in Rome.

[1] The last of these is reproduced in V. A. Smith's _Story of Fine Art in India and Ceylon_, p. 467.

[2] N. N. Martinovitch, 'The life of Mohammad Paolo Zaman' (_Journal of the American Oriental Society_, Vol. XLV, pp. 108–9, 1925).

[3] _Op. cit._, Vol. II, Plate 173. [4] P. W. Schulz, _op. cit._, p. 195.

APPENDIX A (p. 1)

THE long list of such pious princes includes the names of many whose busy lives could hardly have been expected to afford leisure for so toilsome an occupation. In India, Nāṣir ad-Dīn Maḥmūd Shāh (1246–1265), one of the early Sultans of Dihlī, is said to have made two copies of the Qur'ān every year (*Ṭabaqāt-i-Akbarī*, Bibl. Ind., p. 77). Of the Mughal imperial family, Bābur sent a copy to Mecca, transcribed in the special form of script which he is said to have himself devised (A. S. Beveridge, *Bābur-nāma*, App., p. lxiii). Prince Dārā Shikoh (*ob.* 1659) is known to have made several copies, and his brother, the Emperor Aurangzīb (1659–1707), sent to Medina two sumptuously bound and illuminated copies, valued at 5,000 rupees, finely written out by his own hand (*Ma'āthir-i-Ālamgīrī*, p. 532), and other copies he made still exist in India.

APPENDIX B (p. 46)

Such iconoclastic zeal may on other occasions have been prompted by superstitious fears, as in the case of the frescoes discovered by Professor von Le Coq in Turfan and now set up in the Museum für Völkerkunde, Berlin; many of these have had their eyes dug out and their faces scored across, because the peasants fear that, unless this is done, demons may come out of the figures and torment them.

APPENDIX C (p. 74)

The royal warrant,[1] issued by Shāh Ismā'īl in 1522, appointing Bihzād director of the Royal Library, is of such supreme importance in the history of Persian painting that it may fittingly be added to the other original sources that have been translated in the last chapter from Persian histories. But Khwāndamīr wrote it in language so involved and rhetorical that only the most earnest students are likely to care to puzzle out the meaning of it; it has therefore been here relegated to an appendix.

'The will of the Painter of the workshop of creation and origination, and the volition of the Draughtsman of the picture-gallery of the sky and of the earth—(inasmuch as in accordance with His word "He fashioned you and made your forms beautiful",[2] His marvellous design of the existence of the race of men has been wrought by the pen of His power in the most beautiful of forms on the page of phenomenal existence, and the picture of the superexcellence of human beings over all the rest of God's creatures, in accordance with His words "We have favoured them beyond many of Our creation",[3] has been drawn by the finger of His wisdom)—have signed the decree "We have made thee a viceregent upon earth"[4] upon the gilded page of the sun by the pen of Mercury, in our[5] auspicious name, and have designed and adorned the pages

[1] The Persian text with a French translation was published in the *Revue du Monde Musulman*, Tome XXIV, 1914 (Mirza Muhammad Qazwini et L. Bouvat, *Deux documents inédits relatifs à Bihzad*).
[2] Qur'ān, xl. 66. [3] Qur'ān, xvii. 72. [4] Qur'an, xxxviii. 25. [5] i.e. Shāh Ismā'īl.

of the azure sky in order to write the daily record of the annals of our victories and triumphs, by the sprinkling of silver stars and the ruling of vermilion lines of the evening glow. Therefore it seems fitting and suitable that the tablet of our divinely-inspired royal mind, which is the receptacle of rays of heavenly light and the seat of the manifestation of various forms of His benevolence, should be fashioned in such manner that all the weighty matters of our royal court and all the important affairs of our imperial administration shall be entrusted to skilled, intelligent and experienced persons, of distinguished merit, who by the draughting of their subtle intelligence and the colour-blending of their fine natures may make manifest upon the tablet of existence a sketch of the creation of all kinds of ability and a picture of the production of all manner of sagacity, and may lift the veil from the face of that which is sought for and aimed at.

'Accordingly, at this present time the marvel of the age, the model of painters and paragon of gilders, Master Kamāl ad-Dīn Bihzād, (who by his painting brush has put Mānī to shame and by his limner's pencil has abashed the pages of Artang,—who like a pen (in the hand of a writer) has always set his forehead on the line of our commands to which obedience was due, and has set his foot like a compass in the circle of obedience to the threshold of the refuge of the Caliphate,) has been covered with our royal benefits and our imperial favours. We command that there be assigned and entrusted to him the office of the control and the superintendence of the staff of the Royal Library and of the copyists and painters and gilders and margin-drawers and gold-mixers and gold-beaters, connected with the occupations above mentioned, throughout our guarded territories. All the enlightened Amīrs and incomparable Wazīrs and the secretaries of our world-protecting threshold and the envoys of our heaven-like court and the functionaries of royal business and the officials of our ministries,—in general,—and the staff of the Royal Library and the persons mentioned above,—in particular,—must recognize the above-mentioned Master as the director and the superintendent. They must submit to his control and administration all the activities of the Library, and pay due consideration to all his administrative measures authorized by his seal and signature. There must be no disobedience or neglect of any orders or regulations he may make for the control and conduct of the business of the Royal Library. Everything connected with the above-mentioned business they are to regard as belonging to his special province. He, for his part, must draw and depict upon the tablet of his heart and the page of his enlightened conscience the image of integrity and the form of uprightness. He must set out upon this office by the way of righteousness, shunning and avoiding all partiality and dissembling, and not swerve or decline from the highway of truth and virtue. Let all men pay heed hereto and accept these credentials as soon as this royal decree has been honoured and adorned by the stamp of the seal of his exalted Majesty. Written on the 27th of Jumādà I, 928 (= A.D. 1522).'

APPENDIX D (p. 117)

Another etymology connects Burāq with the Pahlavi *bārak* (the modern Persian *bārah*, 'a riding-beast').

INDEX OF MSS. REFERRED TO

GENERAL INDEX